ART101

FROM **VINCENT VAN GOGH** *TO* **ANDY WARHOL,** KEY PEOPLE, IDEAS, AND **MOMENTS IN THE HISTORY OF ART**

ERIC GRZYMKOWSKI

Avon, Massachusetts

Published by
Adams Media, a division of F+W Media, Inc.
57 Littlefield Street, Avon, MA 02322. U.S.A.
www.adamsmedia.com

ISBN 10: 1-4405-7154-6
ISBN 13: 978-1-4405-7154-1
eISBN 10: 1-4405-7155-4
eISBN 13: 978-1-4405-7155-8

Printed in the United States of America.

10 9 8 7 6 5 4 3 2 1

Library of Congress Cataloging-in-Publication Data
Grzymkowski, Eric.
Art 101 / Eric Grzymkowski.
pages cm
Includes bibliographical references and index.
ISBN-13: 978-1-4405-7154-1 (pb : alk. paper)
ISBN-10: 1-4405-7154-6 (pb : alk. paper)
ISBN-13: 978-1-4405-7155-8 (eISBN)
ISBN-10: 1-4405-7155-4 (eISBN)
1. Art--Outlines, syllabi, etc. I. Title. II. Title: Art one oh one. III. Title: Art one
hundred and one.
N5305.G79 2014
702'.02--dc23

2013034871

Cover images © Clipart.com. Interior illustrations by Eric Andrews.

*This book is available at quantity discounts for bulk purchases.
For information, please call 1-800-289-0963.*

CONTENTS

INTRODUCTION

Many people are intimidated by "art books." And rightfully so:
Too often, the writer assumes that the reader possesses a level
of technical skill and knowledge far beyond that of the casual art
enthusiast. "Simple" concepts like perspective, color theory, and
the process of combining lines to create shapes are glossed over
(or omitted entirely). The beauty of Leonardo da Vinci's *Mona
Lisa* is presented as indisputable fact, without any explanation
as to why it is supposed to be the greatest painting ever created.

Not *Art 101*, however. Here, you'll be able to learn about art
without feeling like you're reading a textbook for advanced art
students. You'll find art techniques, movements, and mediums as
well as the fascinating stories of famous artists presented in such
a way that you can understand and appreciate them—and maybe
throw around a few key terms at museums or cocktail parties.

While it would take tens of thousands—possibly even
millions—of pages to cover *every* aspect of art, the topics featured
in this book encompass a large swathe of art history, theory, and
technique. Many of the entries directly relate to one another (such
as Henri Matisse and Modern Art), but you can also pick and
choose the topics you find most compelling and skip around at
your leisure. You can read about Van Gogh's struggles for notoriety
and transition straight to ancient cave art. Maybe you're interested
in sculpture or want to brush up on the history of typography. Just
like a museum, this book contains "rooms" of myriad topics from
around the world and throughout time. After reading *Art 101*, you'll
finally be able to fully appreciate what's hanging on the walls and
sitting behind glass...

COLOR THEORY

Why we like what we see

Color is one of the essential building blocks for creating works of art, along with line, texture, shape, and a few other elements. Color can be used to alter the mood of a piece, draw the viewer's eye to a certain portion of the canvas, and define the various objects within a work of art. The decisions an artist makes in regard to color may appear random, but they are often quite purposeful and are almost as much a science as an art.

COMBINING COLORS

Most children are taught three primary colors: red, yellow, and blue (RYB). By combining these three colors in different proportions, it is assumed any imaginable color could be created. While this is mostly true, RYB is actually just one set of primary colors. Other color combinations can also be used to produce an array of other colors, such as red, green, blue (RGB) and cyan, magenta, yellow (CMY). For most artists, however, red, yellow, and blue remain the most popular primary colors.

Colors created by combining two primary colors, such as purple from mixing red and blue, are referred to as secondary colors. Those colors created by mixing a primary color with a secondary color, or by mixing two secondary colors, are known as tertiary colors, such as with mixing blue and green to create blue-green.

COMPLEMENTARY COLORS

The concept of complementary colors first began to take shape when Aristotle noted that the viewer's impression of a color could change depending on the way light hit that color. Saint Thomas Aquinas would later expand on this in the thirteenth century, when he noted that certain colors appeared more pleasing when placed next to certain other colors. For example, purple appeared more pleasant next to white than it did next to black. During the Renaissance, artists such as Leonardo da Vinci also noted that certain colors, such as red and green, looked particularly pleasing when placed alongside one another, but they did not understand why.

In 1704, Isaac Newton expanded on the observations of Renaissance artists to create a circle divided into seven colors. Those colors opposite each other were the most contrasting, with those next to each other being the least contrasting. His circle would later be divided into twelve sections to produce the "color wheel" recognizable by today's artists.

The term "complementary colors" was first introduced by an American scientist living in Britain named Benjamin Thompson. While observing lit candles, he discovered that the colored light produced by the candle and the shadow it produced contained colors that "complement" one another. (Although shadows may appear gray or black, they are actually made up of a combination of complex colors that are directly affected by the light that casts them.) He determined that this must be true with all colors of the spectrum, and that each individual color had its perfect counterpoint.

Artists and scientists later discovered that the attributes of complementary colors go well beyond the simple matter of being pleasing to the eye when adjacent to one another. For one, when a

color appears on top of another, it takes on elements of the color that is complementary to the background. For example, a red ribbon placed on a yellow background will take on a slightly purple hue, because purple is the complementary color to yellow.

Additive Versus Subtractive Colors

While experimenting with different color combinations and how colors interacted, artists and scientists discovered that colors behave differently depending on the medium. This lead to two classifications of color: additive color and subtractive color. Additive color generally refers to light and can be observed on modern televisions and projectors. In essence, the complete absence of light creates a dark "blackness" that is altered when colored light of particular wavelengths is added. By contrast, subtractive color refers to pigments and dyes that are added to block or "subtract" certain wavelengths of light to display the desired color. For example, red paint on a canvas actually absorbs or "subtracts" all other colors of the spectrum and leaves the viewer with the color red.

THE TEMPERATURE OF COLORS

It is generally believed that certain colors can evoke particular moods and emotions in the viewer. When referred to in this manner, colors can roughly be broken down into cool colors and warm colors:

- The cool colors generally consist of blues, greens, and grays and are believed to relax the viewer and recede into the background.
- By contrast, warm colors like reds, yellows, and browns imply motion and excite the viewer.

THE COLOR OF COLOR

The way a color appears to the viewer is greatly dependent on how deep the color is, also known as "saturation." In a simple sense, how red is a particular red? An artist can adjust the appearance of a color by adding different colors. For example, adding a little black paint to blue paint creates a darker shade of blue, while adding white paint to orange paint produces a lighter tint. The artist is not limited to just black and white, however, and can use any range of colors to lighten or darken colors. He or she could also mix the paint with both light and dark colors to produce a tone, which is created by adding grey or with a combination of shading and tinting.

The Eye of the Beholder

The average human can distinguish between approximately one million distinct colors, but some people might be able to see as many as 100 times that amount. These people, known as tetrachromats or "superseers," possess an additional photoreceptor cone in their eyes, which theoretically gives them access to a color spectrum imperceptible to most humans.

BAUHAUS

Art at the service of industry

The Bauhaus was both a school and a movement in Germany founded by Walter Gropius in 1919. Gropius maintained a utopian vision of a unification between fine art (such as painting) and craftsmanship (such as woodworking). This daring new design philosophy attempted to place both types of artists on equal footing and combine their disparate skills in the pursuit of the ultimate art form. As it evolved, Bauhaus worked hand in hand with the growth of industry, training its artists to meet the new modern challenge of designing for mass production. Bauhaus pottery, furniture, sculpture, and architecture emerged in a style known for its clean lines and simple, geometric shapes.

THE ROOTS OF BAUHAUS

History and politics paved the way for the Bauhaus movement. Here are some of the key factors that art historians deem influential to the movement:

- The fall of the German monarchy after World War I brought freedom from censorship. Thanks to this new sense of freedom, the art world was open to new experiments.
- The notion that art could be the perfect marriage of form and function was one of the foundations of the Bauhaus school of thought, but it was not a new concept. The English designer

William Morris had been a firm believer in the concept several decades earlier during the nineteenth century.

- Modernism had been seeping into the cultural fabric of Germany since before World War I. German architectural Modernism (also known as Neues Bauen) in particular likely influenced the rational, simplified design of Bauhaus art. It also demonstrated that art and mass production could successfully merge.

FOUNDING PHILOSOPHY OF BAUHAUS

The German architect Walter Gropius founded the Bauhaus school in 1919. Bauhaus (which translates to "house of construction") was more than an abstract philosophy of art: It was the name for a new school of design—the first of its kind—in Weimar, Germany. In Gropius's Proclamation of the Bauhaus, he delivered the school's mission statement: to create a collaborative society of crafters, each skilled in areas as diverse as architecture, pottery, painting, and sculpture. To Gropius, the beauty of art lay in its usefulness and its relevance to daily life as well as its visual appeal.

Having seen the work of Russian and Dutch designers, Gropius taught artists that mass production did not mean the end of individual creativity but rather an artistic challenge that could deepen the significance of art in daily life. Because a great number of countries and philosophies were represented within its faculty, Bauhaus became a center of collaboration and debate regarding the role of art in modern society. The term *Bauhaus* evolved as well. It came to define the many clean, geometrically balanced works of art that grew out of the school's teachings.

THE MAKING OF A BAUHAUS ARTIST

Bauhaus shaped its artists by instilling in them the skills of both fine art and design. Before students were allowed to focus on their specialized coursework, they were required to take an introductory course in materials, color theory, and design principles. Some of the famous visual artists who taught the course included:

- Russian painter Wassily Kandinsky
- Multitalented, German-born artist Josef Albers
- Swiss painter Paul Klee

Once students passed the intro course, they could move on to classes as diverse as metalworking, cabinetmaking, weaving, pottery, typography, or wall painting. Teaching such a wide range of crafts at the school eventually became a financial burden. By 1923, philosophical and practical forces aligned to shift the focus of the school from the integration of all crafts to an emphasis on designing for mass production. The school's slogan became "Art into industry."

THE END OF THE BAUHAUS SCHOOL

Eventually, the school struggled financially, though its biggest threat was a politically turbulent environment that forced the constant movement of the school from city to city. Due to pressure from the Nazi party, its doors officially closed in 1933.

THE NEW BAUHAUS SCHOOL

Thanks to the emigration of many of its teachers to American universities, the teachings of the Bauhaus school managed to live on. The New Bauhaus school was established four years later in 1937 in Chicago. The name has since been changed to the Illinois Institute of Design, which remains open to this day.

FAMOUS BAUHAUS DESIGNS

The Bauhaus style, also called the International Style, is characterized by its lack of ornamentation, its minimal form, and the way in which its design serves its function. Some of the most famous examples of Bauhaus style are:

- Invented by Marcel Breuer in the mid-1920s, the "Wassily" chair is an excellent and lasting example of the Bauhaus style. The chair's exposed steel and canvas gave it a futuristic look that is still popular today.
- Marianne Brandt's silver teapot, with its geometric components, nondrip spout, and heat-resistant handle, is another notable emblem of Bauhaus's practical leanings.
- Wilhelm Wagenfeld's 1924 table lamp is known for its simple, straightforward styling. Made while he was a student at the Weimer school, it has since earned the name, "Bauhaus Lamp."

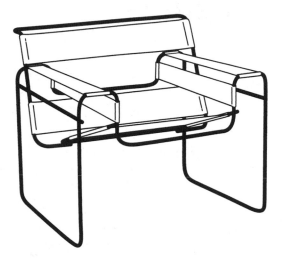

Wassily chair

Architecture in this style is often cubic in shape, eliminates unnecessary ornamentation, is made for open floor plans, and features basic colors like white and gray. Glass is used liberally, often replacing walls, and roofs are flat instead of pitched. The museums and schools within Bauhaus, like the Dessau school (1925) with its open feel and pinwheel arrangement, were some of the first examples of Bauhaus architecture. It would later inform town and cityscapes in Europe, America, and beyond.

In the decades following the closing of the school, examples of Bauhaus architecture included the United Nations Secretariat Building in New York City, which was completed in 1952; Houston, Texas's Transco Tower, constructed in 1983 (now known as the Williams Tower); and numerous small buildings in Israel.

ART THERAPY
The healing power of creation

For many artists, the very act of creating art can serve as an outlet for the stress, anxiety, confusion, and dissatisfaction they experience in their daily lives. They can express themselves with their art in ways that simply aren't possible using any other method. Artists have been aware of the benefits of self-expression for centuries, but it was not until relatively recently that those outside the artistic community began to take notice.

HILL'S ART THERAPY:
THE JOY OF PAINTING

The first of two schools of art therapy began in the middle of the twentieth century with a British military painter named Adrian Hill. While recovering from tuberculosis in 1938, Hill discovered that painting helped him keep his mind off his illness and appeared to aid in his recovery. He shared his love of painting with other patients at King Edward VII Sanatorium, many of whom also reported the act of painting improved their mood and helped relieve stress.

Once he recovered, Hill worked to spread the message of his new form of therapy throughout England. He recruited other artists to travel to hospitals and paint with patients, especially soldiers returning from war. Hill's form of art therapy was primarily concerned with the act of creation rather than the actual works produced. He, as well as other early adopters of his method, refrained from analyzing the work of their patients in search of any deeper meaning.

The program spread to 200 hospitals around Britain by 1950 and Hill would later establish the British Association of Art Therapists in 1964 to continue to spread the benefits of art therapy. The patients seemed to enjoy creating artwork, and that was enough for Hill.

NAUMBURG'S ART THERAPY: THE SYMBOLISM OF ART

Around the same time that Hill practiced his laissez-faire approach to art therapy, an American psychologist named Margaret Naumburg was developing an approach that used art as a communication tool between patient and therapist. She was not the first to use art therapy in this way, but she was the first to use it as the primary focus of the interaction between doctor and patient.

Naumburg's work was centered around symbolism and the subconscious desires of her patients expressed through drawing. Her preferred technique was to have her patients close their eyes and scribble a drawing on a piece of paper. She then asked them to identify the objects they had drawn and express their feelings about them. Rather than interpret the images herself, Naumburg instead relied on the patients to express their own inner desires while interpreting their art. In fact, she felt it was counterproductive to offer any analysis herself. Once any subconscious problems were brought to light through the act of drawing and interpreting, they could be addressed and treated by the therapist.

METHODS

In the years since Hill and Naumburg popularized art therapy among the medical community, several methods for using art as a means to diagnose and treat patients have emerged.

Diagnostic Drawing Series

One of the most popular forms of modern art therapy was first introduced in 1982 and consists of three separate drawings, each of which must be completed by the patient using only pastels and paper. The instructions are very rigid and must be delivered precisely as they are written below:

- **First picture:** "Make a picture using these materials."
- **Second picture:** "Draw a picture of a tree."
- **Third picture:** "Make a picture of how you are feeling using lines, shapes, and colors."

Once the exercise has been completed, it is up to the therapist to interpret the work of the patient. Everything from the colors selected to where on the page the patient chose to draw can provide the therapist with valuable information to help the patient work through his or her issue.

The Mandala Assessment Research Instrument

In this exercise, the patient selects a card containing a mandala (an intricate image contained in a geometric shape). The patient then selects a card depicting a solid color and uses oil pastels corresponding with that color to re-create the mandala. During the process, the patient is asked to draw on personal experience to describe any

significance that particular mandala might have to his or her own life. The significance of the mandala is purely subjective—the shapes and patterns on a particular mandala might evoke different feelings and emotions depending on who is looking at it.

The free association the patient is encouraged to provide while drawing gives the therapist insight into his or her personality.

House-Tree-Person

Here the patient is asked to draw a house, a tree, and a person. The therapist then asks open-ended questions about the figures in order to determine both the mental abilities as well as the emotional state of the patient. The questions can be simple such as, "what type of tree did you draw?" to more complex such as, "is the person who lives in the house happy?"

An example of a house-tree-person therapy drawing

Road Drawing

One of the most subjective assessment methods, this method asks the patient simply to draw a road. Depending on how the patient populates the drawing, this can offer insight into his or her past, present, and future ambitions. During the course of therapy, patients are often encouraged to add to their road to illustrate how their own opinions about their lives have changed.

An example of a road therapy drawing

Family Sculpting

Although not as popular as other art therapy methods, family sculpting is unique in its more tactile approach to art therapy. This

method was first developed by psychotherapist Virginia Satir and seeks to unlock the inner feelings a patient has toward his/her family that the patient is otherwise unwilling or unable to express. The patient is provided with several lumps of clay and is then instructed to mold the clay into representations of each individual family member. The way the patient creates each figure can provide the therapist with vital information. For example, a patient who is fearful of his or her father might sculpt that figure as large and menacing in comparison to another figure.

Some therapists might take the process one step further and ask the patient to then situate the sculptures in relation to each other. This can identify issues between certain individuals, for example, if the patient placed the sculpture of the mother far separate from the rest of the family, it might indicate the mother is distant.

Today, art therapy is a popular practice among psychologists and therapists, particularly those working with children. It has been used to aid with post-traumatic relief during natural disasters and to help both children and adults deal with complex issues, such as the death of a loved one.

ART NOUVEAU

A celebration of decoration

The World Fair in Paris in 1878 set the tone: Nations came together to celebrate the progress of the "civilized" world, and Art Nouveau borrowed from this spirit. While the world of academic art was still preoccupied with emulating the great works of the past, Art Nouveau, French for "new art," hoped to create a novel style that was grounded in the present and honored the unique artistry of the individual.

The earliest use of the term *art nouveau* appeared in an art journal in the 1880s, describing the symbolic, mystery-laden work of twenty Belgian reformist painters and sculptors calling themselves Les Vingt. These artists and others like them in Europe and America were inspired by a new calling: to create a common language across all forms of art.

WHAT IS ART NOUVEAU?

Historically, fine art and decorative art had been viewed as separate entities, with fine art given more credibility. Art Nouveau was an effort to unite and equalize art of all mediums. Architects, jewelry crafters, engravers, embroiderers, and other skilled craftsmen were invited into the Art Nouveau style and supported in the great pursuit of Gesamtkunstwerk, the harmonious integration of all art forms into one masterpiece. Drawing its inspiration from nature, Art Nouveau was an organized reaction against the principles of industrialization, such as an emphasis on straight lines and mass-produced consumer goods. The style covered more than just paintings: Jewelry, pottery, furniture, and architecture all exhibited the curvy, wandering lines

and elaborate detail characteristic of Art Nouveau. The movement started with an ambitious goal: to unite artists all over the world to create a uniquely decorative style of art.

ART NOUVEAU'S RELATIONSHIP WITH ARTS AND CRAFTS

The birth of Art Nouveau is closely related to the Arts and Crafts movement that flourished from 1860 onward in England and in other parts of the world. Arts and Crafts had emphasized the importance of fine craftsmanship as opposed to mass-produced items, which Arts and Crafts proponents believed lacked individual style. A key difference between the two movements was that many Art Nouveau artists embraced modern industrialization. With its help, they were able to mass-produce their work in advertisements, posters, labels, and magazines to reach a wider audience and fuel the movement itself.

Total Work of Art

German opera composer Richard Wagner used the term *Gesamtkunstwerk* in an 1849 essay to describe the integration of a wide variety of mediums to achieve maximum drama. Decades later, it would become part of the vocabulary of the Art Nouveau movement.

THE LOOK OF ART NOUVEAU

Art Nouveau work exhibits at least a few of the following signature markers:

- **Ornate Curves and Flowing Lines:** In Art Nouveau work, lines are painted, etched, or embroidered in a continuous, winding path that either depicts or emulates the growth pattern of nature's vines and plant life. Eating utensils, paintings, and furniture alike exhibit this detail.
- **Earthy Subject Matter:** Nature is everywhere in Art Nouveau handiwork, sculptures, and paintings. Animals, flowers, or plants are pervasive.
- **Unusual Raw Materials:** A focus on the natural environment encouraged artists to sculpt, design, and create lavish art with new materials including rare wood, iridescent opals, glass, and even animal horns.
- **Useful Finished Products:** Whether it's a Tiffany lamp, a curvy chair, or an engraved doorknob, Art Nouveau artists take pride in the notion that art can be a practical component of daily life.
- **Sensuality:** Idealized female figures surrounded in lush flowers are a common subject of Art Nouveau posters and paintings. Three-dimensional objects of this style pushed the boundaries of the time: A carafe shaped like a woman's body, for example, used the object's inherently interactive nature to heighten its sensual appeal.

The Art of the Hippies

Art Nouveau, with its erotic overtones based in sensuality and reverence for nature, was well suited to the American "hippie" culture of the 1960s. It's no wonder that the movement experienced a resurgence during this free-wheeling decade of sexual and social liberation.

FAMOUS ART NOUVEAU ARTISTS

Many art historians credit Czech artist Alphonse Mucha with the start of the Art Nouveau movement. His theatre poster for the play *Gismonda* was instantly popular when it appeared in the streets of Paris. It bore a unique style that was promptly imitated by aspiring and established artists alike. Mucha's commercial work often featured gorgeous goddess-like women engulfed in flowering vines.

Gustav Klimt is perhaps the most widely known Art Nouveau artist. His erotic paintings, rich with gold, mosaic detail (such as *The Kiss*, 1907–1908) were immediately cherished for their decorative, Byzantine beauty and they still occupy the walls of major art galleries all over the world.

Henri de Toulouse-Lautrec is another widely respected Art Nouveau artist whose poster art showcased the variety of roles women held in society, including both conventional and unconventional.

Charles Rennie Mackintosh, Antoni Gaudí, and Louis Comfort Tiffany (who invented the Tiffany style in America) also made significant contributions to Art Nouveau. The drawings of Aubrey Beardsley, and the architecture of Victor Horta and Paul Hankar are also familiar examples of this style. René Lalique, Georges Fouquet, and Philippe Wolfers were famous for incorporating women as fairies and sirens in their Art Nouveau jewelry.

Although it reached an international audience as it had set out to do, Art Nouveau was a relatively brief moment on the timeline of art history. Its optimistic endeavor to make beauty a part of everyday life was a refreshing detour from the numerous cynical art movements (such as Neoclassicism and Art Deco) that preceded and followed it.

DADAISM
The absurdity of life and art

Dada is the nonsense word that describes an equally nonsensical movement of art that swept through Europe and extended into New York City in the early twentieth century. The movement united artists in Zurich, Berlin, Cologne, Hannover (Germany), Paris, and New York City to support each other to protest World War I and the state of affairs in the realm of art—namely, the celebration of traditional paintings and sculptures. Their chosen method of protest: photography, collage, found objects, and other mediums that allowed for the impulsive creation of surprising and perplexing art. The movement ran concurrent with World War I and revealed the overall disenchantment that accompanied it.

ROOTS OF DADA

Dada was born in Zurich in 1916 when a group of young, like-minded artists and activists met at a local cafe called the Cabaret Voltaire to express their opposition to World War I. Jean Arp, Richard Huelsenbeck, Tristan Tzara, Marcel Janco, and Emmy Hennings were among those who joined together with a shared belief in challenging traditional viewpoints. The Cabaret Voltaire became the site of many baffling Dada "performances" that riled up their audiences and enraged locals. Nonsense poems were recited as music blared, and performance art purposefully added to the confusion.

Dadaism did not promote a particular style or technique for creating art. It simply encouraged collaboration between artists who wanted to rise up and challenge the faulty rationale of warring

countries and rail against staunch traditionalists who were closed off to any alternative visions of the world. As French artist Jean (Hans) Arp put it, their goal was "to destroy the hoaxes of reason and to discover an unreasoned order."

The Name Game

There is some conjecture as to how artists came to choose the name Dada. Some say they stabbed a penknife into a French-to-German dictionary and took the word it pointed to. Others claim that the name was consciously chosen for its bizarre translation into various languages. It means "hobbyhorse" in French and "yes, yes" in Russian.

The philosophies of the Zurich group influenced similar activity in Berlin, Cologne, Paris, and New York City. In New York City, Alfred Stieglitz's 291 Gallery became what the Cabaret Voltaire was to Zurich's Dada movement. While the Dada events at the 291 Gallery were similar in nature to the artistic "protests" in Zurich, the artists were less focused on the war and more focused on ridiculing the prevailing art establishment. Artists such as Marcel Duchamp, Man Ray, Morton Schamberg, and Francis Picabia joined together in New York to spread their subversive ideas through novel art forms.

DADA OBJECTS AND PUBLICATIONS

The time-worn traditions of painting and sculpture were not spontaneous and edgy enough to convey the Dadaist's revolutionary

message. Instead, they found the freedom they craved in the mediums of collage, photomontage, and found-object construction (the artistic presentation—and sometimes transformation—of common everyday objects). A prime example is Duchamp's found-object urinal construction *Fountain*, which exemplified the sort of spur-of-the-moment counterculture message of Dadaism. Though it was rejected from the American Society of Independent Artists' first exhibition, Duchamp continued to submit variations of the piece to stir up a debate about the true nature of art. He hoped to show his audience that the creative process of the artist is more valuable than its physical manifestation in the gallery.

In an effort to document their expressions of art, publish their work, and spread their manifestos, the separate factions of the Dada movement published their own periodicals and journals.

DADA IN BERLIN

German cities also became hubs for the Dadaists, allowing them a means to vent their grievances against the establishment. Max Ernst and Johannes Baargeld led the movement in Cologne. The pinnacle of Dadaism, however, occurred in 1920 Berlin at the first International Dada Fair. The Berlin movement was more aggressive and politically oriented than all other factions. Its international fair, held in a small backyard gallery, featured a German officer with the head of a pig. All the more disturbing: the officer/pig was suspended from the ceiling.

MOST NOTABLE DADAISTS

Following are some of the key names within the Dada movement:

- Alfred Stieglitz (American photographer and gallery owner)
- Clément Pansaers (Belgian poet)
- Man Ray (American photographer and painter)
- Marcel Duchamp (French artist)
- Max Ernst (German artist)
- Paul van Ostaijen (Flemish writer)
- Philippe Soupault (French writer)
- Francis Picabia (French artist)
- George Grosz (German artist)
- Jean Arp (French artist)
- Kurt Schwitters (German artist)
- Theo van Doesburg (Dutch artist)
- Tristan Tzara (French author)

Dada began to go stale in 1922, but its outrageous style and success in marrying art and protest lived on in other ways. Its eager departure from the rules of reality would inspire the Surrealists, while its spontaneous creation of art would take hold again during the Abstract Expressionist movement. Some would even credit Dada with the evolution of 1970s punk rock, with its aggressive, dissonant sound.

IMPRESSIONISM

A club for salon rejects

The Impressionist movement began with a small collection of artists—primarily Claude Monet, Edgar Degas, Pierre-Auguste Renoir, and Alfred Sisley—in France around the 1870s. At the time, portraits, still lifes, and religious and historical art dominated the French art world. The goal of many artists at the time was to produce realistic paintings with careful attention to detail. Artists used dark, subdued color and cautious brushstrokes and spent their days in the studio carefully perfecting their techniques. The Impressionists sought to break from nearly all of these conventions.

A NEW SCHOOL OF THOUGHT

Instead of broad, well-defined brushstrokes, the Impressionists painted short, thin lines with little distinction. Instead of portraits and still lifes, the Impressionists preferred to paint expansive land-scapes or open-air scenes. They also often selected everyday scenes and subjects for their paintings, as opposed to portraits of wealthy socialites or religious-themed imagery. Other artists generally preferred to paint static scenes, but the Impressionists emphasized movement and the notion of capturing a moment in time. While their contemporaries often painted their landscapes from a studio, the Impressionists adopted an entire new method of painting that allowed them the freedom to paint outside.

EN PLEIN AIR

The Impressionists were strong advocates for a new philosophy of painting dubbed "en plein air," which translates simply as "in the open air." They spurned the traditional artist's studio in favor of carting their easel and paints outdoors to capture scenes as they occurred.

In the past, painting outdoors posed a number of logistical problems for the artist. For one, changing light and weather conditions required the artist work quickly. Exposure to the elements could also cause the paint to run in unexpected ways or force sand and other debris into the painting. The process of mixing paints was time-consuming and not especially conducive to outdoor work, and easels were bulky and cumbersome to carry around. The Impressionists found solutions to many of these problems.

In 1841, artist John G. Rand invented an oil paint that could be packaged in tubes and easily transported by an artist working outdoors. At around the same time, a new type of easel called the "box easel" was invented. The legs of this new invention were telescopic, which allowed the whole easel to fold down to the size of a briefcase. They also often included an area for brushes, paints, and other tools. With these new advances, artists could easily carry everything they needed to paint for an entire day.

OUT OF THE SALON

The premiere showcase for artwork in nineteenth-century France was the Salon de Paris, an annual public exhibition of paintings and sculptures that attracted artists from around the world. While

several Impressionists managed to showcase their work at the event, for the most part their radical paintings were deemed inadequate and refused entry. In 1863, Napoleon III created a separate exhibition dubbed the Salon des Refusés (Salon of the Refused) to feature work denied admission to the Salon de Paris, but this did little to assuage the anger the Impressionists felt at being snubbed.

In 1873, several Impressionist painters created the Société Anonyme Coopérative des Artistes Peintres, Sculpteurs, et Graveurs (Cooperative and Anonymous Association of Painters, Sculptors, and Engravers) to hold exhibitions separate from the Salon. Their first such event took place in 1874 and included artwork from thirty artists. Not surprisingly, the critical response was mostly harsh. One critic, Louis Leroy, took offense to Monet's *Impression, Soleil Levant* (*Impression, Sunrise*) and used it to define the collective artists as "Impressionists" whose work he likened to unfinished sketches. While some members of the group scorned the new moniker, Degas in particular, most embraced it and felt it suited their new style of painting.

The group of artists now officially known as the "Impressionists," held seven more exhibitions in the following twelve years, although the members fluctuated. The group was plagued with disagreements over the nature of Impressionism as well as who should be allowed to join their exhibitions. Also, while many in the group abhorred the Salon and everything it stood for, many Impressionists continued to submit their work. Some even gained acceptance there, most notably, Édouard Manet, Monet, Renoir, and Sisley—although Manet did not consider himself an Impressionist and never participated in their exhibitions.

Few of the Impressionist painters achieved critical or financial success directly from the exhibitions, however, the exhibitions did serve to garner interest in their work. Renoir and Monet grew to prominence both during and after the Impressionist exhibitions and both achieved financial and critical success in their later lives. Many other artists began to emulate their style, and by the late 1880s work from Impressionist artists could even be seen at the Salon de Paris—much to the chagrin of some of the founding members of the movement.

The Post-Impressionists

Although too young to participate in the initial Impressionist movement, a number of prominent artists adopted their style and added their own variations. This included Paul Cézanne, Georges Seurat, and Vincent van Gogh among others. However, unlike the Impressionists, the Post-Impressionist artists were not a cohesive group and often differed in their opinions on the future of art.

At a time when painting standards were at their most strict, Impressionists scoffed in the face of convention and ignored most, if not all, of the rules laid out by the critics of the day. Although their work was initially met with disdain, the Impressionist painters of the late nineteenth century have produced some of history's most popular works of art that hang in major galleries and museums the world over.

CLAUDE MONET (1840–1926)

The Impressionist's Impressionist

Claude Monet was one of the founding members of the Impressionist movement and the artist indirectly responsible for the group's moniker. He is best known for his iconic paintings of water lilies inspired by those found on his property in Giverny, France, but his works span more than sixty years and consist of hundreds of landscapes, portraits, and still lifes.

EARLY LIFE

Claude Monet was born in Paris on November 14, 1840, but his family moved to the port town of Le Havre in Normandy when he was five. Like many young artists, he was less than enthusiastic about his time in the classroom. He preferred to spend his days outside drawing caricatures of the local residents. Realizing his appreciation for the arts, his parents enrolled him in the Le Havre secondary school of the arts at age ten.

He spent much of his youth selling charcoal drawings locally and honing his techniques. His artwork did not amount to anything more than a hobby or pastime until he met Eugène Boudin, a French landscape artist who would introduce him to a new style of painting that would later define Monet's career.

Boudin was a strong advocate for a new philosophy of landscape painting dubbed "en plein air," which translates simply as "in the open air." He, along with other artists at the time, spurned the traditional artist's studio in favor of painting outside.

Monet immediately took to Boudin's new style and abandoned his cartoonish caricatures. He spent several years exploring the local beaches of Normandy and painting with Boudin until he moved to Paris in 1859 to study at the Académie Suisse. He found that few of the students and teachers there shared his appreciation for en plein air painting, but he refused to abandon it in favor of more traditional methods.

THE BIRTH OF IMPRESSIONISM

After a brief stint in the military, Monet returned to Paris, where he befriended other like-minded artists such as Pierre-Auguste Renoir, Alfred Sisley, and Frédéric Bazille. He frequently took outdoor trips with his friends to paint, but the resulting works were not immediately embraced by the art community. Instead, Monet's first real recognition came from an indoor painting he made in 1866 of his future wife Camille Doncieux titled *La Femme à la Robe Verte (The Woman in the Green Dress)*.

Monet was forced to flee Paris in 1869 during the Franco-Prussian war. He settled in London—where his paintings were met with limited enthusiasm—before traveling to the Netherlands in 1871. Shortly thereafter, he returned to France where he would soon help to redefine the art world.

In 1874, Monet joined a group of young, like-minded artists in an exhibition that featured his painting *Impression, Soleil Levant (Impression, Sunrise)*. A critic used the painting as an example of the unpolished "Impressionist" pieces he saw on display which he felt seemed more like sketches than finished works. Rather than take offense, the group of artists embraced the notion and adopted it.

Despite the negative response from critics, Monet's popularity among his peers and the public grew in the years following the first Impressionist exhibition. Unfortunately, it was also around this time that his wife and muse Camille Doncieux contracted tuberculosis. She passed away on September 5, 1879, leaving Monet with two children. He grieved but determined to continue with his work.

Monet's Muse

Camille Doncieux was not only Monet's first love and mother to his two children, she was also one of his favorite subjects. Several of his most famous works included *La Femme à la Robe Verte (The Woman in the Green Dress)* and *La Japonaise (Camille Monet in Japanese Costume)*, a full-figure painting featuring Camille wearing a blond wig dressed in a bright red kimono to highlight the French obsession with Japanese culture emerging at the time. He even painted her on her deathbed shortly before she succumbed to tuberculosis.

THE OPEN-AIR STUDIO OF GIVERNY

Following the death of his wife, Monet and his children moved in with family friends Ernest Hoschedé and his wife Alice. Ernest was rarely home and Alice and Monet quickly developed a close friendship that many believe was romantic from the outset. Regardless of their potential romantic involvement, the mixed family unit moved around France for several years until settling in Giverny, the site for many of Monet's most famous paintings.

The small village with its picturesque landscapes was the perfect setting for Monet's work. His success as a professional painter improved dramatically after his move to Giverny, and in 1890 he

was able to purchase the house he had been renting and transform it into an outdoor studio of sorts. By carefully cultivating the gardens surrounding his home, as well as the pond and water lilies on his property, Monet could have complete control over the setting for his paintings. In his later life, the grounds of his home in Giverny served as his primary subject matter, including his most famous series *Water Lilies*, comprising some 250 individual works.

ARTIST UNTIL THE END

Toward the end of his life, Monet traveled around Europe painting primarily landscapes, but he also continued to paint series subjects around his home in Giverny. He developed cataracts around 1914, which may have affected the way he saw the world and his choice of colors, but did little to deter his painting. He continued to paint right up until his death in 1926 from lung cancer.

In the decades since his death, the popularity and value of his paintings have reached a level achieved by only a select few artists in history. His works can be found in museums around the world and routinely sell for tens of millions of dollars at auction, with one of his *Water Lilies* paintings fetching just over $80 million in 2008.

Ever the Perfectionist

Many artists often become dissatisfied with their work, but few were as self-critical as Monet. He was notorious for fits of rage directed at his paintings, which he would tear, throw, or even burn if he felt they did not meet his expectations. No one is certain how many of his paintings were destroyed during his outbursts, but some estimate it could be as many as 500.

MAN RAY (1890–1976)

An enigma of his time

Man Ray was a chameleon of the art world. His most thrilling talent was the versatility he showed in mastering a wide variety of mediums. His paintings, photographs, sculptures, and films surprised and delighted audiences with something dangerously provocative and unexpected. In America, his fame came in connection with his photography. Though he worked in Paris, New York City, and Los Angeles, he felt most at home in Paris, where the public was more aware of the full depth of his work. He never officially aligned himself with one specific art movement, and preferred to dabble in several different art movements throughout his career. Nonetheless, his work is forever tied to the Dada and Surrealist trends of the early twentieth century.

MAN RAY'S TALENT EMERGES

Emmanuel Radnitzky (Man Ray's given name) was born in 1890 in Philadelphia, Pennsylvania, but his family moved to Brooklyn when he was about seven years old. His parents, Russian Jewish immigrants, were prompted to change the family name to "Ray" as a result of the discrimination they encountered in the city. Emmanuel later changed his first name to "Man" and used the moniker "Man Ray" as one inseparable entity.

Man Ray showed an early aptitude for art, excelling in the areas of drafting and illustration. He was offered a scholarship to study architecture, but declined in order to pursue his passion: painting.

In 1912, four years after graduating high school, he took drawing classes in Harlem at the Ferrer Center and allowed his artistry to blossom. He took on commercial art and illustration work to support himself while spending his free time basking in the avant-garde works hanging in Alfred Stieglitz's 291 Gallery on Fifth Avenue. Man Ray's photography would eventually reveal Stieglitz's influence with its raw, unvarnished approach to its subject.

Man Ray found much-needed inspiration at the Armory Show of 1913, where he came face-to-face with the paintings of Pablo Picasso, Wassily Kandinsky, and Marcel Duchamp. For a short time, he experimented in the Cubist style he had encountered there. *The Black Tray* (1914), with its layered shapes, is a clear example of this influence.

Man of Mystery

Man Ray did not willingly share the details of his upbringing with the public. He discouraged family members in America from giving interviews about him and worked hard to maintain an aura of mystery.

Around this time, two important people came into Man Ray's life: One was the Belgian poet Adon Lacroix, whom he married in 1914 and separated from a few years later. The other was Marcel Duchamp, a kindred spirit who became a lifelong friend and artistic partner. Man Ray fell in step with Duchamp's artistic journey, emulating his bold style and working alongside him. Duchamp's attempts to imply movement in his paintings, for example, led to similar attempts by Man Ray, such as his 1916 painting *The Rope Dancer Accompanies Herself with Her Shadows*, inspired by an acrobatic show.

MAN RAY TRIES ON DADAISM

After meeting in 1915, Duchamp and Man Ray organized a Dada move-
ment in New York along with another artist named Francis Picabia.
Dadaism encouraged spontaneity in its radical anti-art approach to
making art. One example of Man Ray's contributions to this movement
is his famous 1921 installation, *The Gift*. This surprisingly provocative
piece combined multiple found objects and is best described as tacks
glued to the bottom of an iron. In 1920, he wrapped an army blanket
around a sewing machine and tied it with felt and string. He called the
object *The Enigma of Isidore Ducasse* (a reference to a line written by
the poet Isidore Ducasse). This object would make him a favorite of the
French Surrealists, who enjoyed the juxtaposition of disparate objects.

PHOTOGRAPHY AND MAN RAY

In 1917, Man Ray began exploring his talents in photography, even
opening his own portrait studio. He was now firmly embedded in New
York City's avant-garde art scene, having developed a reputation as an
intellectual and innovator. With the help of Duchamp, he founded a
group called Société Anonyme to promote avant-garde art worldwide.

Despite the roots he had grown in New York, he had not truly found
his place in the world until he moved to Paris in 1921. The flourishing
artistic community at Montparnasse suited him perfectly and allowed
him to bounce between art mediums and explore his potential as an artist.

The French Surrealists welcomed Man Ray to the Parisian art
scene, where he became an essential member of the movement. In
the midst of his artistic experimentations in Paris, Man Ray rein-
vented an art form that he named "rayograph." It involved placing

interesting arrangements of objects on photosensitive paper and making images from the negatives—no camera required. He described this method as "pure Dadaism."

To support his experiments as an artist, he made a living as a fashion photographer for leading publications like *Harper's Bazaar* and *Vogue*. During the 1920s and 1930s in Paris, he ran in the same social circles of the literary elite including Gertrude Stein, James Joyce, and Ernest Hemingway. His close relationships to famous artists and writers of the time gave him a unique opportunity: He became a trusted portrait photographer of the cultural icons of his time.

MAN RAY LEAVES HIS MARK

Man Ray took full advantage of the artistic freedom he enjoyed in Paris. He continued to paint, photograph, and construct objects that impressed the Dadaists and Surrealists alike, but he also began directing a number of short films, including his now-famous Surrealist film *L'Etoile de Mer (The Starfish)*, which was released in 1928.

Paris might have remained Man Ray's home for the rest of his life, if World War II had not intervened and forced him to move back to the United States. In 1940, he relocated to Los Angeles, where he immediately met his wife, a model and dancer. He became increasingly irritated with the limitations of his reputation in America—it frustrated Man Ray to be thought of as a photographer, when he considered himself to be so much more.

He finally returned to his beloved Paris after the war in 1951 to paint, sculpt, and work on his memoir. His autobiography, *Self-Portrait*, was eventually published in 1965. Man Ray continued to show his art in major cities throughout Europe and in America until his death in 1976.

APPROPRIATION

Finding beauty in the mundane

If you find a broken mirror on the ground and hang it on your wall, is it art? What if you take the shards and rearrange them? Or incorporate them into a painting? Depending on whom you ask, the answer to all of these questions is an emphatic "yes."

WHAT IS APPROPRIATION?

Although the very nature of appropriation leaves its definition open to interpretation, it generally refers to the process of making art by taking objects and using them in ways that were different than originally intended. This can involve a great deal of effort on the part of the artist, such as Andy Warhol's detailed re-creation of a can of Campbell's Soup, or it can require almost no effort at all, as in Marcel Duchamp's snow shovel inscribed with the title, *In Advance of the Broken Arm.*

The appropriated item can be an everyday object, such as a car tire, a broken piece of furniture, or even a rock or stick. It can also be an existing work of art, such as a film (or compilation of films), a photograph, or even a famous painting like the *Mona Lisa*. While some critics refuse to acknowledge many appropriated works as legitimate art, others argue the only criterion for something to fall into that category is that the artist displays it as such.

PIONEERS OF APPROPRIATION

Appropriation has its roots in early collage techniques from around 200 B.C. in China, but it did not emerge as an artistic movement until the early twentieth century. Around that time, Modernist painters such as Pablo Picasso and Georges Braque began incorporating common objects like newspaper clippings, pieces of cloth, or wallpaper directly into their paintings. Aside from altering the visual aspect of their works, the inclusion of external objects carried with them the emotions associated with their original purpose. For example, the newspaper clippings in Picasso's *Guitar, Sheet Music, Glass* contained references to the Balkan War, a controversial subject at the time.

While their works did contain found objects and appropriated items, the pieces were still distinctly new artistic works made up of a combination of elements. It was not until Marcel Duchamp began experimenting with found objects that the definition of "art" would be permanently altered.

Homage Appropriation

Since the Renaissance, and even before, budding artists have re-created famous masterpieces to learn the various techniques employed by their predecessors. That act in and of itself is a form of appropriation, but modern artists would take that concept one step further and re-create paintings while adding their own distinctive style. Picasso re-created several famous works, including Eugène Delacroix's *The Women of Algiers* and Diego Velázquez's *Las Meninas (The Maids of Honor)*, but he painted the figures in his signature Cubist style with distorted and exaggerated features.

ONE MAN'S TRASH . . .

While Picasso and Braque used found objects in their art, Duchamp went so far as to find objects and call them art. He pioneered a type of art later dubbed "ready-made" with his piece *Bicycle Wheel*, which consisted of the fork and wheel of a bike mounted upside down on a stool in his studio. He later insisted he merely liked the way it looked and did not create it with artistic intention. But regardless of his initial intent with *Bicycle Wheel*, he enjoyed the idea of displaying mundane objects as art and continued to pursue new creations, including *Bottle Rack* (a signed metal bottle drying rack) and *Comb* (a dog-grooming tool with an inscription along its side).

While Duchamp took great pleasure in bending the rules of traditional art, his ready-mades were not always well received. When he submitted a bathroom urinal entitled *Fountain* to a 1917 exhibition with the Society of Independent Artists, it was quickly rejected. Rather than acquiesce to the art community, Duchamp pushed the envelope even further with his 1919 *L.H.O.O.Q.*, a copy of the *Mona Lisa* sporting a beard and mustache. When spoken aloud, the letters of the work sound out the French phrase, "Elle a chaud au cul," which roughly translates to "she has a hot ass." Apart from enraging many members of the artistic community, *L.H.O.O.Q.* and works like it also brought into question the legality of appropriation.

WHO OWNS A WORK OF ART?

Apart from utilizing found objects in new and interesting ways, appropriation can also appear as the artist taking completed works and altering them greatly—or hardly at all. For example,

photographer Sherrie Levine created an entire exhibition in 1980 titled "After Walker Evans," consisting of photographs she took of Walker Evans's iconic images of rural America. Evans's estate accused her of copyright infringement and appropriated the photos to prevent their exhibition.

This raises the question of when is appropriation art, and when is it theft? And the answer is that it depends. Andy Warhol's popular Campbell's Soup paintings are often cited as being acceptable, since the image of the can of soup and Warhol's re-creation of it were not in direct competition. However, when Warhol created silkscreens from photos taken by Patricia Caulfield, she filed a lawsuit and the two settled out of court.

Some artists have successfully argued that their appropriated works are obvious parodies of the original (such as Duchamp's *L.H.O.O.Q.*) and are thus exempt from copyright infringement, but others have been forced to pay royalties to the original artist or cease displaying their appropriated works.

TATE MODERN

Power plant turned museum

With more than 40 million visitors since its official opening to the public in 2000, London's Tate Modern is one of the most popular attractions in the United Kingdom. It is the most popular modern art museum in the world and features more than 70,000 modern and contemporary pieces ranging from the early twentieth century to today from artists around the world.

HISTORY OF THE TATE MODERN

Although the Tate network of museums began as a single museum site in 1897, the idea to establish a separate location for Britain's collection of modern art was not announced until 1992. Two years later, a committee selected the Bankside Power Station as the location for the Tate Modern. An industrial building filled with massive, dormant machinery seemed like an odd choice for an art museum to many, but the power station offered several important features—most notably, a stunning 500-foot-long turbine hall with 115-foot ceilings that would later serve as the entrance hall to the museum.

An international competition to select an architect to renovate the building began in 1994 and Swiss architects Jacques Herzog and Pierre de Meuron were selected. They began work in 1995 and spent approximately $221 million and five years stripping out the interior of the space to make it suitable for use as an art gallery. The museum opened its doors in May of 2000.

Fast Facts about the Bankside Building

- The power plant's chimney is 325 feet high and was specifically constructed to be shorter than the dome of St. Peter's Cathedral, which is 375 feet tall.
- The building's brick facade is one of its most notable features, consisting of approximately 4.2 million bricks.
- The Bankside Power Station remained mostly dormant from 1981 until construction began on the Tate Modern in 1995.
- Although most of the original machinery has been removed, a large overhead crane still remains in the turbine hall of the Tate Modern.

INSIDE THE MUSEUM

Aside from serving as an extravagant entryway, the former turbine hall also doubles as an area for showcasing large installations and collections, the most elaborate of these perhaps being Olafur Eliasson's 2003 piece titled *Weather Project*, which bathed the interior of the hall with a hazy mist of sugar water and artificial sunlight produced by hundreds of monochromatic lamps.

When the museum first opened, it strayed from the convention of displaying artwork chronologically in favor of doing so thematically based on the following groupings:

- History/Memory/Society
- Nude/Action/Body
- Landscape/Matter/Environment
- Still Life/Object/Real Life

This structure allowed the museum to draw attention away from any chronological gaps in its collections and helped to differentiate it from other modern art museums. The museum's curators have since adjusted this structure to the following:

- **Poetry and Dream:** Focused primarily on Surrealist paintings, this area of the museum also features artists who were influenced by the Surrealist movement or whose paintings share a similar dreamlike quality. The collection contains pieces by Pablo Picasso, Giorgio de Chirico, Man Ray, Marcel Duchamp, and other prominent artists.
- **Transformed Visions:** Heavily influenced by World War II, works in this collection experiment with representing the human form and common experiences in abstract ways. Featured artists include Mark Rothko, Jackson Pollock, Francis Bacon, and Henry Moore.
- **Structure and Clarity:** This collection centers around abstract art and artists who shied away from realistic depictions of the world in favor of geometric shapes and concepts. It also showcases the impact abstract art had on film and photography as art forms. Several works by Pablo Picasso appear in the collection as well as those by Piet Mondrian, Georges Braque, Werner Mantz, and Wassily Kandinsky.
- **Energy and Process:** Works in this collection include artwork crafted from common materials in order to elevate everyday objects to meaningful pieces of art. These include sculptures, films, photography, and assortments of found objects. The contemporary American artist Bruce Nauman features prominently alongside Lynda Benglis, Robert Morris, and Cy Twombly.

Temporary Exhibitions

Apart from the galleries featured year-round, the Tate Modern devotes two wings of the main building to rotating exhibitions. These can range from large retrospectives to smaller collections.

EXPANSIONS AND THE FUTURE OF THE MUSEUM

Plans to expand the museum began in 2004 in light of its overwhelming popularity in its first few years. These new expansions would nearly double the size of the museum.

On July 18, 2012, the Tate Modern opened a curious addition to the museum in the form of three underground oil tanks formerly used by the power plant. The enormous subterranean spaces feature large contemporary art installations and are also used for performances and large video displays. Several other expansion plans are currently in the works.

The Room as a Canvas

While most art is relatively easy to transport from museum to museum, some works of art are entirely dependent on a particular location. These are known as "installations," and they can exist as a small interactive sculpture or transform an entire room. For example, the art group Random International's *Rain Room* in the Museum of Modern Art is a large installation piece that consists of water cascading from the ceiling that ceases falling wherever it senses the presence of a human body. The Tate Modern is especially famous for its elaborate installations, which routinely take over much of the 11,000-square-foot entryway to the museum.

TYPOGRAPHY
Words as art

Although it may not seem like it at first glance, a great deal of thought goes into the artistic value of the words as they appear on the page of a book—or nowadays, on screens. In fact, every letter, word, period, and even the spacing between the characters can convey mood and emotion in just the same way that a painter evokes feeling with a paintbrush.

THE FIRST TYPOGRAPHERS

The concept of the written word as an art form is nothing new. The art of calligraphy dates back as many as 6,000 years in Asia and at least to the Greek and Roman empires in the West. However, the first evidence of typography did not emerge until the Minoan society of Crete around 1800 B.C. In 1908, archaeologists uncovered a clay Minoan artifact they dubbed the Phaistos Disc, which depicted multiple symbols, many of which were identical to each other. The disc was most likely created by pressing identical tiles into the soft clay to produce consistent characters and symbols. The technique used to create the Phaistos Disc remained an isolated anomaly until the Middle Ages, however.

Between the tenth and twelfth centuries, the same method of using prefabricated tiles to create identical letters began to emerge in Europe and throughout the Byzantine Empire. This allowed scribes to create consistent works, but it was also time-consuming, which limited their ability to create written works en masse. It would

be another 200 years before Johannes Gutenberg would introduce a method of printing that allowed typography to achieve its current maturity as an art form.

A NEWER AND FASTER METHOD

Around 1440, a German blacksmith and goldsmith named Johannes Gutenberg introduced his revolutionary version of the printing press. The machine used the concept of "moveable type" to place individual molds of letters—which could be rearranged depending on the piece being printed—onto plates. While not the first printing press in existence, Gutenberg's version was far more efficient and could produce more than 3,000 pages of text a day. The impact on the literary world was both profound and immediate. Gutenberg's press began mass-producing copies of the Bible for the first time in history, giving access to a text formerly reserved to members of the clergy and aristocracy. The press did not limit itself to religious texts, and soon works of poetry and philosophy made their way throughout Europe, which sparked a notable increase in literacy rates. The ability to quickly and efficiently communicate new thoughts and ideas to the masses also fueled the Protestant Reformation and helped break down the divide between upper- and lower-class citizens in Europe.

THE ELEMENTS OF TYPOGRAPHY

When placing "glyphs" (a term used to refer to characters or symbols) on a page, there are a number of factors that determine how visually appealing the finished product will be:

Typeface

Often used interchangeably with the term "font," a typeface is actually a collection of fonts which each have unique weights, widths, slopes, and other attributes. Popular examples, such as Helvetica, Arial, and Times New Roman are actually typefaces, whereas subsets such as Helvetica Neue 75 Bold are fonts.

Type Color

Different from traditional concepts of color, in typography the term instead refers to the balance between negative white space on the page and the darkness or lightness of the letters themselves.

Spacing

In typography, spacing between glyphs is often just as important as the glyphs themselves. This can refer to the space between characters (kerning and tracking), the space between words (word spacing), or the space between lines (leading). By adjusting these various spacing elements, the designer can affect the ability of the reader to easily understand and comprehend the message of the printed page. If the letters are too far apart, for example, the reader might have trouble combining them to read the word. Yet if they're too close together, they might blur together and become illegible.

There are also numerous situations where the presentation of the words on a page is equally important—or even more important—than the words themselves. This is often the case on magazine covers or book covers where the words can be manipulated to convey a deeper meaning. For example, on the cover of the book *Change the Way You See Everything Through Asset-Based Thinking*, the first half of the title is presented backward.

PERSPECTIVE

The illusion of depth

Many pieces of art exist in a two-dimensional space, such as paintings, drawings, etchings, and silkscreens. Despite the limitations of a flat surface, however, the artist is able to ascribe three-dimensional attributes to the elements of a piece of artwork. Using various techniques, the artist can create a scene with towering mountain peaks appearing to exist many miles from the viewer—all on two-dimensional canvas mere feet or inches away.

WHAT IS PERSPECTIVE?

A simple way to understand perspective is to imagine a painting or drawing as a tracing of a scene viewed through a window. The result is a perfectly scaled down version of the objects seen through the window. A tree seen through the window might be 40 feet tall in reality, but on the tracing it might take up only an inch of the paper if it is far enough away.

If the artist were able to move the window closer, the objects would appear to be larger and would thus be drawn larger on the page. If the artist moved the window farther away, the objects would shrink in size relative to the artist. By adjusting the size of objects relative to each other, the artist can imply depth and distance.

TYPES OF PERSPECTIVE

The various types of perspective drawings are most commonly broken up by the number of "vanishing points" they contain. In art, a vanishing point refers to a single point where two parallel objects appear to converge into one. For example, a straight railroad track spanning into the distance will eventually obscure into a single line at the edge of the viewer's vision.

One-Point Perspective

One-point perspective occurs in a painting or drawing that contains a single vanishing point along a horizontal line, either vertically or horizontally. Most commonly this includes images of hallways, buildings, roads, railways, or other objects consisting of parallel lines.

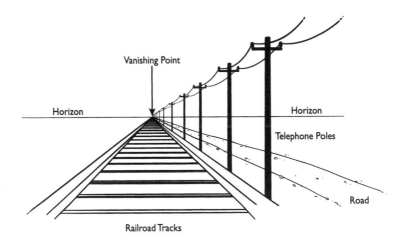

Two-Point Perspective

A two-point perspective occurs when two or more vanishing points exist on a horizontal line. This might come in the form of a street corner with one road terminating diagonally in one direction and the other road terminating diagonally in another, or of a river forking off in two separate directions.

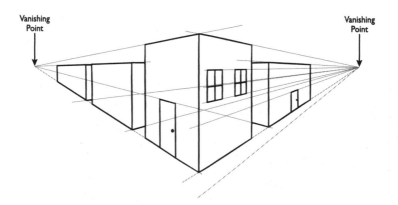

Vanishing Point

Vanishing Point

Three-Point Perspective

A three-point perspective is any drawing that contains three vanishing points on a horizontal line. The best example is to imagine looking up at a tall building from street level, with two sides of the building forming two separate vanishing points and the third formed as the building rises up into space.

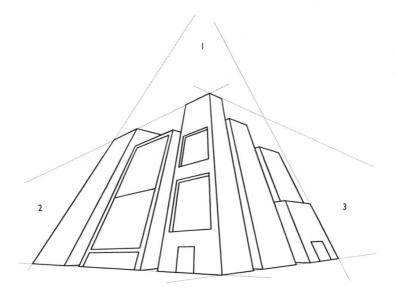

ART 101

Four-Point (or Infinite-Point) Perspective

An infinite-point perspective drawing is one that contains more than three vanishing points on a horizon line. This usually creates a curved or spherical image and can also result in the phenomenon of an "impossible" scene when the scope of the scene depicted goes beyond 360 degrees.

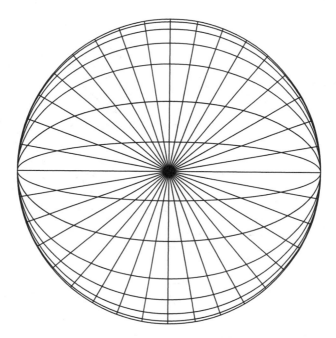

Zero-Point Perspective

It is also possible to have a painting or drawing that contains no parallel lines and thus no vanishing points. For example, you'd find this perspective in a sloping valley, a still pond, or any natural scene where parallel lines are uncommon and would appear unnatural. Despite the lack of vanishing points, it is still possible for the artist to convey depth and distance.

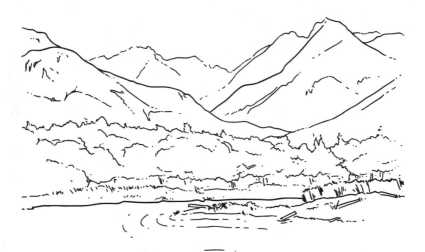

THE HISTORY OF PERSPECTIVE

Ancient artists typically had little regard for perspective, and instead based the size of the figures depicted on importance rather than distance from the viewer. It is clear that medieval artists, and possibly early Greek artists, understood the concept of perspective but

routinely ignored it when it suited their needs. For example, a painter might draw a human figure only slightly smaller than the building he is standing next to, with small figures standing atop the same building. The building is simultaneously depicted as small and large.

It was not until the Italian Renaissance that our current geometrical understanding of perspective began to take shape. In the early 1400s, the architect Filippo Brunelleschi discovered that he could draw a scene in such a way that it would appear identical to the viewer's experience of viewing the same scene from a particular point. To demonstrate this, he painted the Florence Baptistery and cut a hole in the painting to allow the viewer to peer through the back and view it in a mirror. To the viewer's surprise, the reflection in the mirror appeared identical to the actual Baptistery viewed from the same point. Brunelleschi's method was quickly adopted by the Renaissance artistic community.

So Close, Yet So Far Away

Although many ancient and medieval artists did not utilize perspective as we do today, they actually adopted similar methods—just in reverse. Instead of drawing objects at a distance as smaller with parallel lines converging at a distant vanishing point, they often painted distant objects as being larger than closer objects with parallel lines converging at a vanishing point off the canvas, often where the viewer might be standing. This was especially common in early Christian paintings, where important subjects like the Virgin Mary and Jesus were depicted as large figures even when they appeared in the background with other smaller figures in the foreground.

GESTALT THEORY
The whole is other than the sum of its parts

No great works of art simply spring into existence in their completed form. Instead, they are crafted using a series of brushstrokes, chisel blows, prods, pokes, and etches to create forms, shapes, and, ultimately, a finished piece of artwork. However, while it may take an artist hours, days, or years to complete the many steps required to create a finished piece, the viewers experience the piece in an instant when they first view it. And when they do, the Gestalt theory argues that it is the finished product that they are experiencing more so than the individual elements.

THE PSYCHOLOGY OF THE VISUAL WORLD

The Gestalt theory was first introduced as a psychological philosophy by Max Wertheimer, Kurt Koffka, and Wolfgang Kohler in the 1920s. The founding principle of Gestalt theory as it pertains to art is that human perception naturally seeks to group objects and experiences together to create a whole. So, when we look at a picture of a person, instead of taking in the nose, ears, legs, hands, and so on separately, we simply combine them subconsciously to recognize the human form. This does not mean it is impossible to home in on individual elements, just that our brains instinctively focus on the complete image.

Advocates of Gestalt theory have identified several principles that explain what happens when we are presented with various patterns.

Proximity

Advocates of Gestalt theory believe that humans instinctively group elements that are close together as comprising one object. Conversely, humans assume that elements distant from one another comprise separate objects.

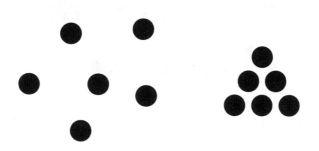

For example, the distance between the circles in the first image leads the viewer to acknowledge them as separate circles with no relation to each other. On the other hand, the tight grouping of the circles in the second image creates a triangle.

Similarity

Even when various objects are intermingled with or overlapping one another, the human brain still adheres to certain biases in order to differentiate like objects from unlike objects. By isolating

similarities in texture, color, shape, and other features, humans instinctively group together objects they believe to be similar.

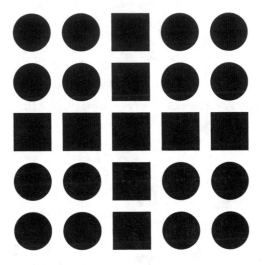

In this image, even though the objects all appear close together and are the same color, you have no trouble discerning the squares that form a cross from the groups of circles outside the cross.

Closure

You may not notice it, but you do not necessarily need to be presented with a complete image in order to perceive the implied finished structure. This can be most easily seen in simple shapes where certain portions of the border are missing, but the artist can utilize this fact to produce far more elaborate images.

In this image, the negative space created by the gaps within the circles creates a cube in our minds.

Symmetry

Whenever possible, the human mind prefers to group symmetrical objects together rather than interpreting them as separate entities. This preference is so strong, that the mind will even take objects separated at a distance and connect them. For example, despite the gap and differences in the following series of brackets, your brain sees them as three distinct groups of symmetrical objects instead of six individual brackets: [] { } []

Common Fate

When it comes to motion, the human mind prefers to group together objects moving on a similar trajectory. If you were to view

two opposing armies of archers firing at one another from a distance, you would perceive the arrows from each side as belonging together. Even when the two clusters of arrows meet, because they are moving in opposing directions, your brain still separates the two masses as being distinct.

While this applies primarily to moving objects, artists can still create this effect by implying movement.

Continuity

In art, it is quite common for multiple objects to overlap and intertwine. However, our brains still interpret them as separate objects. For example, in the following image, we instinctively perceive the arrow as a separate entity to the square, even though they could easily be viewed as one large image.

Good Gestalt

When presented with a group of objects, humans instinctively group them in ways that create orderly patterns wherever possible. In actuality, the below image is a single incongruous object that doesn't really adhere to any common pattern. However, because

our brains instinctively look to simplify objects, we see a square, a triangle, and a circle.

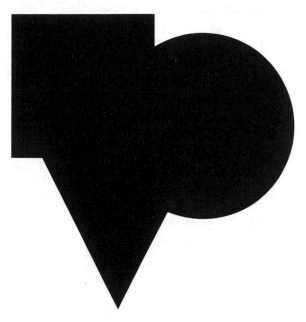

ANSEL ADAMS (1902–1984)

Photographer and nature lover

Ansel Adams was a beloved and brilliant photographer who captured the intense beauty of the American wilderness. In thousands of magnificent photos exhibiting the sheer majesty of Yosemite National Park and other wonders of the American West, Adams knowingly endorsed the preservation of these national treasures. Over the course of his long life, he wore many hats: musician, writer, lecturer, activist, and photographer, but photography was where he had the greatest influence. His precise exposure and darkroom expertise were unmatched—and he was more than eager to share his craft with others. His work has inspired generations of photographers and helped to elevate photography to the status of a fine art.

ADAMS'S UPBRINGING

Ansel Adams was born in San Francisco, California, to a wealthy businessman named Charles Hitchcock Adams and his mother, Olive Bray. He was raised an only child in a very conservative home. When Adams was just a boy, the family lost its fortune in the timber industry due to the financial panic that followed a devastating 1906 earthquake. Adams's mother would never stop pining for their lost fortune and Charles Adams never succeeded in regaining it. Of his two parents, his father had a much deeper impact on his life and career.

Though incredibly smart, Adams's hyperactive nature and difficulty reading caused him to struggle in school. In the end, his father

and live-in aunt decided they would tutor him at home. Despite their dedication, he never earned his high school diploma.

Adams's studies veered into the world of music at age twelve, when he taught himself to read music and play the piano. By the age of eighteen, he was an apt pianist with every intention of pursuing music as a career. The science and precision of his musical craft later influenced his photography.

Young Ansel Adams found solace and joy in nature. He took long, daily walks in the Golden Gate area, reveling in the quiet of the dunes and exploring along Baker Beach and nearby Lobos Creek. At fourteen, he visited the Yosemite Sierra for the first time and was instantly enchanted. Armed with the Kodak No. 1 Box Brownie camera that his father had given him, he began the work of capturing its majesty. In this practice, a career was born. Summer after summer, he forged a deeper relationship with Yosemite.

ADAMS BECOMES A PHOTOGRAPHER

It was the Sierra Club that first recognized Adams's talents and kick-started his photography career. In 1919, he was hired by the Sierra Club to become "keeper" of the LeConte Memorial Lodge, which served as a library and education center. He built friendships with club leaders (figures of America's growing conservationist movement) in the four summers that he held this position.

The 1922 Sierra Club Bulletin was the first publication to feature his photographs. In 1927, the club hired him as chief photographer for their annual, month-long hike. This was a lucky year for him, as he also took his famous photograph, *Monolith, the Face of Half Dome*, and met the man who would catapult his career forward: Albert M. Bender. A

wealthy art patron, Bender was so taken by Adams's work that he gave the burgeoning photographer the financial support and encouragement he needed to publish his first portfolio of work, *Parmelian Prints of the High Sierras*. A year later, the Sierra Club gave him a one-man exhibition of his work at their San Francisco headquarters. At this point in Adams's life, he was starting to believe that he could make a living—and possibly a name for himself—in this field.

The 1930s brought Ansel Adams a whole new level of notoriety. His relationship with established photographers such as Mary Austin, Paul Strand, and Edward Weston helped to shape his artistic style. Strand encouraged his shift from "pictorial" photography to "straight" photography. In straight photography, clarity of content was prioritized over the power to alter the subject matter. Adams would do more than adopt this style; he would become its greatest champion and teacher. As part of f/64, a group of photographers he founded with Weston in 1932, Adams would help legitimize the West Cast movement of straight photography in the eyes of the American public. The de Young Museum in San Francisco featured the work of f/64 and gave Ansel Adams his first one-man museum show soon after.

ADAMS TAKES NEW YORK BY STORM

Ansel Adams visited New York in 1933 to meet his role model, photographer Alfred Stieglitz. Stieglitz embraced Adams as a friend and pupil. With Stieglitz's help, Adams saw his work exhibited at the Delphic Gallery in 1933, published a book in 1935, and enjoyed a one-man show at An American Place in 1936.

Although he had officially "made it" as a photographer, Adams was not bringing in much money. Adams often lamented the amount

of commercial work he was forced to take on in order to pay the bills. His commercial clients included big-name companies like IBM, Kodak, and *Fortune* magazine.

ANSEL ADAMS: MASTER OF TECHNIQUE

Ansel Adams achieved a level of technical mastery rarely seen in photographers. Some of the most renowned photographers of his time (Weston and Strand included) sought his technical advice, as did companies like Polaroid and Hasselblad. He invented the "Zone System," which helped many photographers achieve the optimum level of exposure and modify the contrast as needed. The final product would exhibit a bewildering clarity that eluded most photographers and transfixed photography enthusiasts.

Bigger Is Better

Adams preferred to use large-format cameras when he worked. Although they were expensive, heavy, and awkward, they helped him achieve the sharpness and high-resolution effect he wanted.

Adams preferred to work in black and white, as it afforded him better control over the final print. He also endorsed a photographer's use of "previsualization," the technique of capturing the print in your mind before actually snapping the photo. In an era before digital photography, this technique was crucial to avoid taking multiple pictures and wasting film. Adams left behind a full library of technical

manuals, books, and articles sharing his techniques and knowledge of photography with generations of photographers to come.

MOST FAMOUS PHOTOGRAPHS

Adams was incredibly prolific, but these are some of his most famous shots:

- *Monolith, The Face of Half Dome*, Yosemite National Park, 1927
- *Rose and Driftwood*, San Francisco, California, 1932
- *Clearing Winter Storm*, Yosemite National Park, 1940
- *Moonrise*, Hernandez, New Mexico, 1941
- *Moon and Half Dome*, Yosemite National Park, California, 1960
- *El Capitan, Winter, Sunrise*, Yosemite National Park, California, 1968

Now reproduced worldwide as posters, postcards, and symbols of the American wild, Adams's photographic body of work is a constant reminder that we share the earth with the most spectacular natural formations and that these relics deserve our respect and protection.

EDGAR DEGAS (1834–1917)

A master of movement

Born in Paris in 1834, Edgar Degas was a French artist best known for his works depicting ballerinas. Skilled as a draftsman and in his portrayal of movement, more than half of his paintings, sculptures, and prints feature dance in some form. He was considered one of the founders of the Impressionist movement, but he never identified with the term. Degas eventually became a classical painter of modern life—turning to less romantic subjects like slums, brothels, and horse races—and he greatly influenced painters like Mary Cassatt, Jean-Louis Forain, Walter Sickert, and Henri de Toulouse-Lautrec.

FAMILY LIFE AND EDUCATION

Degas was born Hilaire-Germain-Edgar De Gas, a surname he would later simplify by combining the two parts. He was the eldest of five children in an affluent Franco-Italian family run by Célestine Musson De Gas, a Creole from New Orleans, and Augustin De Gas, a banker and art lover. He enrolled at the Lycée Louis-le-Grand at the age of eight, where he would study for the next decade.

When he graduated from the Lycée in 1853 with a degree in literature, he had already set up an art studio in his home. Though he wanted to work as a copyist at the Louvre, reproducing copies of famous artwork, Degas enrolled at the Faculty of Law at the University of Paris to please his father in the fall of 1853. His efforts at law school were lackluster and his time there was short. In the summer of 1856 he moved to Italy, where he reproduced paintings by

Renaissance masters such as Michelangelo and Raphael, and would spend time in Naples, Florence, and Rome for the next three years.

EARLY CAREER AS AN ARTIST

Degas returned to France in 1859, took an apartment in bohemian Montmartre, and began painting *The Bellelli Family* and a number of historical paintings. *The Bellelli Family* was an ambitious effort that he had planned on exhibiting in the Salon that same year, but did not finish it until 1867. His academic training and mastery of classic art made him perfectly suited to become a historic painter, and during this period he painted *Alexander and Bucephalus*, *The Daughter of Jephthah*, *Sémiramis Building Babylon*, and *Young Spartans*. The first painting that he showed at the Salon ended up being *Scene of War in the Middle Ages*, which was met with a lukewarm reception upon its exhibition in 1865. He did continue to exhibit at the Salon every year for the next five years, but that was the last historic painting he submitted.

After meeting Édouard Manet at the Louvre in 1864, Degas turned his eye toward contemporary subjects like café scenes, theater, and dance. *Steeplechase—The Fallen Jockey*, a scene depicting a jockey unhorsed and laying on the ground during a race, is a good example of this shift in subject matter that would continue in the coming years.

Unlike many of his contemporaries for whom painting was a way to break into elite social circles, Degas firmly believed that both his work and his personal life were private matters. He focused nearly all of his attention on his art and rarely pursued any romantic opportunities.

When the Franco-Prussian War broke out in 1870, Degas enlisted in the National Guard, which left him hardly any time to work on his art until the Treaty of Frankfurt am Main was signed in 1871.

Degas's Dancers

Degas's thirst for classical beauty and modern realism was sated at the ballet, and he regularly wandered the wings of the Palais Garnier, home of the Paris Opéra and its ballet. It wasn't easy getting behind-the-scenes access, which was primarily reserved for a select few wealthy aristocrats, but his persistence eventually gained him admittance. During this time, around 1870, his color scheme was dominated by the pink and white hues worn by the dancers. Although the ballet was steeped in tradition, he modernized the spectacle by experimenting with new techniques such as using closely spaced parallel lines to create shading and combining both dry and wet pastels.

In 1872, Degas left France and went to stay with relatives in New Orleans, Louisiana, where he was reunited with his brother René. He then produced several paintings featuring members of his family. Degas painted the most famous of these, *A Cotton Office in New Orleans*, in 1873.

DEGAS AND THE IMPRESSIONISTS

In 1873, Degas traveled back to Paris. When his father died in 1874, the artist discovered extensive debts incurred by his brother and managed to settle them by selling his house and inherited

art collection. Suddenly forced to make money off his art, he produced some of his best work between 1874 and 1884. Degas then moved away from the too-traditional Salon and toward the young avant-garde artists that would be known later as the Impressionists. Although Degas often butted heads with others in the group, he played a large role in organizing the eight exhibitions that the Impressionists put on between 1874 and 1886. Still, he looked down upon the preferred subject of landscape painters like Monet, and did not enjoy the outrage that the Impressionist Exhibitions caused any more than he did the Impressionist artists' intentionally publicity-seeking ways. He also distanced himself from the press-generated term "Impressionist."

Partially due to infighting caused by Degas's confrontational nature, the small group of Impressionists dissolved in 1886. The general disdain for Degas shared by his contemporaries found the artist isolated from his peers during his later years.

Degas continued to make art into his old age in the form of pastels and sculpture, but he stopped working altogether in 1912, when his apartment in Montmartre where he had lived and worked for most of his life was scheduled to be demolished. Staying true to his philosophy that a painter can have no personal life, he was a lifelong bachelor who spent his final years enjoying his beloved Paris until his death in 1917.

PIERRE-AUGUSTE RENOIR (1841–1919)

The new French master painter

Renoir was a French painter who was at the forefront of the Impressionist movement. He is known as a great celebrator of beauty, especially the female form, and Renoir's female nudes were a favorite motif throughout his career.

EARLY YEARS AND EDUCATION

Pierre-Auguste Renoir was born to a family of artisans in Limoges, Haute-Vienne, France, in 1841. He showed an aptitude for drawing early on, and at the age of thirteen his parents apprenticed him to work at a porcelain factory, where he painted bouquets of flowers on fine china. He was also hired by overseas missionaries to paint religious-themed fans and hangings, and in his youth he frequently studied the French master painters at the Louvre.

Propelled by his talent for and interest in painting, he later went on to a more formal art education. In 1862, he began taking night classes in drawing and anatomy at the École des Beaux-Arts, as well as lessons at the studio of Swiss painter Charles Gleyre, but times were tough in the 1860s for Renoir. In fact, he often couldn't afford to buy paint during that decade. He did, however, meet Alfred Sisley, Frédéric Bazille, and Claude Monet, other students of Gleyre's with whom he shared friendship and artistic ideals. The four aspired to break from art mired in past traditions and bring it closer to life, and the group would later serve as core members of the Impressionist movement.

In the meantime, Renoir did not necessarily identify with the traditional approach of Gleyre, who was a former student of nineteenth-century neoclassical painting, but he acquiesced in order to learn the foundations of painting. Renoir's early works include *Portrait of the Painter Bazille* (1867), *The Painter Sisley and His Wife* (1868), and *Monet Painting in His Garden* (1873).

IMPRESSIONIST YEARS

At that time, most paintings, even landscapes, were done indoors in a studio. Renoir and his three friends from Gleyre's lessons—Sisley, Bazille, and Monet—moved to the forest of Fontainebleau, which had previously attracted artists like Théodore Rousseau and Jean-François Millet. Rousseau and Millet, however, were still mostly bound to the conventions of the era imposed by their training, but unlike many other artists of that time, they had a new philosophy; they wanted art to represent the reality of everyday life.

In 1864, Renoir and his friends picked up where they left off by painting straight from nature at Fontainebleau. They were likely inspired by Manet's controversial 1863 painting, *Déjeuner sur l'herbe (Luncheon on the Grass)*, which focused on mundane scenes instead of the romanticized ideal as its subject. Manet's audacity led him to assume the role of leader of the new Impressionist movement.

The approach practiced by Renoir and his companions differed radically from older techniques. The small, multicolored strokes used by Renoir imbued his paintings with an almost pulsating vitality that had not existed in the old school of painting. Renoir and the other painters that had pioneered Impressionist techniques focused on excluding black to create works inundated with light, but their efforts

to innovate were not immediately rewarded. In fact, their paintings were repeatedly rejected by the Salon, the official art exhibition of the Académie des Beaux-Arts, and therefore very difficult to sell.

Despite an overwhelming lack of support, a portion of the Impressionist community was beginning to gain recognition in some circles, and it wasn't all negative. Because he often preferred a human subject to landscapes, the latter of which were popular among a lot of his colleagues, Renoir managed to set himself apart from the other Impressionists, and was even commissioned for several portraits. He was introduced to upper-middle-class society by the publisher Georges Charpentier, who organized a personal exposition for Renoir's works in 1879 in the gallery La Vie Moderne.

Though during these years he still worried about his own financial situation, Renoir managed to depict the exuberance and pleasures of life, and created a number of his most famous masterpieces during this period: *La Loge* (1874; *The Theatre Box*), *Bal du moulin de la Galette* (1876; *Dance at Le moulin de la Galette*), *The Luncheon of the Boating Party* (1881), and *Mme Charpentier and Her Children* (1878).

Renoir finally received recognition for his work in 1874. In that year, six of his paintings were hung in the first Impressionist exhibition, which was held independently of the official Salon, although it would take another decade for the movement to solidify its inimitable vision. Two more of his works were also shown with Paul Durand-Ruel in London.

REJECTION OF IMPRESSIONISM

In 1881, Renoir made several trips throughout North Africa and Europe. Inspired by the oil paintings Eugène Delacroix created there, he first went to Algeria, followed by a trip to Madrid to

see the work of Diego Velázquez. Then, in Italy, he saw Titian's masterpieces in Florence, as well as the paintings of Raphael in Rome. Although many of these artists ended up influencing him, Raphael in particular had a profound effect on Renoir's outlook. Renoir was attracted to the many characteristics of classicism he saw in Raphael's work, including an emphasis on line and form over color, which eventually led him to modify his style. The works Renoir produced in 1883 and 1884, in fact, depart so much from his former work that they are generally considered part of his "Ingres," "harsh," or "dry" period.

Still, however, Renoir carried over the radiant palette that he'd employed as an Impressionist. He remained largely in opposition to Impressionism until approximately 1890, during which time he made a number of trips to Provence. The physical and climatic separation from Paris allowed Renoir freedom from his ties to Impressionism, and he was moved by the sensuality of the bright, sunlit region. The natural environs of southern France also enabled him to break away from his recent obsession with classicism. Distancing himself from both poles of his painting, his art took a fresh new turn toward painting nudes and domestic scenes and the return of thin brush strokes and vague outlines.

Another positive change involved his financial situation. He wed Aline Charigot in 1890, who had served as a model for *Le Déjeuner des canotiers* (*The Luncheon of the Boating Party*, 1881) and, along with their children, would continue to model throughout their marriage. In 1892, the dealer Paul Durand-Ruel, with whom he had shown works almost eighteen years prior, arranged a successful exposition for Renoir.

LATER YEARS: PAINTING THROUGH RHEUMATOID ARTHRITIS

After Renoir developed rheumatoid arthritis in 1894, he began to gravitate toward southern France, where his health benefited from the warm, dry climate. In 1907, Renoir purchased a farm called Les Collettes in the small village of Cagnes-sur-Mer, which was close to the Mediterranean coast, and settled there permanently. In 1910, he lost the ability to walk, and his condition continued to worsen over time, but he never stopped painting. He died in the same village in 1919, after visiting the Louvre and seeing his works hanging with the old masters whom he had so admired in his youth.

Self-Portraits

In addition to the many portraits he painted throughout his life, Renoir also painted quite a few self-portraits. The earlier self-portraits, which he completed in 1875 and 1876, contrast vastly with the ones he completed in his later years, including two in 1910. His early self-portraits were very dark in color and tone, while his later versions were much more vibrant.

RENÉ MAGRITTE (1898–1967)
Bourgeois member, perverse painter

Born in Belgium in 1898, René François Ghislain Magritte was one of the most prominent Surrealist artists. His dreamlike paintings contained elements of horror, danger, humor, and mystery. Blurring the line between reality and illusion, telltale symbols of his works include the female torso, the apple, the pipe, the bourgeois "little man," the bowler hat, the castle, the rock, and the window.

EARLY YEARS: SURREALISM AND EXPATRIATION

Little is known of Magritte's early life, other than that he was born in 1898 in the province of Hainaut, Lessines, to Léopold Magritte, a tailor, and Régina (née Bertinchamps), a milliner. He began drawing lessons in 1910, and two years later his mother, whose multiple suicide attempts drove her husband to preventatively lock her in her bedroom, finally succeeded in drowning herself in the River Sambre. Although it was long rumored that a thirteen-year-old Magritte was present when her body was discovered about a mile down the river, the tale was later proved false. Even so, several of Magritte's paintings—those from 1927 and 1928, in particular—feature the image of a woman whose dress is covering her face, which is how it is said she was found.

Magritte went through various artistic incarnations before dabbling in Surrealism. He modeled his earliest paintings (ca. 1915) off of the Impressionists, and then studied under Constant Montald at the Académie Royale des Beaux-Arts in Brussels. For the next six

years, he painted mostly female nudes influenced by Futurism and Metzinger's brand of Cubism.

Magritte then served in the Belgian infantry from the winter of 1920 until the fall of the following year, and in 1922 married Georgette Berger. From 1922 to 1926 he had to put his art on hold while he worked in various occupations in order to stay financially afloat. In 1922 to 1923, he was employed at a wallpaper factory as a draftsman, and then he designed posters and advertisements. In 1926, however, a contract with Galerie le Centaure, an art gallery in Brussels, enabled him to paint full-time. It was during this time that he painted his first Surrealist work, *The Lost Jockey (Le jockey perdu)*.

In 1927, Magritte held his first exhibition in Brussels, but the negative criticism that ensued drove him into depression. Upon his subsequent move to the Paris suburbs with his wife, he befriended André Breton and Paul Éluard, who introduced him to the collages of Max Ernst. At that point, Magritte joined the Surrealist movement (which had taken shape with the Surrealist Manifesto of 1924), and became a leading member.

When the Belgian gallery supporting him was shuttered at the end of 1929, Magritte's wages went with it, and he returned to Brussels in 1930, where he would primarily stay for the rest of his life. Despite his prominent role with the French Surrealists, Magritte hadn't made much of an impression in Paris, so he took another job in advertising until he and his brother, Paul, formed an agency that paid the bills.

GERMAN OCCUPATION AND EXPERIMENTAL STYLES

During the 1940s, Magritte experimented with a wide range of styles. He remained in Brussels during the German occupation of Belgium,

which led to his losing touch with Breton and entering his short-lived "Renoir Period." Responding to the sense of alienation he felt while his country was occupied during World War II, he adopted a colorful style rooted in Impressionism. In 1946, he abandoned the darker, violent nature of his earlier work and joined several other Belgian artists and signed the manifesto Surrealism in Full Sunlight. From 1947 to 1948, Magritte's "Vache Period" saw his painting influenced primarily by Fauve, with bright tones, quick crude brushstrokes, and caricatured subjects such as the flaming chess pawn–inspired character in his 1947 piece *The Cicerone*. During this Vache Period, Magritte turned out phony Picassos, Braques, and Chiricos that he passed off as originals and sold to support himself. When times were tough after the war, he branched out into counterfeiting banknotes with his brother, Paul, and fellow Surrealist Marcel Mariën.

As far as his art during this decade was concerned, his paintings were essentially unsuccessful, and by the end of 1948, he reverted to the enigmatic, easily recognizable style that dominated his prewar surrealistic work.

In the 1960s, Magritte's work gained momentum and had a significant impact on pop, minimalist, and conceptual art. Although his work was first exhibited in the United States in New York in 1936, two retrospective exhibitions later followed: one at the Museum of Modern Art in 1965, and the other at the Metropolitan Museum of Art in 1992. In 1966, he oversaw the construction of eight bronze sculptures derived from images in his paintings. He continued to paint surrealistic images until he died of pancreatic cancer in 1967 at the age of 68.

COMMON THEMES

Several of Magritte's paintings prominently feature an apple. The most famous of these is The Listening Room (1952), one version of which is currently on display at the Menil Collection in Houston, Texas. The other, created in 1958, is held in a private collection. Although both paintings share the subject of near-identical green apples, they are placed in different rooms. Two later paintings, *The Son of Man* (1964) and *This is Not an Apple* (1964), also feature an apple as the focus.

Other common themes in Magritte's work include the sea and wide skies, which date back to his youth. Dislocations of various elements—such as space, time, and scale—also figure into his work. Good examples of this can be found in pieces like *Time Transfixed* (1939), in which a steaming locomotive juts out of a fireplace in an empty room, and *Golconda* (1953), in which identically dressed men wearing dark coats and bowler hats fall like drops of heavy rain toward the house-lined street below.

Celebrating Magritte in His Hometown

Two Brussels museums display Magritte's work. Housed in the building occupied by Magritte and his wife between 1930 and 1954, the René Magritte Museum is mainly a biographical museum. Second, 250 of the artist's works are hung at a new Magritte Museum, which opened in 2009 next to the Royal Museum of Fine Arts.

MARCEL DUCHAMP (1887–1968)

Artist and anti-artist

Marcel Duchamp was a French-born painter, sculptor, and writer who earned U.S. citizenship in 1955. Considered one of the most important artists of the twentieth century, he broke down the boundaries between works of art and everyday objects by jettisoning traditional aesthetic canons. His celebrated and revolutionary "ready-mades" effectively ushered in a new of era of art, and he had close ties to both the Dadaist and Surrealist movements.

EARLY LIFE AND WORK

Duchamp was born in 1887 in the Upper Normandy region of France to a culturally inclined family of nine. Of Duchamp's six siblings, one died as an infant and three became successful artists like himself: Jacques Villon, a painter and printmaker; Raymond Duchamp-Villon, a sculptor; and Suzanne Duchamp-Crotti, a painter.

At the age of eight, Duchamp went away to school. At Lycée Pierre-Corneille in Rouen, he received a rigorous education in which he excelled in mathematics and drawing. Although he wasn't an exemplary student, he won prizes in both subjects, and the award he received for drawing inspired him to pursue art more seriously.

Duchamp traveled to Paris in the fall of 1904 to study art at Académie Julian, but during that year he rarely attended class. He did, however, start drawing cartoons that he would later sell to comic

magazines. The pun-heavy drawings echoed the vulgar sense of humor that would crop up in his work for the rest of his life. Much of his early work is Post-Impressionist, but he also experimented with other contemporary trends like Cubism and Fauvism. What's clear is that he didn't stick to any one style, and this aesthetic fluidity in itself was considered revolutionary.

In 1911, he befriended avant-garde art devotee Guillaume Apollinaire, even though Apollinaire had originally criticized "Duchamp's very ugly nudes" upon their display in 1909. Duchamp's work began to show hints of Cubism at this point. He also formed a lifelong friendship with Francis Picabia, whose painting strictly conformed to the Impressionist camp until he eschewed the movement in 1909. Duchamp and Picabia later found Cubism too methodical, static, and limiting, and together explored Futurism and Abstractionism. In fact, Duchamp and his brother Jacques led a discussion group that later came to be known as the Puteaux Group. Other artists and writers regularly met at Jacques's home in Puteaux, where Orphic Cubism was born. Unlike traditional Cubism, Orphic Cubism shied away from recognizable subject matter and relied almost exclusively on abstract shapes and colors to convey meaning and emotion. While Duchamp distanced himself from the group and refused to participate in theoretical discussions, he did adopt the Cubist style in his painting.

Duchamp then entered a period of transition, during which he strived toward the depiction of the fourth dimension in art by using mathematics to advance his art. Works from this period include *Coffee Mill (Moulin à café)*, which is considered his first of several "machine" paintings, and *Portrait of Chess Players (Portrait de joueurs d'échecs)*, which utilized elements from Cubism such as overlapping frames and multiple perspectives. He painted both pieces in 1911.

NUDE DESCENDING
A STAIRCASE, NO. 2

In 1911, Duchamp submitted *Portrait*, a painting made up of a sequence of five nearly monochromatic, overlaid silhouettes, to an exhibition. This work and its play on the mechanistic stages of movement served as the blueprint for the provocative *Nude Descending a Staircase, No. 2*, which demonstrates elements of both Cubism and Futurism. The latter piece, however, blends the silhouettes, which had largely retained their integrity in Portrait, to create a cinematic effect.

Nude received vastly different receptions in France and in the United States. The committee in charge of the twenty-eighth Salon des Indépendants, held in February 1912, rejected it outright. Although members of the selection committee were family friends of the Duchamps and no strangers to Cubism, they were scandalized by the artist's unusual image. The following year the painting was revealed at the Armory Show in New York City, but this time the work was welcomed with open arms. The disparate reactions to the same painting disconcerted Duchamp, and at the age of twenty-five he started to move away from traditional painting. Some believe that the irony inherent in Duchamp's work, which bordered on a mockery of art, damaged his own conviction in it. Others saw Duchamp's stance as simply goading.

Having lost his faith in painting, Duchamp turned away from aesthetics, or what he called "retinal art," and toward a more academic philosophy. For the studies that he began for *The Large Glass, or The Bride Stripped Bare by Her Bachelors, Even* in 1913, for example, he favored the regimented geometry of industrial design, and until 1923 Duchamp's work on the piece consisted almost entirely of preliminary studies.

Ready-Mades

Duchamp pioneered the concept of the "ready-made," an idea that had a significant impact on contemporary art. Essentially, the concept of the ready-made implies that an artist can take completed objects or nearly completed objects and turn them into art simply by displaying them. Works such as *Pharmacy* (1914), which consisted of a cheap reproduction of a winter landscape to which he added two drops of color, challenged the notion of authorship.

NEW YORK AND *THE LARGE GLASS*

At the onset of World War I, Duchamp moved to the United States, where he had experienced so much success at the Armory Show years earlier. A famous man in the eyes of Americans, he received a warm reception when he arrived in New York in 1915 and was given a studio by Walter Arensberg, an American art collector, critic, and poet, where he worked on the piece he later titled *The Large Glass*. A massive piece spanning more than 9 feet by 5 feet, *The Large Glass* consisted of two panes of glass filled with geometric shapes made from foil, wire, and other substances.

Although he received many offers from art galleries, he had little interest in painting full-time and instead taught French lessons to get by. The artworks he did produce he gave to friends or sold for deliberately modest amounts. Many are now part of the Arensberg Collection, which was left to the Philadelphia Museum of Art.

In 1918, he sold the still-unfinished *The Large Glass* to Walter Arensberg, then spent nine months in Buenos Aires, where he heard the news of the armistice of World War I. That news prompted him to move back to Paris. Once there, he stayed with Picabia, made ties

with the first Dadaists, and turned his attention to the cinema once he finally gave up on *The Large Glass*. He produced a short film, *Anemic Cinema* (1926), and spent a lot of time playing chess, a subject on which he published a treatise in 1932. Duchamp later became more closely connected with the Parisian Surrealists and helped poet André Breton, who published the first comprehensive piece on Duchamp in a Paris magazine called *Minotaure* in 1935, organize all the Surrealist exhibitions between 1938 and 1959.

Around the start of World War II, he again fled to New York, where his reputation was revived by the exhibition of *The Large Glass* at the Museum of Modern Art (MoMA) and an issue of an art magazine that was dedicated to him. In 1960, many retrospectives of Duchamp's shows were organized, and after his death it was revealed that he had worked in secret on a piece called *Étant donnés: 1. la chute d'eau, 2. le gaz d'éclairage (Given: 1. the waterfall, 2. the illuminating gas)* for twenty years between 1946 and 1966. The piece is now at the Philadelphia Museum of Art where it can be viewed through two peepholes placed in a wood door, which reveal a nude female figure laying on her back in the grass with her face not depicted, legs spread, holding a lamp in her hand.

Fountain

The story behind *Fountain*, one of Duchamp's most famous and controversial works plays out more like an adolescent prank than a work of art. After dinner in New York with some painters and an art collector, Duchamp and the rest of the group made their way to JL Mott Ironworks, a plumbing supply store located at 118 Fifth Avenue. Inside, Duchamp selected a "Bedfordshire" model porcelain urinal, brought it to his studio, turned it 90 degrees onto its back, signed it "R. MUTT 1917," and entitled it *Fountain*.

THE ART INSTITUTE OF CHICAGO

Art school and encyclopedic museum

Located in Chicago's Grant Park, the Art Institute of Chicago is a combination of accredited school and encyclopedic art museum. It is the second-largest art museum in the United States, and it contains more than 300,000 works of art. The permanent collection features European, American, and Asian sculpture, paintings, prints, drawings, decorative arts, photography, textiles, and arms and armor, in addition to African, pre-Columbian American, and ancient art. Its Impressionist, Post-Impressionist, and American paintings are among the most celebrated pieces in the museum.

HISTORY OF THE INSTITUTE

The Institute began as the Chicago Academy of Design in 1866, started by a group of thirty-five artists in a studio on Dearborn Street. Their goal was to run a free art school and gallery modeled after European art academies like the Royal Academy in London. The charter was granted in 1867 and classes, which met daily for a cost of $10 per month, began in 1868. The organization was successful enough to construct a new five-story building on West Adams Street, which opened shortly thereafter in the fall of 1870.

In 1871, the Great Chicago Fire destroyed the building and the Academy suffered significant financial losses as a result. Although efforts were made to carry on classes in rented facilities, by 1878

the Academy was $10,000 in debt. Arrangements made with local businessmen with the intention to save the Academy failed, and in 1879 some of its members founded a new organization, the Chicago Academy of Fine Arts, which bought the assets of the bankrupt organization later that year. Then, in 1882, the Chicago Academy of Fine Arts was renamed the Art Institute of Chicago.

COLLECTION:
AMERICAN AND EUROPEAN ART

The Art Institute of Chicago houses more than 300,000 works of art spanning 5,000 years of creativity. Although the collection features pieces from cultures around the world, it is best known for its impressive assortment of Western artworks. Notable Impressionist works include more than thirty paintings by Claude Monet, including paintings from *Haystacks* and *Water Lilies*, as well as Pierre-Auguste Renoir's *Two Sisters (On the Terrace)* and Gustave Caillebotte's *Paris Street; Rainy Day*.

Post-Impressionist highlights include:

- Paul Cézanne's *The Basket of Apples* and *Madame Cézanne in a Yellow Chair*
- Henri de Toulouse-Lautrec's *At the Moulin Rouge*
- Georges Seurat's *A Sunday Afternoon on the Island of La Grande Jatte,* which inspired a musical
- Henri Matisse's *Bathers by a River,* one of the five most pivotal pieces of his career

Highlights of non-French paintings of the Impressionist and Post-Impressionist collection include Vincent van Gogh's *Bedroom in Arles* and *Self-Portrait, 1887.*

Paintings of interest from the American collection include Mary Cassatt's *The Child's Bath* (1892), which was revolutionary in the way it portrayed an intimate moment; Grant Wood's *American Gothic* (1930), which depicts a man, a woman, and a pitchfork; and Edward Hopper's *Nighthawks* (1942), which was acquired by the Institute within months of its completion and is one of the artist's most famous paintings.

COLLECTION: AFRICAN AMERICAN ART

The Art Institute of Chicago has long played an integral role in the exhibition of African American art, and its collection provides a historical narrative of the struggle of African Americans in the United States. Samuel J. Miller's confident Frederick Douglass daguerreotype, for example, subverted the very medium that had been used to perpetuate racial stereotypes, and Archibald John Motley used his art, which imbued a sense of racial pride, to diffuse race-related tension. Other artists that helped advance the shifting sentiments toward African American art include Richmond Barthé, with his piece *The Boxer*, and Jacob Lawrence, with his piece *Graduation*.

LOGAN MEDAL OF THE ARTS

Initiated in 1907, the Logan Medal of the Arts is associated with the Art Institute of Chicago, which distributed the award from its

inception through the 1960s. Named for arts patron Frank Granger Logan, who was a board member at the Institute for over half a century, the medal was awarded by Logan and his wife Josephine, both of whom strongly opposed all forms of modern art. The pair founded the Society for Sanity in Art in 1936, and Josephine published her book *Sanity in Art* in 1937. A total of 270 awards were given between 1917 and 1940 and were received by notable artists like Edward Hopper and Frank Moore.

FAUVISM

Wild beasts of the art world

In 1905, a collection of bright, garish paintings were exhibited together at the Salon d'Automne in Paris. Those who witnessed them were shocked by the bold use of color and the passion so apparent in their creation. Louis Vauxcelles, a prominent art critic, was aghast. He called the painters "fauves," which means "wild beasts" in French. The term Fauvism naturally followed.

FAUVISM AT FIRST SIGHT

Spearheaded by Henri Matisse at the beginning of the twentieth century, the style of Fauvism would cause some of Europe's great artists to unleash their inner "beast" and paint their feelings about their subjects using an unprecedented assortment of vivid colors. While Impressionists often kept a cool distance from their subjects, Fauvism emphasized the artist's emotional relationship with the person or object being painted. Its aggressive lines, assault of bright colors, and sense of artistic abandonment earned the style a unique, though relatively short, chapter in art history. In the brief period of time from 1905 to 1908, it created a full-fledged uproar. In the words of one art critic of the time, Fauvism was like "flinging a pot of paint in the face of the public."

What did the artists do to deserve such a statement?

1. They rejected the fantastic imagery of the time and reverted to painting landscapes and scenes of bourgeois life as the Impressionists once had.

2. They used paint directly from the tubes to juxtapose bright colors and express their raw emotion.
3. They smeared their unmixed paint colors in spontaneous, irrational ways.
4. They kept their painting simple. They didn't get too detailed, lest they squelch the energy of their work.
5. They painted large objects such as landscapes, which lent themselves to wild brushstrokes on larger areas.
6. Their color choice was unrelated to the color of the subject they painted.

THE FIRST FAUVISTS

The Post-Impressionist color play of Paul Gauguin, Vincent van Gogh, and Georges Seurat were the early inspiration for Fauvism. These artists had a knack for using pure, unmixed color to imply emotion, light, and even movement. It was Henri Matisse who, at the turn of the century, took those early color experiments a step further. Matisse's work in the early 1900s drifted away from the subtle hues of his time and employed vivid, unmixed paint color to enhance his own personal expression. In 1905, he completed *Luxe, Calme et Volupté*, commonly recognized as the first Fauvist painting.

In the seaside town of Collioure, joined by his friend André Derain, Matisse continued to reinvent himself and inspired others to do the same. He painted his 1905 *The Open Window* in amplified tones. Terracotta flowerpots on a windowsill were expressed in passionate red while reflections in the water were a curious shade of pink. In *Woman with the Hat* (1905), Matisse transformed the traditional salon portrait into something altogether shocking. His wife, Amelie, is shown posing in

her best garments except the garments have been articulated in starkly contrasting patches of blues, greens, and reds. His brushstrokes are short and broad—implying a hastiness that horrified most art enthusiasts. This new style Matisse had developed was energetic, unfinished, and to some appalling. Nonetheless, it caught on.

The Color of Emotions

"I used color as a means of expressing my emotion and not as a transcription of nature."—André Derain

Soon a few artists in Matisse's inner circle began to follow suit. André Derain, a former schoolmate of Matisse's and Derain's friend, Maurice de Vlaminck, become the principal figures of Fauvism. Derain created vivid landscapes in bold, colorful brushstrokes: The red sky and green waters of Derain's *London Bridge* (1906) are a lasting example of Derain's commitment to putting color first. Vlaminck's work included moody landscapes in eye-popping colors, such as *The River Seine at Chatou* (1906) with its orange trees and bright yellow sailboat.

Gradually, as the movement gained momentum, the circle of Fauvist artists grew. French artists such as Othon Friesz borrowed from this fresh approach to painting, as did Raoul Dufy and Georges Braque (whose experiments with Fauvism would lead him down the road to Cubism). Other painters associated with the Fauves were Georges Rouault, Henri Manguin, Charles Camoin, Albert Marquet, and Jean Puy. While Fauvism did not last long enough to define the careers of these artists, it did function as a steppingstone to further artistic experimentation.

FAUVISM FIZZLES

By 1908, the spirit of Fauvism was dampened as art wandered away from erratic emotion and toward the more controlled, mathematical approach of Cubism. Matisse, however, did not abandon the style he so bravely introduced a few years earlier. He continued to find inspiration in the kinetics of color and the freedom of self-expression that Fauvism provided.

Despite the quick fade of Fauvism, it made a lasting impact on art and paved the way for Abstract Expressionism. Max Beckmann, Oskar Kokoschka, Egon Schiele, George Baselitz, and many others were encouraged by its bold experiments in color.

DIEGO RIVERA (1886–1957)

Fresco pioneer of Mexico

The outspoken artist Diego Rivera insisted on the right of everyday people to be both the audience and subject of art. In choosing the very public medium of fresco, Rivera was able to wield his paintbrush as a social and political weapon. The giant murals he painted often reflected his own personal and political views while paying fitting tribute to the history, the progress, and the struggles of Mexico's working class. Rivera is considered the father of Mexican murals, but his contributions went well beyond art.

BORN AND RAISED IN MEXICO

Diego Rivera was born in 1886 in Guanajuato, Mexico. His mother was a physician and his father was a teacher and news editor. Like many artists, he found his calling early. He began drawing at age three and was enrolled in the National School of Fine Arts in Mexico City at age ten. At the age of sixteen, his strong opinions were already starting to get him in trouble: His participation in a student protest lead to his expulsion from school.

Despite this early setback, he had his first successful art exhibit in 1906 and began to garner some praise. The governor of Veracruz gave him a scholarship that allowed him to travel to Europe in 1907 to study art. At the age of twenty-one, Rivera sailed abroad to begin the work of finding himself and his art.

DIEGO'S LIGHT BULB MOMENT

For the next fourteen years, while the Mexican Revolution raged on in his own country, Rivera absorbed himself in the techniques of the European masters. He took great interest in the works of Renoir, Matisse, Gauguin, and especially the Post-Impressionism of Cézanne. He was also there to witness and embrace the birth of Cubism at the hands of Pablo Picasso and Georges Braque. But it wasn't until he traveled to Italy and studied the work of Giotto and other Renaissance fresco artists that he found his medium. The large scale of murals and their public display made them the perfect match for Rivera's bold, unflinching perspective.

MAKING A NAME FOR HIMSELF

Rivera returned to Mexico in 1921, just after the end of the Mexican Revolution. He created his first government-commissioned mural, *Creation*, at the National Preparatory School in Mexico City soon after his return. In 1922, Rivera helped to found the Revolutionary Union of Technical Workers, Painters, and Sculptors. Rivera's fame grew as his elaborate government-funded murals adorned the walls of more and more universities and public buildings. Rivera's giant human figures, painted in simple, no-fuss lines, made heroes out of the peasants, farmers, and everyday people they represented. The frescos he painted usually depicted stories of the Mexican Revolution of 1910 and brought Mexican history to life. Blooming with Aztec colors and symbols, they fueled national pride by celebrating local culture and tradition.

While the 1920s established him as a Mexican muralist, Rivera expanded his influence to America in the 1930s. In November 1931, Rivera had a retrospective exhibition at the Museum of Modern Art in

New York City. In 1932, he started work on an immense, twenty-seven-panel fresco called *Detroit Industry* at the Detroit Institute of Art.

After the late 1930s and until his death, Rivera continued to make murals but he spent more time on landscape and portrait paintings. His last mural, perhaps the most ambitious of his career, was left unfinished at the National Palace when he died.

RIVERA AND WOMEN

Diego Rivera was surprisingly successful with women, though he was seldom successful in being loyal to them. Though he had already been married twice and fathered more than one child, in 1928 Diego Rivera met the love of his life when he was reintroduced to Frida Kahlo. In 1929, she became his third wife. They went on to endure a long, passionate, tumultuous marriage characterized by infidelity and hot-tempered fights. At the end of his life, Rivera admitted that his love for Frida Kahlo—though tempestuous—was the only thing of real value in his life.

POLITICS AND CONTROVERSY

Rivera's controversial beliefs, including his fierce communism and strict atheism, turned many people against him and his work. Among the highlights of his active political life were:

- In 1922, Rivera joined the Mexican Communist Party.
- In the late 1920s, Rivera flew to Moscow to paint a mural for the Red Army Club. Before he made the mural, he was kicked out of the country for his participation in anti-Soviet politics.

- The Communist party revoked Rivera's membership in 1929. His loyalty was brought into question, in part, because so much of his work was government-funded.
- In his mural at the Alameda Central, the words "Dios no existe" (God does not exist) angered Catholics and lead to public defacing of his work.
- In 1933, his refusal to remove a portrait of Lenin from the mural *Man at the Crossroads* in the lobby of the RCA building in New York City angered Americans and cost him the job. The painting was destroyed.

Diego Rivera died in Mexico City at the age of seventy. He had helped to develop a form of national art and had inspired the notion of public art in America. President Roosevelt developed the Federal Art Project program within the Works Progress Administration based partly on Rivera's ideas about artists being involved in and celebrating everyday life. More than 5,000 jobs for artists were created via the program.

His firm opposition to organized religion, his questionable relationships with left-wing political figures, and his radical (sometimes contradictory) views ensured that his career was steeped in controversy. It was the unquestionable value of his work that allowed him lasting success as a painter. His legacy continues to be the gift he gave to his countrymen: a voice, a stronger identity, and a stronger sense of pride.

VATICAN MUSEUMS

Most museums per capita

Vatican City may be the smallest independent state in the world—it covers an area less than one quarter of a mile with a population of around 800—but it is home to thousands of the world's most famous paintings and sculptures, as well as the most significant building in the art world: the Sistine Chapel. The galleries are open to the public and receive millions of visitors every year.

IN THE BEGINNING

The first work of art displayed at the Vatican was a large marble sculpture titled *Laocoön and His Sons* acquired by Pope Julius II in 1506. It depicted a Trojan priest and his sons struggling with an onslaught of sea serpents. Shortly after purchasing the piece, Julius welcomed the public to view it to promote appreciation of the arts, establishing the Vatican as a center for art history and culture. Julius often turned to famed Renaissance artists Raffaello Sanzio da Urbino (better known as Raphael) and Michelangelo di Lodovico Buonarroti Simoni for guidance and commissioned them both to adorn the Vatican with sculptures and paintings, most notably the ceiling of the Sistine Chapel, painted by Michelangelo.

THE MUSEUMS

While the various museums in the Vatican can be treated as indi-vidual collections with their own focus and themes, their close

proximity allows visitors to Vatican City to peruse the entire collection of art in a matter of hours.

- **Pio Clementino Museum:** Founded in 1771 by Pope Clement XIV and expanded by Pope Pius VI and Pope Pius VII, the Pio Clementino initially housed Renaissance art and classical antiquities. Today there are fifty-four galleries throughout the museum, mostly containing Greek and Roman sculptures, with the exception of the Sistine Chapel, which is the final gallery contained within the museum.
- **Chiaramonti Museum:** Taking its name from that of Pope Pius VII before he became pope in 1800, the Chiaramonti Museum features more than 1,000 sculptures and reliefs from ancient Greece and Rome including the massive *The River Nile* sculpture and one of the first sculptures obtained by the Vatican, *Heracles with Infant Telephus*.
- **Gregoriano Profano Museum:** One of several museums founded by Pope Gregory XVI, the Gregoriano Profano Museum features pieces retrieved during pontifical archaeological excavations in and around Rome. The galleries feature an open layout with ample natural light from large windows and skylights.
- **Gregorian Egyptian Museum:** Pope Gregory XVI's fascination with ancient art and Egypt in particular encouraged him to found the Gregorian Egyptian Museum in 1839. It consists of nine rooms and contains ancient papyruses, mummies, sarcophagi, and other artifacts.
- **Gregorian Etruscan Museum:** Also founded by Pope Gregory XVI, the Gregorian Etruscan Museum is primarily dedicated to artifacts discovered while excavating Etruria, a region of central Italy now known as Latium. It houses ceramic pieces, as well as

those constructed from silver, bronze, and gold and a collection of Greek vases.

- **Ethnological Museum:** One of the newest museums in the Vatican, the Ethnological Museum was founded by Pope Pius XI in 1926 and first contained 40,000 works from all over the world offered to the Vatican by private donors. It features ancient Chinese coins, sculptures of American Indians, prehistoric artifacts, and art from countless other cultures.
- **Pinacoteca Vaticana:** Initially housed in the pope's personal apartments and consisting of 118 paintings, the art gallery contained in the Pinacoteca Vaticana now lives in its own dedicated building. Today, the museum houses 460 paintings spanning from the twelfth century up until the nineteenth, including pieces by Raphael, Leonardo da Vinci, and Giotto di Bondone.

Famous Works

Some of the most famous Renaissance paintings as well as countless artworks, sculptures, and artifacts from around the world are housed in the Vatican Museums. Including:

- Raphael's fresco, *The School of Athens*
- *The Sarcophagus of Junius Bass*
- Leonardo da Vinci's portrait of *St. Jerome in the Wilderness*
- Caravaggio's *Entombment*
- Giotto's *Stefaneschi Altarpiece*
- Melozzo da Forlì's *An Angel Playing the Lute*
- Michelangelo's *The Creation of Adam*
- Botticelli's *Events in the Life of Moses*

THE SISTINE CHAPEL

Perhaps the most famous building in the world, the Sistine Chapel is the setting for each new papal election and is also the most popular element of the Vatican Museums. It was constructed between 1473 and 1481 by Giovannino de Dolci at the behest of Pope Sixtus IV. The architecture of the building is stunning; however, the most notable features are the frescos and paintings that adorn the walls and, of course, the elaborate ceiling painted by Michelangelo.

First commissioned by Pope Julius in 1508, the series of nine paintings adorning the ceiling of the Sistine Chapel took four years for Michelangelo to complete. The paintings depict a series of stories inspired by the biblical book of Genesis, which detail the creation of the world, the relationship between man and God, and man's ultimate fall from grace. Of all the scenes painted by Michelangelo, the most recognizable is the iconic depiction of God reaching down to touch the hand of a nude male figure in *The Creation of Adam*.

CUBISM

Geometry meets art

Cubism was conceived in Paris in the early 1900s by Pablo Picasso and Georges Braque, two influential young artists willing to defy conventions. Their interest in analyzing a subject's geometrical components and depicting those elements on canvas led art in a brave new direction. While Cubism was initially skewered by art critics, it soon established itself as a legitimate genre of twentieth-century painting and a pivotal force in art's evolution.

CHARACTERISTICS OF THE STYLE

When French art critic Louis Vauxcelles described what Braque had done in a landscape painting in 1908, he referred to its "geometric oddities" as "cubes." The work, *Houses at L'Estaque*, contained elements of Cézanne's own paintings of the area (such as clearly identifiable green trees and bright orange houses) but was noteworthy for the way in which Braque had deconstructed a landscape into a medley of adjoining shapes. Pablo Picasso's works during this time exhibited the same geometric analysis of their subjects. In essence, the style often portrayed an object disassembled and reassembled as an abstraction.

Cubism became the term used to describe paintings that allowed for multiple vantage points. Cubist works allowed onlookers to enjoy several perspectives at once and to consider the shapes inherent in the world around them. During the Cubist movement, landscapes, nude figures, and still lifes were painted in a way that were fragmented but retained just enough of their realistic qualities

to remain recognizable. In order to place more focus on a work's geometric composition, artists used neutral colors like browns and grays. Instead of trying to move beyond the two-dimensional aspect of a canvas, Cubism embraced and emphasized that flatness by breaking up objects and realigning them in interesting ways.

A TIMELINE OF CUBISM

- **1907:** Pablo Picasso is impressed by the African art he sees on display at Palais du Trocadéro in Paris. Picasso and Georges Braque meet in Paris and begin painting together in their Montmartre studios. The nude figures in Pablo Picasso's *Les Demoiselles d'Avignon* draw attention for their rule-breaking play on perspective.
- **1908:** George Braque's *Houses at L'Estaque* gets art critics talking for its oddly geometric depiction of a landscape.
- **1910:** The period referred to as High or Analytic Cubism begins, and the subjects of Cubist paintings become greatly deconstructed and more difficult to discern.
- **1911:** The first Cubist exhibit opens in Paris and displays works by Fernand Léger, Robert Delaunay, Henri Le Fauconnier, Jean Metzinger, and Albert Gleizes.
- **1914:** The movement loses some of its steam. The period sometimes referred to as Late Cubism begins (more on this period in a minute).

CHAMPIONS OF CUBISM

Picasso and Braque may have founded this new style, but many painters joined the movement, including Fernand Léger, Robert and

Sonia Delaunay, Juan Gris, Roger de La Fresnaye, Marcel Duchamp, Albert Gleizes, Jean Metzinger, and even Diego Rivera. Sculptors Alexander Archipenko, Raymond Duchamp-Villon, and Jacques Lipchitz also contributed to the Cubist art movement.

FAMOUS CUBIST PAINTINGS

Lasting works by Georges Braque include *Large Nude* (1908), *Houses at L'Estaque* (1908), *Violin and Pitcher* (1910), and *Man With a Guitar* (1911).

Picasso also left behind many famous Cubist works, including his *Les Demoiselles d'Avignon,* which is often credited with starting the movement. *Self Portrait* (1907), *Woman with Mandolin* (1910), and *Three Musicians* (1921) represent his Cubist style at various stages.

While Juan Gris's paintings are not as renowned as Picasso's, several pieces that represent his progression as an artist are *Portrait of Pablo Picasso* (1912), *The Sunblind* (1914), *Harlequin with Guitar* (1919), and *View across the Bay* (1921).

In the Armory Show, Marcel Duchamp shocked the American public with the painting *Nude Descending a Staircase, No. 2* (1912).

THE THREE PHASES OF CUBISM

As with many other art movements, the style of Cubism evolved over time. It is described by art historian Douglas Cooper in three distinct phases that relate to the dominant Cubist artists of the time.

- **Early Cubism (1906–1908):** Picasso and Braque build the foundation of Cubism, unifying Cubist works under the themes of a fragmented subject and an irrational but decodable clash of perspectives.
- **High Cubism (1909–1914):** The Spanish artist Juan Gris, who has been named the "Third Musketeer of Cubism," altered the style a bit to suit his taste. The most noticeable difference was his injection of bright color.
- **Late Cubism (1914–1921):** Cooper defined this last chapter as a radical avant-garde movement that often featured musical instruments, the human figure, or everyday household items. Words and letters were sometimes incorporated in these paintings.

CUBISM'S LASTING INFLUENCE

The Cubism of France became known as Futurism in Italy, Vorticism in England, Suprematism and Constructivism in Russia, and Expressionism in Germany. It influenced everything from twentieth-century music to literature to architecture. The boundaries broken down by Cubism gave way to the rebellion of the Dadaist and Surrealist art movements. In short, it was Cubism that freed artists from the long-held conventions of Post-Impressionism and helped art catch up with modern times. Far from over, the principles and philosophy of Cubism continue to influence today's artists.

JACKSON POLLOCK (1912–1956)

The paint splatter guy

Best known for his unique style of drip painting—which often found the artist pouring paint directly onto a canvas laid down on the floor—Jackson Pollock was one of the most influential artists of his time. He achieved considerable fame and recognition during his life, but ultimately his life would begin to mirror the chaotic paintings he created so passionately.

EARLY LIFE

Pollock was born the youngest of five brothers in 1912 and spent most of his youth in Arizona and California. His family encouraged his interest in art from an early age, especially his oldest brother Charles, who was also an artist. As a teenager, Pollock enrolled in the Manual Arts High School in Los Angeles, but was soon expelled for starting fights with the other students. At eighteen, Pollock moved to New York City to live with Charles and study under Charles's instructor, Thomas Hart Benton.

Like many artists living in the Depression era, Pollock took advantage of the Public Works of Art Project—a portion of Roosevelt's New Deal—which allowed artists to work for $25 a week producing art. The project enabled him to produce scores of pieces of art, but it also served to fund his alcoholism—a problem he sought psychiatric treatment for in 1937.

After completing his treatment, Pollock met contemporary artist Lee Krasner and the two quickly developed a romantic interest. They were married in 1945 and purchased a home on Long Island, with a barn converted into a studio for Pollock to craft his large murals.

His unique paintings had gained the attention of noted socialite and art collector Peggy Guggenheim, who commissioned him to create *Mural* (1943) for her townhouse. She would later offer him a contract that allowed him to perfect his drip technique in his private studio.

DRIP TECHNIQUE

Unlike most artists who painted in front of an easel, Pollock preferred to set his canvases on the floor so he could walk around them and view them from above while he worked. Inspired by Indian sandpainting, Pollock began dripping and splattering the paint onto the canvas using brushes, sticks, turkey basters, and even his own hands and body at times. Those lucky enough to watch him work described his technique as dance-like, as he moved around the canvas applying paint in fluid strokes. In some cases, Pollock would add other elements, such as sand or glass to his pieces to enhance the texture.

Many of his contemporaries criticized the seemingly random nature of his technique, but Pollock insisted he always had a vision for the piece while he was painting. Possibly as a reaction to critics and to dissuade viewers from attaching their own preconceived symbolism to his paintings, he ceased to give his paintings meaningful titles and instead resorted to numbers followed by a year, like in his most famous painting *No. 5, 1948*.

LATER LIFE AND DEATH

After Pollock was featured in an issue of *Life* magazine in 1949, his fame and notoriety soared. His paintings frequently sold out

at private exhibitions and he was heralded by many as the greatest living artist. Despite his success, he was also deeply affected by critics who claimed he was a fraud. He soon returned to drinking heavily and the mood of his pieces became notably darker in color and tone. He transitioned to painting in black and white briefly, which proved unpopular but did not diminish demand for his work.

His drinking combined with pressure from the public took a toll on his marriage and his art. He stopped painting in 1956 and grew distant from his wife, who traveled to Paris without him that summer. Shortly after, on August 11, 1956, Pollock crashed his car into a tree near his home while intoxicated and traveling with two other passengers, only one of whom survived. The artist was thrown from the car and died instantly.

After Pollock's death, Krasner continued to live in their home in Long Island, adopting Pollock's barn studio for her own paintings. She managed the sale of his remaining artwork and did her best to ensure his legacy remained a positive one. Before her death in 1984, she founded the Pollock-Krasner Foundation, which provides grants to young artists.

Is It Real?

Due to both his immense popularity and his unique style, Pollock had no shortage of imitators both during his life and after his death. As a result, the authenticity of his paintings has come into question on numerous occasions. In 2006, a documentary titled *Who the #$&% Is Jackson Pollock?* premiered, following seventy-three-year-old truck driver Teri Horton, who purchased a painting for $5 at a thrift store that some art experts believe may be an authentic Pollock. The painting is unsigned; however, forensic evidence revealed fingerprints matching Pollock's, as well as other indications of its authenticity. Horton has received several offers for her painting—one in excess of $9 million—but she refuses to sell it for anything less than $50 million.

EDWARD HOPPER (1882–1967)

The art speaks for itself

Edward Hopper was a New York–based American realist painter and printmaker best known for his oil paintings, particularly those involving seascapes and rural landscapes, as well as those depicting scenes of quotidian American life and the people living it. He largely focused on quiet moments devoid of action, and he was known as an introverted, well-read, conservative man. Many of these quiet moments have at the heart of them the subject of a solitary woman, who often appears ambiguously lonely.

FORMATIVE YEARS

Edward Hopper was born in 1882 to a middle-class family in Nyack, New York, just north of New York City. His father, Garret Henry Hopper, was a dry-goods merchant, and his mother, Elizabeth Griffiths Smith, had a considerable inheritance through which his parents led a comfortable life. At the age of five, Hopper began to demonstrate a talent for drawing, which his parents encouraged by keeping him well stocked with art supplies. He created his first signed oil painting, *Rowboat in Rocky Cove*, in 1895, which hinted at his emerging interest in nautical themes. He started painting self-portraits as a teenager, a subject that would endure through his student years, and much of his career as an artist.

Hopper studied for six years at the New York Institute of Art and Design, where he had two very influential teachers. Under the tutelage of William Merritt Chase, Hopper studied oil painting, and in

those days he emulated Chase's style, as well as that of French painters like Manet and Degas. The other teacher who had a marked effect on Hopper was the artist Robert Henri, who taught "life class"—a course focused on drawing the human figure—at the institute. Henri suggested that his students try to impart a contemporary spirit in their work. The first painting of Hopper's to depict the interiors for which he later became famous was *Solitary Figure in a Theater* (ca. 1904).

Hopper took part-time work with an advertising agency starting in 1905. The job entailed designing covers for trade magazines. Although he would continually turn to illustration gigs until the mid-1920s to fulfill economic obligations, it led him to loathe that type of work.

During that artistically unfulfilling time, however, Hopper made three trips to Europe, each of which was anchored in Paris. He seemingly went to observe the creative zeitgeist of the city, but in reality Hopper studied alone and later claimed to have remained virtually unaffected by everyone in that scene save Rembrandt, and French engraver Charles Méryon. Hopper imitated the latter's sullen depictions of Parisian life.

HOPPER'S STRUGGLE WITH ANONYMITY

Hopper rented a studio in New York City after his last trip to Europe. Grappling with his own style, he was forced to return to freelance illustration work, which required relentless solicitation. He fell into frequent periods of depression, and his painting suffered for it. In 1912, however, Hopper got a change of scenery in Gloucester,

Massachusetts, where he was inspired to do his first outdoor paintings in America, including *Squam Light*, which was his maiden lighthouse painting. That particular work set the stage for many more to follow.

Hopper sold his first painting, *Sailing*, at the Armory Show in 1913, at the age of thirty-one. Unfortunately, his career did not take off then as he had hoped, and wouldn't until many years later. Soon after, Hopper moved to Greenwich Village, where he would remain for the rest of his life.

In 1915, Hopper turned to etching. He produced about seventy works in this vein, the bulk of which depicted urban scenes of Paris and New York, but this medium didn't receive much attention until the 1920s. In the early '20s, however, two of Hopper's most remarkable works were not etchings but a pair of paintings: *New York Interior* (1921) and *New York Restaurant* (1922). Two other paintings that he did during this time—*Girl at Sewing Machine* and *Moonlight Interior*—belong to what would later be considered his "window" paintings. In each of these, a figure, usually female, is near or looking out a window of an apartment or viewed from the outside looking in.

Mediums and Methods

While Hopper is best known for his oil paintings, his watercolors and etchings have received substantial attention as well. The sketches found in his notebooks are also of excellent quality, but they were never intended for public display. The way Hopper utilized light and shadow effects to create mood in many of his works, such as in *Early Sunday Morning* (1930), *Summertime* (1943), *Seven A.M.* (1948), and *Sun in an Empty Room* (1963), has often been likened to the cinematographic techniques used in film noir.

BREAKTHROUGH AND RISE TO FAME

In 1923, with the help of his wife, model, and lifetime companion, Josephine Nivison, six watercolors that Hopper painted in Gloucester were admitted to an exhibit at the Brooklyn Museum. Although Nivison was also an artist and former student of Robert Henri, she put aside her own artistic aspirations and joined her husband in his hermitic lifestyle.

Hopper was especially prolific during the 1930s and early '40s. In fact, he even thrived during the Great Depression. In 1931, he sold thirty paintings. Several major museums, including the Whitney Museum of American Art and the Metropolitan Museum of Art, paid thousands of dollars for Hopper's works, and his status as an artist was bolstered as a result.

In 1933, Hopper was granted his first large-scale retrospective at the Museum of Modern Art, and the following year the Hoppers built a summer house in South Truro, Massachusetts. They spent the rest of their lives alternating between their modest flat in the Village and their home on Cape Cod.

FAMOUS WORKS

One of Hopper's most celebrated works is *Automat* (1927), which depicts a lone woman gazing into a coffee cup at a diner at night. Another, *Chop Suey* (1929), also depicts the female subject in a public interior, but there is a pair of women talking at the café rather than one. *Nighthawks* (1942) once again takes on the subject of a community interior, but it is painted from the perspective of someone outside. In *Office in a Small City* (1953), Hopper depicts a man sitting in a corner office, ostensibly surveying the cityscape that lies beyond his window.

ELEMENTS OF ART

The building blocks of art

In the same way that a writer combines letters to create words, which can then be constructed into sentences and paragraphs to tell a story, the artist has his or her own tools to create a piece of art. While the completed work is most often viewed as a single finished entity, many would argue it is nothing more than a sum of the various elements employed to craft it. These elements form the foundation for famous paintings like the *Mona Lisa*, *Starry Night*, and *The Birth of Venus* to the most trivial doodles in the margins of a notebook.

LINE

Line is perhaps the purest and most simple element of art—at least, at face value. Just as in geometry, it is defined as an object created by connecting two points. But how the artist chooses to span those two points allows for nearly infinite possibilities. He or she could draw a vertical line, a diagonal line, a horizontal line, a curved line, or a zigzagging line in any number of directions. A painting or drawing can consist of hundreds or thousands of individual lines blending together to create intricate shapes and designs, or even a single line that curves around the entirety of the canvas to create an image like this drawing:

An example of a drawing made with a single line

While it may appear to be a combination of multiple lines, the flowers are actually a single continuous stroke throughout the portrait.

SPACE

In art, space refers to both the physical space within objects and the area that separates them, as well as the implied depth created by the arrangement of the objects. The area occupied by objects constitutes "positive space," whereas the area between them is often referred to as "negative space." For example, in Monet's famous *Water Lilies* series of paintings, the green lilies constitute positive space, while the water between them constitutes negative space.

The artist can also convey three-dimensional space on a two-dimensional canvas. For example, by painting two figures with one significantly smaller than the other, the artist can give the impression

that the smaller figure is significantly farther away—even though the two figures are actually the same distance from the viewer.

TEXTURE

The artist can either create tangible texture that can be physically felt by the person interacting with it, or implied texture, which merely conveys the idea of a particular texture. In his later life, many of Van Gogh's paintings contained layer upon layer of paint, which created rough sections that actually rose off the canvas.

To imply texture, an artist might apply shading to a section of a mountain to fool the viewer into believing the surface is actually rocky and cracked instead of merely flat paint on a flat canvas.

COLOR

Using various pigments and dyes, the artist can create a range of different hues which the viewer's eyes and brain interpret as colors. The three traditional primary colors (red, blue, and yellow) exist independently of all other colors, whereas any other color can be created by combining proportions of the three primary colors. An artist can use color to define shapes, imply depth, express mood, and in myriad other ways.

SHAPE

By using lines and contrasts in color and texture, the artist can define various objects throughout a piece of art. These objects

can take on simple forms like squares, circles, triangles, and other geometric figures or more complicated structures like mountains, human faces, animals, and so on. Shapes can have clearly defined borders or ambiguous borders implied through shading or the use of contrasting colors.

TONE/VALUE

Tone most often refers to the use of light and dark within a piece of art. The contrast between the two can be used to create depth, by shading a portion of an object to make it appear three-dimensional, as in the image below.

The shadow of the sphere cast on the ground combined with the shading appearing directly on the sphere create the illusion that the circle on the page actually exists in a three-dimensional world.

PRINCIPLES OF ART

A basic set of rules

If the elements of art are considered to be the building blocks of art, the principles of art are the rules and techniques that artists use to both create and critique works of art. These principles are taught in art schools the world over—although with small variations occurring from teacher to teacher—and are employed by artists of all skill levels. As with any set of rules, they can be bent, broken, and ignored in the pursuit of innovation, but they are still essential concepts for both fledgling and professional artists.

MOVEMENT

Even though most works of art consist of static images, it is still possible for the artist to convey the illusion of movement. One simple way is by drawing lines behind an object, like a baseball, to imply the ball is in flight. While this method is certainly effective, it is not always aesthetically pleasing. Another less obvious method is to draw subjects in poses that imply they are in motion, such as jumping in the air or poised to strike a blow. The viewer subconsciously assumes that the subject must be in motion, as no one is capable of floating in midair.

Movement can also refer to the way the viewer's eyes move across the piece of art, which can be controlled by a skilled artist. The human eye is naturally attracted to geometric shapes, and the artist can compose a piece of artwork to appeal to that bias. For example, placing a triangular mountain in the middle of a painting forces the viewer's eyes from the bottom left of the mountain, up to the peak, and down the other side.

UNITY

Unity is a rather subjective principle, as it depends greatly on the viewer's reaction to the various elements employed in a piece of art. Put simply, unity refers to the balance of the elements present in a piece. A piece with good unity combines all of the elements of art so that they complement each other instead of competing with one another.

HARMONY

Similar to unity, harmony is a difficult term to define, but in general it refers to the consistency of the elements present in a piece. Consistent use of elements throughout a piece creates harmony, whereas contrasting use of elements creates disharmony. For example, the consistent curved lines in Van Gogh's *Starry Night* give the whole painting a pleasant sense of harmony. Had he instead incorporated harsh zigzags in conjunction with the curves, the painting would appear disjointed.

VARIETY

While it's true that consistency creates a harmonious piece, it is important for an artist not to rely too heavily on one element or style. Utilizing different color schemes, shapes, tones, and so on, adds variety to a work and can make for a more interesting piece of art. However, in traditional art, the artist must be careful not to incorporate too much variety or the piece may appear busy and chaotic.

BALANCE

Balance generally refers to the concept of maintaining consistent concentrations of elements in various areas of a piece of artwork. This can come in the form of symmetrical, asymmetrical, or radial balance.

- **Symmetrical balance** exists when the various elements of a piece are evenly distributed on either side of either the vertical or horizontal midpoint of a piece. Da Vinci's famous *Last Supper* is a good example of symmetrical balance, as the piece features Jesus Christ in the center with his twelve disciples evenly distributed on both his left and right.
- **Asymmetrical balance** may seem like a misnomer, but a piece can be both asymmetrical and balanced if the different areas of the piece are not identical, but still contain equal weight. For example, an artist could paint a large tree on one side of a painting with a number of small houses comprising a village on the other.
- **Radial symmetry** exists when various objects in a piece branch off from a central point.

Symmetric

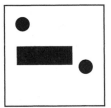
Asymmetric

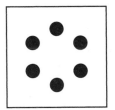
Radial

CONTRAST

By placing starkly different objects, colors, or other elements in close proximity to one another, an artist can create a more visually interesting finished piece. This can come in the form of dark colors alongside light colors, conflicting shapes (such as squares with hard edges adjacent to circles), opposing rough and smooth textures, or any number of other contrasting elements. The artist can also use contrast to draw the viewer's eye to a particular area of the piece of art.

PROPORTION

In art, proportion is the relative size of particular elements of a work in relation to one another. For example, if an artist were drawing a proportional human body, he or she would draw the legs slightly longer than the torso and the head significantly shorter than both. However, many artists like Pablo Picasso ignored traditional proportion to create a drastically different image from what the viewer would normally expect.

PATTERN AND RHYTHM

Although separate concepts, rhythm and pattern are often combined when explaining the various principles of art. In art, patterns appear as repeating arrangements of color, shapes, and the other elements of art. The way the patterns appear in a piece and their relationship to other patterns creates rhythm, which can be used to move the viewer's eye around the piece.

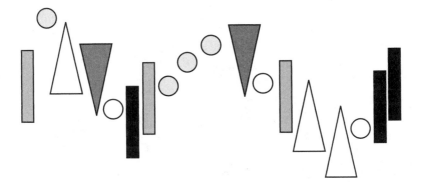

Pattern

Rhythm

FRIDA KAHLO (1907–1954)

Passion, pain, and a paintbrush

In many ways, Frida Kahlo (born Magdalena Carmen Frieda Kahlo y Calderón) is the pride of her native Mexico: Her compelling self-portraits of pain and endurance are filled with elements of indigenous folklore and symbols of her native land. Kahlo's fierce and unapologetic portraits of the female form were underappreciated during her lifetime, but were later reborn to worldwide acclaim during the feminist movement of the 1970s. Her paintings, though small in scale, left a powerful mark on the timeline of twentieth-century art.

GROWING UP IN MEXICO

Frida grew up with three sisters in Coyoacán on the outskirts of Mexico City in her family home, La Casa Azul. Kahlo always had a special connection with her father, a German photographer who was only nineteen when he immigrated to Mexico. Her mother, Matilde Calderón y Gonzalez, was a staunch Catholic with Spanish and Mexican-Indian roots.

When she was six years old, Kahlo began a lifelong battle with chronic pain and suffering: She was stricken with polio and spent nine months in bed making her recovery. Because of the damage polio caused to her right leg and foot, she walked with a limp for the rest of her life.

PIVOTAL MOMENTS

At the age of fifteen, things looked more promising for Kahlo. She began her studies in the very prestigious pre-med program at the

renowned National Preparatory School in Mexico City. She made her presence known, dressing in the bright colors and bold jewelry of her indigenous ancestors.

Coincidentally, in her first year at the school, the famous muralist Diego Rivera was painting one of his latest creations in the lecture hall. This sparked in Kahlo an interest in Rivera and his work that would one day blossom into a full-blown love affair, despite their twenty-one-year age difference. For the time being, she dated Alejandro Gómez Arias, the leader of a left-wing political group on campus. The two were dating when Kahlo experienced the pivotal tragedy of her life: In 1925, the bus that the couple was traveling in crashed into a streetcar and Kahlo was gravely injured. A steel handrail impaled her, cutting straight through her hip and destroying her reproductive organs. She sustained major life-threatening injuries, including a fractured spine and pelvis. These injuries would give way to a long struggle with chronic pain; a struggle that would both fuel her career and end her life prematurely.

FRIDA KAHLO FINDS ART

During her long recovery in the hospital and at home, Frida Kahlo found that painting provided some solace. She finished her first of many self-portraits the year after her accident and offered it to Gómez Arias. Throughout her career, she focused her attention primarily on still lifes and portraits of herself or intimate friends and family. While her work included elements of the Realism, Symbolism, and Surrealism movements in Europe, she distanced herself from these and preferred to celebrate the influence of her own country and its indigenous traditions.

Kahlo was largely self-taught, though she learned from the techniques employed in her father's photography and in Diego Rivera's murals. It was her unique and brave perspective that drew people to her figurative creations; paintings that stood in stark contrast to the more popular abstract art of her time. Her body of work reads like a diary, depicting her most personal tragedies in raw, unapologetic terms.

- In 1932, she painted the self-portrait *Henry Ford Hospital* in an attempt to convey the pain of her second miscarriage. Objects, including a fetus and a pelvic bone, are attached by bloody veins to her naked bedridden figure.
- In 1944, she painted *The Broken Column*. In it, her torso is split open to reveal a crumbling spine. Nails pierce her flesh from head to hip and tears drip from eyes that stare courageously ahead.
- In 1951, with her health in a steady decline, she painted herself confined to a wheelchair. Instead of an artist's palette, she sits with her own heart on her lap, bloody brushes in the other hand.

Although she sold only a few paintings during her lifetime, her legacy grew with the passing of time.

Recognition Comes Late

Frida Kahlo traveled via ambulance to her first one-woman art exhibit in Mexico City in 1953. Her right leg had recently been amputated and her health was in steady decline. It was the first and only exhibit of its kind that she would enjoy in her native country.

DIEGO RIVERA AND FRIDA KAHLO

While Kahlo's work eventually earned great fame, so did her fiery relationship with Diego Rivera. Theirs was an epic love story of a suffering artist prone to deep, dark depression and a much older and established artist with a reputation for womanizing. They met in 1928 and married a year later. Though Kahlo and Rivera were united by their political beliefs (both became members of the Mexican Communist Party) and artistic passion, their relationship was marred by miscarriages, constant fighting, and extramarital affairs, including Rivera's tryst with Kahlo's younger sister Cristina, and Kahlo's alleged affair with exiled Soviet communist, Leon Trotsky.

Their eventual divorce brought such despair that they married again, but their second marriage fared no better. Knowing that they could not live without each other, they made the best of their rocky relationship by living in separate but adjoining homes.

Diego Rivera was always a strong supporter of his wife's art. In 1954, Frida succumbed to pneumonia and thus her lifelong battle with pain ended. After her death, he transformed her childhood home into a museum of her work.

Beloved Brows

Diego Rivera is quoted as describing Kahlo's joined eyebrows as "the wings of a blackbird, their black arches framing two extraordinary brown eyes."

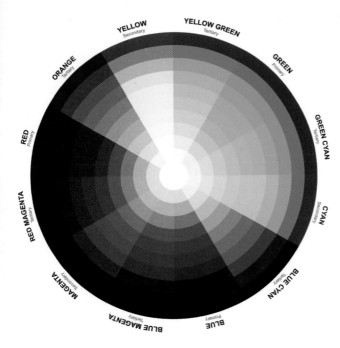

The color wheel shows complementary colors, which are generally considered pleasing to the eye when used together.

This 13,000-year-old *Swimming Reindeer*, on display at the British Museum, is a carving of two reindeer swimming in tandem. It was carved from a mammoth tusk and is an amazing example of surviving Ice Age art.

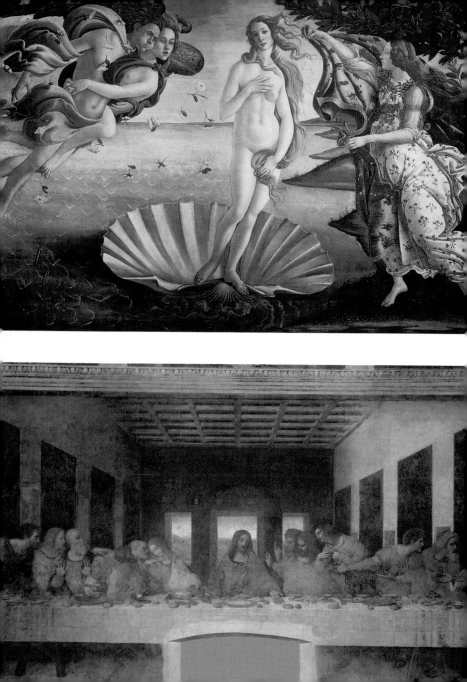

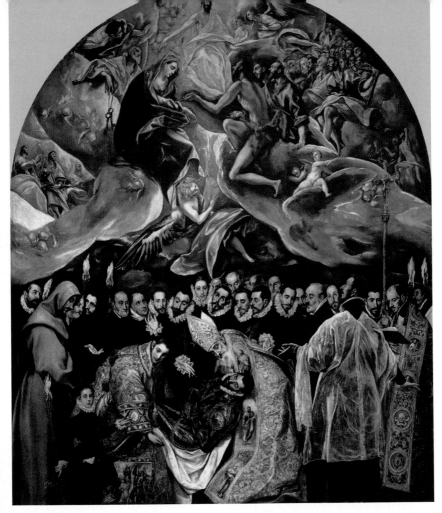

Opposite page: Sandro Botticelli's *The Birth of Venus* (1486) is an example of Renaissance art's focus on mythological themes and lifelike human portrayals. • Leonardo da Vinci's Renaissance masterpiece *The Last Supper* (1495–1498) exemplifies symmetrical balance, as the piece features Jesus Christ in the center with his twelve disciples evenly distributed on both his left and right. **This page:** While it has possible roots in Byzantine art, Renaissance works, and Mannerism, El Greco's *The Burial of the Count de Orgaz* (1586–1588) is celebrated for its use of brilliant gold and standout red, the stretched bodies of the saints, and the compact action of the scene.

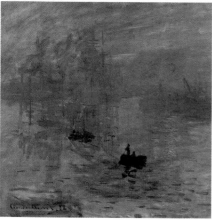

This page: Edward Hicks, a devout Quaker and preacher, painted *The Peaceable Kingdom* in 1833. The theme of this piece of folk art, drawn from chapter 11 of Isaiah, was a message of peace, both for animals and humans. • Claude Monet's *Impression, Sunrise (Impression, soleil levant)* (1872) was initially scorned by critics for appearing unfinished, but came to be known as the painting that gave birth to the term "impressionist." **Opposite page:** *A Bar at the Folies-Bergère* (1881–82), by Édouard Manet, is an example of realism. In it, he captures a Parisian barmaid in the chaos of her surroundings. • Pierre-Auguste Renoir's *The Luncheon of the Boating Party* (1881) is a classic impressionist take on everyday pleasures.

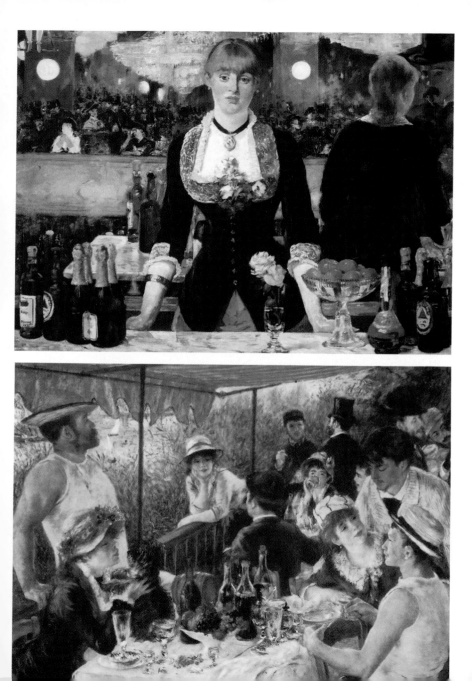

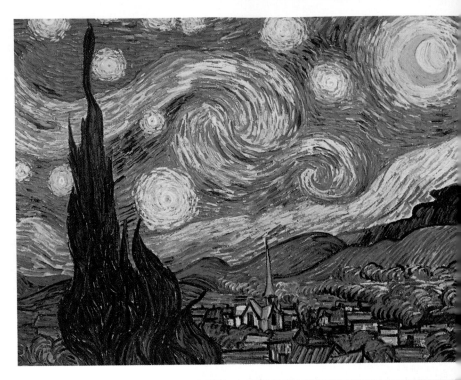

This page: The consistent curved lines in Vincent van Gogh's iconic *Starry Night* give the whole painting a pleasant sense of harmony. • Paul Cézanne's *The Bathers* (1890–1892) shows the post-impressionist master's love of the outdoors. **Opposite page:** Man Ray's 1916 painting *The Rope Dancer Accompanies Herself with Her Shadows* was inspired by an acrobatic show and attempts to show movement in a Dada style. • Georgia O'Keeffe was a major player in the development of American Modernism. Shown is *Evening Star III* (1917).

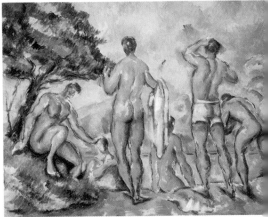

The Rose Dancer Accompanies Herself With Her Shadows

The outspoken Mexican artist Diego Rivera is known for his painting, murals, and frescoes celebrating the history, progress, and struggles of Mexico's working class. Here, *Flower Day (Día de Flores)* (1925) is a depiction of a seller of calla lilies. • One of Edward Hopper's most famous paintings is the realist *New York Restaurant* (1922). • In 1941 the National Park Service commissioned photographer Ansel Adams to create a mural for the Department of the Interior Building in Washington, D.C. This photo from that collection is titled *Grand Teton*.

BANKSY

Artist or menace?

The artistic merit of graffiti is a hotly debated topic in the art world, and at the center of that debate sits Banksy. His pieces are just as likely to sell for hundreds of thousands of dollars as they are to be painted over by city officials or vandalized by rival artists. He is arguably the most famous graffiti artist of all time, yet to this day no one knows for certain who he actually is.

THE WORLD AS A CANVAS

The artist known as Banksy goes to great lengths to hide his identity from the public, but there are a few things known about his past. He was born in the early to mid-1970s in or near Bristol, England, where he began his obsession with street art. His first graffiti art appeared in the Bristol area during the early 1990s in the form of freehand images and lettering spray painted on buildings, billboards, and other public surfaces. His early pieces were time-consuming, which increased his risk of being caught by police while working. Around the late '90s into the 2000s, Banksy began experimenting with elaborate stencils that could be fabricated beforehand and employed on-site to cut down on the amount of time spent painting. Many graffiti artists criticize his use of stencils as a cop-out, claiming it goes against the spirit of the art form. Regardless, it remains Banksy's preferred medium for creating his street art to this day.

THE ART OF
ANTIESTABLISHMENTISM

From the beginning of his career, Banksy's art took a staunchly anti-status quo stance. Often utilizing animal characters and life-like human figures, Banksy uses his art to poke fun at war, society's obsessions with wealth, censorship, industrialization, and even art itself. His work frequently contains either textual or metaphorical messages that urge the viewer to think differently about the world. For example, in 2005 Banksy painted a series of nine pieces along the Israeli West Bank barrier wall which depicted a little girl frisking an Israeli soldier, children tunneling through the wall with a shovel and pail, a protester throwing a bouquet of flowers, and other subversive imagery.

Not all of his work is serious, however, and many of his paintings are more tongue-in-cheek than outright rebellious. One piece features a large rat (an animal common in his work) holding a paintbrush with the words, "so little to say . . . and so much time" written above it. In an act of guerrilla art, Banksy once hung a rock in the British museum depicting an ancient human hunter pushing a shopping cart, drawn in the style of a cave painting. The piece went unnoticed by museum officials for several days before it was discovered.

OUT OF THE STREETS AND
INTO THE GALLERIES

One of the biggest issues with Banksy's unique brand of street art is that, once completed, it is rarely portable or transferable. One cannot easily sell a painting etched onto the side of a building—although

several individuals lucky enough to own homes on which Banksy painted have later sold them as "murals with houses attached."

Luckily for art connoisseurs interested in obtaining their own original Banksy pieces, the artist has held several exhibitions during his career, many of which were equal parts spectacle and art showing. In 2006, his show *Barely Legal* featured a full-grown elephant painted pink and gold to act as a live "elephant in the room" and a metaphor for world poverty (or, more specifically, the public's decision to ignore it).

As a result of his exhibitions, and rising popularity in the celebrity world, his paintings began to sell for tens of thousands of dollars, then hundreds of thousands. In 2007, his acrylic and spray paint piece of retirees bowling with bombs titled *Bombing Middle England* sold for an astonishing £102,000, a record-breaking number for his work, with other paintings soon doubling and tripling that number.

Rather than revel in his success, Banksy scorned it, for the most part—or at least gave the impression that he did. He once posted a picture on his website of an auction scene with a frame up for bid containing the phrase, "I can't believe you morons actually buy this shit." Some speculate his indifference is merely a marketing tool to add to his mystery, but most believe his disdain is genuine.

EXIT THROUGH THE GIFT SHOP

In 2010, Banksy produced and appeared in (albeit with his face and voice obscured) a documentary following French American Thierry Guetta and his obsession with street art. The film details a brief history of street art and focuses on Guetta's eventual rise to fame in the art world under his new persona, "Mr. Brainwash." The authenticity

of the film is open to debate, but Banksy insists both the overnight success of the artist Mr. Brainwash—his first show sold more than $1 million of art—and the film itself are genuine. Throughout the film, Banksy appears to be just as surprised as the audience as to how easy it was for a relative nobody in the art community to create a name for himself and subsequently monetize his brand.

IDENTITY

Several individuals have been suggested as the identities of the infamous Banksy, but so far none have been confirmed by the artist himself or any of his colleagues. Several photographs have surfaced allegedly depicting Banksy at work, but no one has been able to confirm whether the person shown is actually the artist.

The most popular theory centers around a British man named Robin Gunningham, whose background lines up with the supposed background of Banksy. The artist himself rarely comments on these theories, and prefers to ignore the speculation. As for the reason for his anonymity, he has stated the obvious fact that it allows him to create his art without fear of police action. In the end, the mystery of Banksy's identity continues to fuel his celebrity and popularity.

THE LOUVRE

The world's most famous museum

Originally built as a rampart to protect the city from an Anglo-Norman invasion in 1190, what is today the Louvre Museum has gone through numerous changes over the centuries. It is now home to around 35,000 pieces of art, including the *Mona Lisa*, the *Code of Hammurabi*, and the *Venus de Milo*. The museum receives approximately 8.8 million visitors each year.

ORIGINS AS A FORTRESS

King Philip II Augustus of France commissioned the Louvre to be built in 1190 as an arsenal. By the middle of the fourteenth century, Paris had grown into a much larger city, and the Louvre was now enclosed within the growing city, losing its role as defensive fortress. Later that century, Charles V's architect, Raymond du Temple, began the Louvre's transformation into a royal residence.

RESIDENCE

After the death of Charles VI, the Louvre remained without royal tenants until 1527, when François I decided to move in. He had part of it demolished to provide more light and space. This was the first in a long series of construction projects that the building would undergo over the next 150 years.

Louis XIV vacated the Louvre to live at Versailles in 1674, and the ongoing work on the Louvre was halted. The Académie Francaise, Académie des Inscriptions et Belles-Lettres, and Académie de Royale de Peinture et Sculpture took up residence in the palace from 1692–1792. In 1699, members of the Académie Royale de Peinture et de Sculpture held their first exhibition in the Louvre's Grande Galerie.

THE BEGINNINGS OF A MUSEUM

Louis XV restarted the Louvre's construction in 1756, and in 1791, the Assemblée Nationale deemed that the Louvre and nearby Tuileries Palace would now be a national palace for the king and for the sciences and the arts. The Museum Central des Arts opened in August 1793, with free admission to all (though artists were given priority—the general public could only visit on weekends).

THE LOUVRE'S EARLY ACQUISITIONS

Once the Museum Central des Arts opened in 1793, art began to be added to what is today a 35,000-piece collection. Beginning in 1798, the Louvre acquired many treasures, including:

- Paintings and antiquities from the Vatican and Venetian republic
- Pieces from Florence and the Capitoline Museum in Rome
- Sculptures from the Musée des Monuments Français and Versailles
- Various Egyptian antiquities
- Medieval and Renaissance decorative arts

- The Musée de la Marine
- A museum of Assyrian art
- The Musée Mexicain, which included traditional crafts and folk art
- An Algerian museum
- An ethnographic museum
- The Musée des Souverains, which included treasures from France's royal dynasties
- The collection of the Marquis Campana, which included 11,385 paintings, objets d'art, sculptures, and antiquities (later becoming the Musée Napoleon III)
- Discoveries made in Iran by French archaeologist Marcel Dieulafoy
- The Musée des Arts Décoratifs
- Georges Braque's *The Birds*
- Masterpieces from Leonardo da Vinci (*Mona Lisa*), Eugène Delacroix (*July 28: Liberty Leading the People*), *Aphrodite*, the *Law Code of Hammurabi*, Michelangelo's *The Rebellious Slave*, Jean-Auguste-Dominique Ingres's *Une Odalisque*, and the *Winged Victory of Samothrace*.

THE GRAND LOUVRE

Once the Tuileries Palace was destroyed by fire in 1871 and completely demolished in 1883, what we know as the modern Louvre was born. Royals no longer resided there, and it was now solely the home to culture.

In 1926, Henri Verne, France's director of national museums, put into motion a large extension of the exhibition space. Work began in 1930 and continued through World War II.

However, World War II required that the museum's collections be evacuated in 1939. The heaviest pieces could not be removed and

were protected by sandbags. The collections were housed at the Châ-teau de Chambord in the Loire Valley at first, but were later broken up and sent off to various chateaus for safekeeping. The Louvre reopened in 1940 under the Occupation, but it was mostly empty.

Once the war was over, the expansion of the Louvre's collections continued. Various museums within the Louvre were transferred to other locations outside of the main museum, including the Musée de l'Impressionisme to what became the Musée d'Orsay.

In September 1981, President François Mitterrand announced his plan to restore the Louvre palace entirely so that it could fully function as a museum.

In 1983, the Etablissement Public du Grand Louvre took over control of the project. The Chinese-American architect I. M. Pei was commissioned to extend and modernize the Louvre. Pei was respon-sible for building the glass pyramid, which opened in 1989. It still serves as an entrance to the reception hall, where visitors can make their way to the temporary exhibition areas, Charles V's original moat, an auditorium, and public amenities.

THE GLASS PYRAMID

I. M. Pei's glass pyramid, which serves as the main entry point for the Louvre, stretches 70 feet high and 115 feet wide. It consists of 603 rhombus-shaped glass segments and seventy triangular glass segments. The pyramid and the underground lobby beneath it were planned due to the problems with the Louvre's original main entrance, which could no longer handle the growing daily crowds. Museums across the world have duplicated this concept, most nota-bly the Museum of Science and Industry in Chicago.

EL GRECO (1541–1614)

A modern artist before his time

El Greco ("The Greek") was a Cretan artist whose unusually emotional paintings and altarpieces stunned his contemporaries and forced him to forge his own path. Though he was largely unappreciated during his lifetime, his advanced use of space and color would become legendary two and a half centuries later. Established artists like Picasso would study El Greco's paintings and emulate his style. Historians still battle over the facts of his life and career, making wild speculations about his sanity, his mystical abilities, and even his vision. One thing they agree on is that El Greco provided the people of his time with a glimpse into the future of art.

EARLY LIFE

Doménikos Theotokópoulos, the artist who later signed his works "El Greco," was born on the island of Crete in 1541. Because Crete was part of the Republic of Venice at that time, El Greco leveraged his citizenship and began his artistic career studying in Venice at the tail end of the Renaissance. He was lucky enough to secure Titian, the greatest painter of his time, as his teacher. Due to this early influence, El Greco's early works echo the Venetian Renaissance values of smooth brushwork and a carefully constructed relationship between color and light.

While he exhibited the skills of the Renaissance artists who came before him, El Greco's reverence for their work had its limits. In Rome, he had boldly claimed that if Michelangelo's *Last Judgment* in the Sistine Chapel were destroyed, he would replace it with

something just as good and perhaps more Christian. He echoed the belief of religious leaders at the time, many of whom were up in arms about the orgy of naked flesh in Michelangelo's work.

Why the Name "El Greco"?

At the time Doménikos Theotokópoulos visited Italy, it was customary to identify a man by his place of origin. The artist embraced the new nickname "El Greco."

It is well documented that El Greco was in Spain in the spring of 1577 and traveled to Madrid before settling in Toledo. The reason for El Greco's move from Italy to Spain, however, is still unknown. Some speculate that his negative critique of Michelangelo had turned the public against him, prompting him to move elsewhere. Others believe that he had secured, or hoped to secure, commissioned work in Spain. A new monastery was being built near Madrid at the time, so it's possible that El Greco may have left in pursuit of the commission to help design and decorate the building.

He did secure a commission in Spain for the church of Santo Domingo el Antiguo at Toledo. In Rome he likely met many Spanish ecclesiastics, including his close friend Luis de Castilla. Luis de Castilla was instrumental in securing him this enormous undertaking at the Toledo church.

HIS WORK IN TOLEDO

El Greco spent the next two years of his life designing altar frames and adding his unique touch to the altars. His inspiration for the

altar frames most likely came from the famous Venetian architect Palladio. His painting for the high altar, *Assumption of the Virgin* (1577–1579), went beyond Venetian influence and was the first clear indication of El Greco's own style. It incorporated the highlighting techniques and brush strokes of his contemporaries, but it also presented violent contrasts in colors and a heightened dramatic tension.

In the years he spent painting *Assumption of the Virgin*, El Greco also worked on *El Espolio (The Disrobing of Christ)*, one of his greatest masterpieces. Despite its departure from most other work of its kind, the expertise of this painting was immediately apparent and still impresses today's onlookers when they see it hanging in the Toledo Cathedral. Its artfully crowded composition and dark color palette (erupting with gold and red) succeed in highlighting the suffering of the central figure of Christ. Paintings like this one did not fit neatly into any one category, but they did exhibit qualities of the Italian Mannerists (known for their lack of perspective and conflict-ridden composition) and the iconic subject matter of Byzantine art.

El Greco did not feel the need to conform to the precise style of revered Renaissance masters like Michelangelo. In fact, he seemed to want to rise above their ranks. The inspiration behind the male nude in the painting *St. Sebastian* (1577–1578) is somewhat indicative of El Greco's understanding of and competitive attitude toward Michelangelo's art. The making of a male nude demanded comparison to Michelangelo's Adam in *Last Judgment* or his sculpture, *The Genius of Victory* in the Palazzo Vecchio, Florence. The pose of Saint Sebastian himself is similar to the pose Michelangelo gave Laocoön in his sculpture in the Vatican.

LATER YEARS

Widespread acceptance did not come for El Greco during his time, though it doesn't appear to have stopped him from following his artistic instincts into wild and uncharted territory. One stylistic choice that did not sit well with his contemporaries was his manner of elongating the human form. It started with his first male nude, *St. Sebastian* in 1578, and carried over to many other paintings. His work reflected Spain's movement away from the delicate balance of Raphael and toward Mannerism.

In 1586, El Greco revealed his vaguely supernatural work of art: *The Burial of the Count de Orgaz.* Its depiction of a Toledo philanthropist being received by Jesus, Mary, and a smattering of saints into the realm of heaven is a mystical exploration of a local legend. It was well received in the 1580s and continues to be a source of inspiration for today's artists. Its style is difficult to pinpoint: While it has possible roots in Byzantine art, Renaissance works, and Mannerism, it is sheer El Greco. The use of brilliant gold and standout red, the stretched bodies of the saints, and the compact action of the scene are some of its unique successes.

El Greco contributed an impressive amount of paintings to the churches and convents of Toledo from 1590 onward. Two of his later acclaimed works were *The Opening of the Fifth Seal* (1608), which is said to have inspired Picasso's *Les Demoiselles d'Avignon,* and *View of Toledo* (1612), a rare landscape painting rife with emotion. He also worked in sculpture and architecture until his death in 1614. Today he is considered a genius whose style was centuries ahead of his time.

SALVADOR DALÍ (1904–1989)

Painting the subconscious

Salvador Dalí was the embodiment of Surrealism. His lucid and haunting imagery came to define the movement for a generation of followers and fans. His flamboyant personality helped him to gain immense fame for a wide array of work in film, writing, printmaking, sculpture, advertising, and, most of all, painting.

YOUNG DALÍ

Salvador Dalí was born in 1904 in Figueres, Spain, to Salvador Dalí Cusi, a notary, and Felipa Domènech Ferrés. Figueres, a town close to the coast and the French border, was a Catalan town with its own official language. His father's position as a notary afforded Dalí and his family a comfortable lifestyle, but his temper made for a tension-filled relationship with his son. Instead, the young boy bonded deeply with his mother. She accepted his uniqueness and encouraged his drawing from an early age.

Every summer, the family escaped to the seaside town of Cadaqués, Spain, where Dalí would paint and draw the people and scenery surrounding him. Ramon Pichot, a family friend and local painter who dabbled in the Catalan avant-garde style, took Dalí under his wing and became his mentor. Pichot was well connected in Paris and later introduced Dalí to such notable personalities as Pablo Picasso. It was Pichot who convinced Dalí's father that his son had the talent to pursue a career in painting. Thanks to Pichot's faith and

encouragement, Dalí was allowed to apply for admission at the San Fernando Academy of Art in Madrid.

A CAREER BEGINS

In Madrid in 1922, Dalí took advantage of the opportunity to experiment with and showcase his craft: He tried his hand at Cubism, Purism, and Futurism and secured two solo exhibitions and several shared exhibitions at Madrid and Barcelona galleries. He also built key relationships with fellow artists and future associates Federico García Lorca and Luis Buñuel. As a teenager, Dalí was successfully building the foundation for a long career. He had proven his technical ability to his peers in works like the incredibly realistic *Basket of Bread* (1926), but he was forever in search of a new form of art or a challenge that he could tackle head-on. He began to feel as though the Academy had nothing left to offer him. After refusing to take his final exams and stating that no teacher there was qualified to judge his work, he was expelled.

DALÍ DISCOVERS SURREALISM; SPAIN DISCOVERS DALÍ

Dalí spent some time traveling to Paris in the first few years after leaving art school. During one of these visits, he met the great Pablo Picasso. After their meeting in 1926, Picasso's influence cropped up in a number of his paintings, but it was not the only influence to show through. Dalí's art reflected a wide range of influences from the classic styling of Raphael, Vermeer, and Velázquez to the cutting-edge

philosophies of Dadaism. It wasn't until he was introduced to Surrealism by painters Joan Miró, René Magritte, and poet Paul Éluard that he found himself at home in one genre. Surrealism's break from tradition, rich imagery, and prevalent symbolism merged well with Dalí's own way of thinking and painting. It also incorporated Freudian theories, which had already captured Dalí's attention.

The year 1929 was a pivotal one for Dalí. This was the year that he met André Breton, the founder of Surrealism, and officially joined the movement. It was also the year that he met his future wife, Helena Diakonova (known as "Gala"). The fact that she was ten years older and married to the poet Paul Éluard did not stop the couple from becoming instant partners. Gala became an immensely important part of Dalí's life: She was his muse, an avid supporter of his art, and a business manager. They married in 1934 and were nearly inseparable until her death in 1982.

DALÍ'S HEYDAY

Dalí's art was already prone to the peculiar and disturbing, often showing subjects in various states of decay. In 1929, he continued along these lines working with Luis Buñuel on the films *Un Chien Andalou* (1929) and *L'Age d'or* (1930). The shockingly violent *Un Chien Andalou* (which showed a woman's eyeball being cut open by a razor) was well received and brought fame to the young artists. His primary role on the films was to serve as a scriptwriter.

Dalí's Surrealist paintings were similar in spirit: Objects dissolved, melted, or morphed into something else in unusual and haunting ways. In 1931, Dalí painted what is his most famous piece to this

day: *The Persistence of Memory*. The pocket watches in this painting melt into the landscape and are eaten by ants. The symbolism of Dalí's painting reads like Einstein's theory: *Time is fluid and relative*. Ants, along with other animals like elephants, snails, and locusts, would become recurring symbols of death and deterioration. Dalí also featured eggs as a symbol of hope and love in paintings like *The Great Masturbator* (1929) and *The Metamorphosis of Narcissus* (1937).

Despite being a fierce leader of the movement, Dalí eventually fell out of favor with Surrealist founder André Breton. While many of the Surrealists felt art could spark political change, Dalí felt the two should remain separate. For example, Dalí paid little attention to Hitler's rise to power during the early 1930s, while his contemporaries were often very vocal with their disdain for the German leader. His differences lead to him being officially expelled from the Surrealist group in 1934.

By this point, Dalí was achieving widespread fame in America. He seemed unfazed by the rejection given to him. He began to promote "paranoiac-critical method" as a method of cultivating good art. Paranoiac-critical method amounted to stirring up delusion within oneself in order to paint without interrupting the flow of the subconscious onto the canvas. The method caught on with Surrealist artists and lead to fashion, sculpture, poetry, and painting that was truly raw, personal, and uninhibited.

DALÍ'S FAME

In 1940, Dalí and his wife moved to America to escape World War II. Dalí spent eight years in the United States, where he enjoyed immense popularity thanks to his intense commercial presence and

collaboration with celebrities like Walt Disney in the film *Destino* (for which he provided storyboards and artwork) and Alfred Hitchcock in the film *Spellbound* (for which Dalí designed a dream sequence). His art during this time grew more classical and religious in nature. When he and Gala returned to Spain, his style continued to evolve, merging with new and unusual media like holography.

In 1989, after a long and celebrated career, Salvador Dalí died of heart failure in his hometown of Figueres, Spain. He left behind two museums in his honor: The Salvador Dalí Museum in St. Petersburg, Florida, and his own Dalí Theatre-Museum in Figueres.

The Unstoppable Dalí

"At the age of six I wanted to be a cook. At seven I wanted to be Napoleon. And my ambition has been growing steadily ever since."—Salvador Dalí

THE MET

A new home for world art

The Metropolitan Museum of Art, also known as the Met, is America's world-renowned center of art. Though its history is short in comparison to museums of similar stature throughout the world, it has caught up quickly in terms of its holdings. The ever-expanding New York City landmark now houses more than 2 million works of art, including vast collections of drawings, photos, paintings, musical instruments, costumes, armor, and cultural artifacts. Each year it brings the experience of art and art history to about 5 million visitors.

THE HISTORY OF THE MET

The idea to build a national gallery of art in America was conceived in Paris by a group of Americans in 1886. Upon his return to the United States, a man named John Jay stayed true to the group's mission. Jay was a well-connected lawyer who immediately went to work enlisting the help of civic leaders, businessmen, artists, and philanthropists to make this idea of a national gallery a reality. In 1872, he reached his goal: The brand-new Metropolitan Museum of Art opened its doors to the public. Its first location in the Dodworth Building at 681 Fifth Avenue provided city residents and visitors from afar access to its treasures: more than 170 European paintings. That number would grow exponentially over the next eight years and warrant a change in location.

The First Acquisition

On November 20, 1872, the Met eagerly accepted its first object: a Roman marble sarcophagus. J. Abdo Debbas, the American vice consul at Tarsus (a city in what's now Turkey), gave the ancient coffin to the museum as a gift and got the ball rolling.

The Met moved briefly to the Douglas Mansion in 1880 before finding its current home on Fifth Avenue and Eighty-Second Street. The building on Fifth Avenue was designed by architects Calvert Vaux and Jacob Wrey Mould. Expansions were added starting in 1888 and continued with the latest addition built in 1991.

By the twentieth century, the world knew the Met as a premiere cultural establishment. A painting by Pierre-Auguste Renoir and another by Henri Matisse placed the museum in high regard in terms of acquisitions. This pattern of success helped to solidify the Met's status as a world leader in the collection of, among many other things, European paintings.

Today, the Metropolitan Museum of Art takes up 2 million square feet of precious real estate in New York City, making it one of the largest museums in the world. In addition, there is now a small, separate building of the Met called "The Cloisters," showcasing medieval art.

MOST NOTABLE COLLECTIONS

The Metropolitan Museum of Art now hosts about seventeen permanent collections, each with its own department of curators. The art

on display spans the globe and represents a variety of key locations, including:

- American art
- European art
- Ancient Egyptian art
- African art
- Asian art
- Oceanic art
- Byzantine art
- Islamic art

Egyptian Art

Among the Met's most highly regarded collections is its incredible display of Egyptian art. The collection was started around 1906, when public interest in ancient Egypt spiked. The museum sponsored a series of archaeological excavations over the next thirty-five years that unearthed about half of the items in today's collection. Today the ancient Egyptian art collection includes more than 30,000 objects, almost all of which are kept out on display. Thirteen of the many Egyptian mummy cases on display at the Met have bodies inside. Twelve of the bodies are adults; one is a child.

More than thirty-two major galleries and eight study galleries are filled with a vast collection of Egyptian art arranged chronologically from the Paleolithic to the Roman period. The Temple of Dendur, a gift from the Egyptian government in 1965, is perhaps the most remarkable feature of the collection, attracting visitors from all over the world. The temple was built by the Roman emperor Augustus in 15 B.C. in honor of the goddess Isis and the sons of a famed Nubian warrior who came to the aid of the Romans.

European Painting

The Met's collection of European painting is equally impressive, starting with its valuable Vermeers: Five of the approximately thirty existing Johannes Vermeer paintings are now housed at the Met. Its first big acquisition of 170 European paintings in 1870 has since expanded to include roughly 2,500 stunning works of art, making the collection world-class. It represents the work of nearly every European master, including Gauguin, Giotto, Rembrandt, El Greco, Goya, Corot, Courbet, Degas, Cézanne, Manet, Monet, and Van Gogh.

Six centuries of artistic movements and styles are documented in the European paintings department. Masterpieces of note include *Cypresses* by Vincent van Gogh (1889), *Juan De Pareja* by Diego Velázquez (1650), *The Harvesters* by Pieter Bruegel, *Young Woman with a Water Pitcher* by Vermeer (1662), and *Rouen Cathedral: The Portal (Sunlight)* by Monet (1894).

Other major collections belonging to the Museum include an impressive sampling of American art as well as Ancient Near Eastern art, Greek and Roman art, medieval art, modern and contemporary art, arms and armor, costumes, drawings and prints, musical instruments, photographs, and the Robert Lehman Collection (an astounding private collection displayed in a re-creation of the Lehman family residence). For more than a century, the Met has educated and inspired millions of people, accomplishing and surpassing its original goal to bring art to America.

SURREALISM

From a manifesto to a movement

Surrealism was an artistic and intellectual avant-garde movement
that can be traced back to André Breton's 1924 Manifesto of Sur-
realism. Breton's new movement celebrated the imaginary world
of the unconscious and became both a way of thinking as well as
an artistic practice. Surrealism spurned predictable logic and what
Breton called "the realist attitude." Instead, his movement embraced
the dreamlike moments that went against a pre-established reality.

DEFINING A MOVEMENT

The Surrealist movement officially began after Breton outlined the
major concepts of the movement in his 1924 Manifesto. At its core, the
movement sought to do away with common perceptions of reality and
how reality pertained to art. For the Surrealists, one's preconceived
notions of the familiar merely got in the way. To truly appreciate art, one
had to essentially throw everything he thought he knew out the window.

For example, in the Surrealist painter René Magritte's work enti-
tled *The Treachery of Images* (1927–1928), he presented an image of
what clearly looked like a pipe with the words "this is not a pipe" writ-
ten underneath. Clearly, it *was* a pipe, but as Magritte would later say,
"And yet, could you stuff my pipe? No, it's just a representation, is it
not? So if I had written on my picture 'This is a pipe,' I'd have been
lying!" Magritte, like other Surrealists, often incorporated startling
juxtapositions of seemingly disparate elements in order to generate
multiple, oftentimes ambiguous, meanings.

SURREALISM SPREADS AND DIVIDES

Throughout the 1930s, Surrealism's notoriety as an art form began to spread across Europe and became visible to a wider audience. Surrealist landscape paintings such as René Magritte's *Voice of Space* (1931) and Salvador Dalí's *The Persistence of Memory* (1931) made Surrealism recognizable. In 1936, both London and New York hosted international Surrealist exhibitions. In 1937, in homage to its vast influence or perhaps as a joke, Max Ernst finished his painting *The Triumph of Surrealism*. In 1938, the Galerie Beaux-Arts in Paris gathered 300 Surrealist paintings, objects, collages, photographs, and installations made by more than sixty artists from different countries. However, despite this outward success, there were inward divisions within the movement.

André Breton was known to be dogmatic in approach and was often prone to exclusionary tendencies. The results of such authoritarianism erupted into a series of internal disputes and eventual splits within the group. Louis Aragon, who had collaborated with Breton during the early years of his rise to social and intellectual prominence, began to move away from Surrealism. Wanting a more politically motivated art form, in the 1930s he became an active member of the French Communist Party and, along with other former Surrealists, founded the Association of Revolutionary Writers and Artists in 1932. Another close collaborator, the poet Paul Éluard, remained tied to the group until the early 1940s when he also left to join the French Communist Party.

Georges Bataille, having accused the Surrealists of possessing an "Icarian complex" that placed too much emphasis on the desire to soar rather than confront the base matter below, wished to break away completely from Surrealism's strict reliance on the opposition between high and low. Bataille's thinking would become known as base materialism.

Another well-known figure who moved away from Surrealism was the Swiss sculptor Alberto Giacometti. While he wouldn't officially break with Surrealism until after World War II, in the mid-1930s, his art was already moving away from the Surrealist-derived imagery of dream and its abstract forms. Instead, his works were becoming more attached to figurative representations. His elongation of the figure to the point of near nonexistence, what was to become known as *bare realism*, became emblematic of this shift in Giacometti's artistic practice.

After Surrealism's peak of popularity in the 1930s, with the arrival of war, artistic and intellectual production was overshadowed by the demands of wartime. In the post-war period, with the rise of new European and American artistic forms and intellectual currents, Surrealism as an organized movement continued to wane. With the death of Breton in 1966, a certain era of Surrealism had in fact come to a close. However, it continued to have significant influence for artistic groups of the 1950s, '60s, and '70s such as the Situationist International, and particular artists such as Louise Bourgeois.

Similarly, as women were often viewed as the psychic representative of the irrational, they were frequently depicted in relation to the disturbing power the subconscious could have over ordinary things, the "dark" side of the subconscious. However, within the Surrealists' battle against the social institutions of the church, state, and family, for some Surrealist women artists such as Frida Kahlo or Claude Cahun, Surrealism was seen as a way out of the inhibiting confines of middle-class marriage, domesticity, and motherhood. Through their art, it was also possible for them to create more autonomous self-representations. Surrealism became the first Modernist movement in which a group of female artists could explore female subjectivity and give form to a feminine imagery.

PUBLIC ART

Art for the masses

Some art is best viewed in a quiet museum gallery, but there are certain pieces that simply demand to be out in the open. They can range from modest spontaneous sidewalk chalk drawings to massive outdoor sculptures hundreds of feet long. Unlike its museum counterparts, this particular brand of art is meant to be much less a personal encounter and more of a group experience.

EARLY FORM AND SPACES

The earliest form of officially recognized public artwork consists of monuments, memorials, and historical landmarks. It could also be said that architecture or architectural sculpture itself is more widespread and equally fulfills the definition of public art. Today, the term "public art" refers to any type of artwork that has been placed, staged, or created within the public sphere, accessible to anyone, and typically installed outside. "Public art" is now used as an umbrella term that can include any work of art purchased by public funds, or located in the public sphere. This range includes site-specific public art, public art murals, environmental art, interactive art, and participatory art.

The term "public art" first became popular in the 1960s and was used to describe a movement when Modernist sculptors from Europe, Asia, and America began creating enlarged versions of their sculptures and placing them in the public domain—displaying their pieces outside of a traditional, institutionalized environment (i.e., a museum or gallery).

FUNDING PIECES AND PEOPLE

Some of the earliest artists to lead the public art movement were Isamu Noguchi, Henry Moore, and Alexander Calder—all well-established Modernist sculptors. The earliest examples of public art were centrally associated with their individual style and aesthetic—leaving little to no consideration of the actual space, locality, and surrounding community. The core examples of the first "art-in-public-places" or "public art" are *Red Cube* (1968) by Noguchi, *La Grande Vitesse* (1967) by Calder, and *UNESCO Reclining Figure* (1957–1958) by Moore. These pieces were all large, abstract, and placed within urban environments.

In the early 1970s, there was a drastic shift in the style of public art when the NEA (National Education Association) and GSA (General Services Association) began funding the artists' efforts. Once this movement gained public funding and visibility, it was only natural that the general public became aware of the physical and environmental implications each piece possessed. Because these public artworks were placed in urban environments, the artists were soon forced to consider the work's environment, setting, and community's participation. By the early 1970s, artists from all over the world with various styles and backgrounds had begun contributing to the world of public art, such as Niki de Saint Phalle, Richard Serra, Nancy Holt, Maya Lin, Christo and Jean-Claude, Robert Smithson, and more.

The Saga of the *Tilted Arc*

In 1981, artist Richard Serra installed his sculpture *Tilted Arc* in Federal Plaza in New York, New York. His piece was commissioned by the Arts-in-Architecture program of the GSA (General Services Administration). *Tilted Arc* was a curving wall of heavy steel, 120 feet long and 12 feet in height—it carved the space of

the Federal Plaza right in half. The public working in this environment had to walk through a bulk of the obstructed plaza to access their building. The *Tilted Arc* generated a large amount of controversy, causing the regional administrator of the GSA to hold a public hearing about its eventual relocation. Richard Serra testified that the sculpture is intentionally site specific, and that removing it from its location would destroy all meaning. Serra's appeal failed, and on March 15, 1989, the *Tilted Arc* was removed from Federal Plaza and the metal sent to a nearby scrap yard.

PLACES AND SPACES

The typical space used for a public art project can be a city square, plaza, or pedestrian area, as well as a public building, municipal office and transport center, museum, airport, library, college campus, and more. Some participatory or public-involved artworks could be held during a rally, or gathering, and environmental art (earthworks) may be located in remote or secluded areas. There are also public art collections, commissioned by institutions or universities—one of the largest collections being housed at the Massachusetts Institute of Technology, with more than fifty pieces of public art on display across the campus. The locations and spaces of what we now call "public art" can be in any environment—so long as they are built, housed, or situated within the public sphere, accessible to everyone.

CONTEMPORARY PUBLIC ART

Since the 1990s, public art has paved the way for new practices and alternative definitions, some practices becoming more specific

(participatory art, community-based art, relational art, activist art), and others, more comprehensive, such as New Genre Art and Anti-Monument Art.

The leaders of the Anti-Monument Art movement were Jenny Holtzer, Maya Lin, Alfredo Jaar, and Félix González-Torres. Their main goals were to recontextualize both the traditional and nontraditional field of public art—showcasing and making visible issues of public concern in the public sphere. One example is Felix González-Torres's *Untitled* billboard pieces distributed throughout New York City in 1991. The image was a photograph of an unoccupied bed, taken after the death of his longtime partner, Ross Laycock, from AIDS. In an interview, González-Torres stated "When people ask me, 'Who is your public?' I say honestly, without skipping a beat, 'Ross.' The public was Ross. The rest of the people just come to the work."

Public art can represent multiple cultures, communities, and spaces, and one trend is universal about all of these variations—they will never stop changing, morphing, or influencing the spaces that we inhabit, live in, and experience as part of the public sphere.

PABLO PICASSO (1881–1973)

An artist of many mediums, periods, and mistresses

Pablo Picasso was one of the most influential artists of the twentieth century. He worked in a wide variety of mediums, including painting, sculpting, printmaking, ceramics, and stage designing. Picasso is probably best known for his involvement in the creation of the Cubist movement, but he was also at the forefront of two other artistic innovations: He invented constructed sculpture and, with the help of Georges Braque, conceived modern collage in 1912.

EARLY LIFE

Pablo Ruiz y Picasso was born in 1881 in Málaga, Spain, as the first child of a middle-class family headed by Don José Ruiz y Blasco, an undistinguished painter and art teacher, and María Picasso y López. Having showed extraordinary artistic talent from an early age, he was formally trained by his father in figure drawing and oil painting starting at the age of seven. Much of the education Picasso received from his father was rooted in tradition and academia and involved emulating the masters and drawing from live models. Still, Picasso became entrenched in his artwork, and his other studies suffered for it.

In 1891, his father took a job as a professor at the School of Fine Arts in A Coruña, and the family moved there for about four years. It is rumored that during that time Picasso's father swore to give up painting after seeing his son's unfinished but technically proficient sketch of a pigeon, but later paintings of his do exist. In 1895, Picasso's younger sister Conchita died of diphtheria, and the family

moved to Barcelona, where Ruiz was hired at its School of Fine Arts. After completing an entrance exam for the advanced class, Picasso was accepted at the academy at age thirteen.

At the age of sixteen, Picasso left Barcelona to attend the prestigious San Fernando Royal Academy of Fine Arts in Madrid, but the change of scenery didn't make him a better student. He stopped going to classes soon after enrollment, but he took advantage of what Madrid had to offer him as a budding artist. He made frequent trips to the Prado to see paintings by Velázquez, Goya, Zurbarán, and El Greco, the last of whose influence is apparent in Picasso's later work.

THE ARTISTIC PROGRESSION OF PICASSO

By 1893, Picasso had established a convincing artistic voice in his paintings, and by the following year he had truly begun his career as a painter. In the mid-1890s he practiced academic realism as evidenced by *The First Communion* (1896) and *Portrait of Aunt Pepa* (1897), but later in 1897 Symbolist influences crept into his realism, and he started using non-naturalistic tones (colors not normally seen in nature) in his works. The years 1899 and 1900 are considered his Modernist period by some, during which he combined exposure to the work of Rossetti, Steinlen, Toulouse-Lautrec, and Edvard Munch, enduring enthusiasm for old masters like El Greco, and his own perspective.

In 1900, Picasso made his maiden voyage to Paris, where he befriended and moved in with French poet and painter Max Jacob. Neither had any money, and this period was marked by cold and poverty; Picasso was forced to burn many of his paintings just to keep warm.

The Blue Period

Around 1901, Picasso entered his Blue period, which lasted until about 1904. The paintings he made during this time were gloomy in tone, both literally and figuratively. He used, for the most part, shades of blue and blue-green, and the subject matter was quite morose. He often painted prostitutes, beggars, and thin mothers with their children. Blindness was also a recurring theme throughout this period. One of his paintings from this era, *La Vie* (1903), was inspired by the suicide of his friend Carlos Casagemas.

Rose Period

Picasso's Rose period (1904–1906), on the other hand, was much more cheerful in color and content. He painted circus performers, acrobats, and harlequins, the last of which would become a personal symbol for Picasso, in orange and pink hues. The change in timbre reflects Picasso's happy relationship with art model Fernande Olivier, which began in Paris in 1904, as well as his increased familiarity with French painting.

African-Influenced Period

Picasso's African-influenced period began in 1907 and lasted until about 1909. One of his most famous paintings, *Les Demoiselles d'Avignon*, dates from this period, during which the artist formulated ideas that would segue into Cubism.

Cubism

Together with Georges Braque, Picasso developed Analytic Cubism in 1909. This period was marked by a monochromatic, neutral palette. Both artists utilized shapes, like the cube, to represent— or "analyze"—various objects. In 1912, cut paper fragments were

introduced into compositions, and thus Synthetic Cubism, which dominated Picasso's work until 1919, was born.

PERSONAL LIFE

Over the course of his life, Picasso was married twice, had four children by three women, and maintained a bevy of mistresses. In 1904, Picasso took Fernande Olivier, a bohemian artist, as his mistress, but he later left her for Marcelle Humbert, whom he called Eva Gouel. His love for Gouel is featured prominently in many Cubist works, and when she died in 1915 at the age of thirty, Picasso was devastated.

In 1918, Picasso married Olga Khokhlova, a ballerina, and the two had a son, Paulo. The marriage was fraught with financial problems, however—Khokhlova preferring high society to Picasso's bohemian lifestyle—and in 1927 he began an affair with a very young Marie-Thérèse Walter. Although he separated from Khokhlova shortly after beginning his affair with Walter, Picasso remained legally married to Khokhlova until her death in 1955. Picasso continued his relationship with Marie-Thérèse Walter and even fathered a daughter named Maya with her, but they never married. In 1961 he married his second wife, Jacqueline Roque whom he had met in 1953 at the Madoura Pottery in Vallauris, France, while he was still married to Khokhlova. The two remained married until his death in 1973.

MODERN ART
The death of traditional artistic convention

Modern art encompasses a wide range of artworks, including painting, sculpture, architecture, and graphic arts, produced mainly in the twentieth and twenty-first centuries, as well as in the later part of the nineteenth century. The fundamental goal behind the movement is to break with past traditions, and generally accepted historical and academic forms, in a spirit of experimentation. As such, the term extends to an eclectic assortment of movements, theories, and attitudes whose Modernism can be identified primarily through its penchant for questioning convention.

ORIGINS OF MODERN ART IN THE NINETEENTH CENTURY

The birthdate of modern art is widely disputed. Some say it arrived as early as 1784, which is the year that Jacques-Louis David completed his painting *The Oath of the Horatii*. More often than not, though, its beginnings are placed in the latter half of nineteenth-century France. There are two significant paintings from this era: *The Artist's Studio*, which Gustave Courbet showed in 1855, and *Le déjeuner sur l'herbe (The Luncheon on the Grass)*, which Édouard Manet exhibited at Paris's 1863 Salon des Refusés. It's difficult to pin down a particular point in time because, while all three of these paintings show characteristics of Modernism, modern art didn't simply materialize overnight. The change took place gradually over a period of about a hundred years.

Whatever the case, it's apparent that the paintings of Courbet, Manet, and other Impressionists, as well as the works of the Romantics and Realists, rebelled against the deeply ingrained and largely unchallenged academic traditions that had dominated the art world and paved the way for their Post-Impressionist and Symbolist successors. These heirs of the artistic revolution rejected long-established techniques and subjects and shifted toward the expression of a more personalized view.

Of the miscellaneous movements to come out of this cultural metamorphosis starting in the 1890s, including Neo-Impressionism, Symbolism, Fauvism, Cubism, Futurism, Expressionism, Constructivism, Metaphysical painting, De Stijl, Dadaism, Surrealism, Social Realism, Abstract Expressionism, Pop art, Op art, and Neo-Expressionism, many represent a zenith of Western art. Although extremely varied in scope, the inherent Modernism of these movements is marked by the way they explore the possibilities within the medium of painting.

Most of the successful artists of the time were bound to tradition to satisfy the taste of their benefactors. They made a living mostly by pandering to the people behind the commissions and government-sponsored public exhibitions, who preferred the historically limited creative palate of the time, which leaned toward conservative academic art. The Realists, however, took a stand against the idealism that dominated the prevailing style of art. Instead, they sought a realistic portrayal of everyday life, and were influenced, for example, by Eastern decorative arts like Japanese printmaking.

The Impressionists followed suit by moving from the studio to painting outdoors, or en plein air, which was seen as a risky move at the time. The young artists behind the shift toward natural light were also intrepid in their exhibition techniques: The group mounted a series of independent art shows. As word spread to different countries, artists from outside of France began to adopt the Impressionist

style, and a movement was born. It was the first of many movements to emerge in modern art.

Origins of Modernism

The seeds for such a change were originally planted during the Enlightenment, when people turned their focus inward to examine their own personal plights. In fact, modern art critic Clement Greenberg considers Immanuel Kant, an eighteenth-century German philosopher, "the first real Modernist." It is said that the Enlightenment criticized from the outside, but that Modernism criticizes from the inside. Another important event that served as a catalyst for Modernism was the French Revolution of 1789, which was a period of radical social and political upheaval in France. As the public began to question the status quo, suddenly institutions that had remained unopposed for centuries were met with criticism, open discussion ensued, and a sense of self-consciousness erupted throughout the nation.

MODERN ART IN THE EARLY TWENTIETH CENTURY

A number of Post-Impressionist movements born in the first decade of the twentieth century—including Fauvism, Cubism, Expressionism, and Futurism—were considered part of Modernism, but many more followed. The nascent stages of Surrealism, for example, took root right before the start of World War I, when Italian artist Giorgio de Chirico moved to Paris in the summer of 1911. He exhibited several of his dreamlike works, such as his famous *Song of Love* (1914), at various salons in the city over the next few years, and influenced artists like Pablo Picasso and Guillaume Apollinaire. Although the Surrealist movement wouldn't be officially founded by André Breton

until 1924, a full ten years later, Chirico's otherworldly images laid the foundation for others to follow. Meanwhile, modern art debuted across the Atlantic at the 1913 Armory Show in New York City. Many of these movements ceased upon the outbreak of World War I, but others began, such as anti-art movements like Dadaism and others touted by artists like Marcel Duchamp.

MODERN ART AFTER WORLD WAR II

When World War II ended, the epicenter of avant-garde art eventually shifted from Europe to the United States. In 1950s and 1960s America, modern art movements abounded, including Abstract Expressionism, Pop art, Op art, Minimal art, Lyrical Abstraction, Post-Minimalism, Photorealism, and more. The late 1960s and the 1970s saw the arrival of forms like land art (the use of nature as both a canvas and a medium), performance art, conceptual art, and other experimental art movements, but the end of the 1970s heralded what critic Douglas Crimp called "the end of painting." In its stead cropped up a host of new media arts inspired by technology, such as video art.

Still, painting enjoyed a renaissance in the 1980s and 1990s, especially with the rise of Neo-Expressionism. Meanwhile, the advent of photography played an important role in the development of modern art, in that it provided artists with another way to reproduce the physical world: mechanical as opposed to manual. Abstract art, whose followers cared little about reproducing its subject in any immediately recognizable way, also took root in the twentieth century. Then, toward the turn of the century, artists and architects alike began questioning the notion of Modernism, and Post-Modernism was born.

ABSTRACT ART

Moving away from visible reality

Until the mid-nineteenth century, nearly all Western art produced could be linked by a common effort to re-create visible reality. Abstract art, however, severed that overarching sentiment by refusing to represent reality and instead exploring the relationship between forms and colors with little concern for creating a recognizable image.

MAIN THEMES OF ABSTRACT ART

The main themes regarding abstraction include the transcendental, the contemplative, and the timeless. Many abstract artists felt that, through their work, they could transcend normal human experience and express themselves on an almost "divine" level (although not necessarily religious). Others felt that the most important role of artwork was to allow the viewer to interact with it on a personal level and retreat into their own contemplative subconscious. Lastly, many abstract artists took pride in the timeless nature of their work, due to its general lack of easily identifiable subject matter or cultural frame of reference.

ABSTRACT ART IN THE NINETEENTH AND TWENTIETH CENTURIES

Three main art movements—Romanticism, Impressionism, and Expressionism—and several other secondary movements directly contributed to the development of abstract art. This shift was due in

part to a newfound financial independence that artists enjoyed in the nineteenth century. Previously, many artists made a living through work commissioned by the church, but a shift toward private patronage made it possible for painters and other artists to experiment more, especially outside of the bounds of religious representation.

Romanticism

The age of Romanticism set the wheels for change in motion. Although the movement, which stemmed from opposition to the aristocratic stronghold in the later eighteenth century, encompassed literary and intellectual angles as well, the visual arts component specifically rebelled against the neoclassicism that had long dominated the art community. It first appeared in landscape paintings of the era, which often took on an almost mystical feel. Still, most Romantics didn't stray too far from the plane of strict visual interpretation.

Regression to Ancient Ways

Abstract art shares quite a bit in common with art from long ago. Some examples include rock paintings, as well as signs and marks on pottery and textiles. Whether they were made for symbolic or ornamental purposes, the basic geometric forms that dominated the art of ancient cultures suggest that all art needn't replicate the physical world exactly in order to communicate meaning.

Impressionism

One of the first movements to truly diverge from pure realism was Impressionism, which focused on the artist's interpretation of the world rather than a meticulous representation of it. Even though

the brushstrokes were messier, Impressionists carefully analyzed the effects of color and light in nature and tried to reproduce them faithfully. Thus, while Impressionists helped pave the way for Abstract art, a movement started in Germany at the beginning of the twentieth century dubbed Expressionism, took this idea a step further by evoking the artist's own temperament in his work.

Expressionism

Expressionist artists imbued their paintings with an emotional or spiritual vision, and in so doing prioritized psychological states over subject matter. Expressionists employed radical distortion and exaggeration and utilized intense, often arbitrary color and jarring compositions to subjectively express the experience. Many Expressionists were reacting to Impressionism and traditional trends of late nineteenth-century painting. In addition to visual arts, Expressionism encompassed dance, sculpture, cinema, literature, music, and architecture.

Post-Impressionism and the Fauves

Post-Impressionism had a significant impact on twentieth-century abstraction. Painters like Paul Gauguin, Georges Seurat, Vincent van Gogh, and Paul Cézanne, for example, had an enormous influence on the development of modern art. Later, Henri Matisse and his contemporaries took the Paris art world by storm with wild paintings marked by bold forms and vivid colors that were considered Fauvist by the critics. Matisse approaches pure abstraction in three paintings: *French Window at Collioure* (1914), *View of Notre-Dame* (1914), and *The Yellow Curtain* (1915). The crude color language used by the Fauves also made a big impact on another contemporary abstract artist, Wassily Kandinsky.

Cubism

The twentieth-century art movement most directly linked to abstraction, however, was Cubism. Picasso played an integral role in the Cubist movement, beginning with his first painting, which reduced the physical realm to three solids suggested by Cézanne: cube, sphere, and cone. Cubism then went through various incarnations, including Analytic Cubism and Synthetic Cubism, some of which led to the creation of the Dada movement.

Futurism

In 1909, the Italian poet Marinetti published *The Founding and Manifesto of Futurism*. Futurism, which admired speed, technology, youth, and violence, led to a more intense version of abstraction and profoundly influenced art movements all over Europe.

ABSTRACT ART IN THE TWENTY-FIRST CENTURY

Many believe that pluralism—the idea that no one style best represents the artistic zeitgeist—dominates the beginning of the twenty-first century. The "anything goes" attitude allows artists to encompass a wide variety of mediums and aesthetic dispositions, and many have branched into various types of digital and computer-based art, as well as appropriation, collage, photorealism, and more.

REMBRANDT (1606–1669)

The most important artist in Dutch history

Rembrandt's paintings and prints made him one of the most respected artists in European art history and the most important in Dutch art history. He produced art primarily during the Dutch Golden Age, which was a period of economic prosperity and cultural success. A good portion of painting produced during the Dutch Golden Age, which contrasted significantly from the Baroque style that monopolized the rest of Europe, was creatively fertile as well as abundant.

EARLY LIFE

Rembrandt Harmenszoon van Rijn was born in 1606 in Leiden, a city in what it known as the Netherlands today, but back then was part of the Dutch Republic. His large, affluent family was headed by Harmen Gerritszoon van Rijn, a miller who belonged to the Dutch Reformed Church, and Neeltgen Willemsdochter van Zuytbrouck, the Roman Catholic daughter of a baker. Religion played a large role in his works, and many of his paintings reveal his Christian faith.

After attending elementary school from roughly 1612 to 1616, Rembrandt attended the Latin School in Leiden for perhaps the next four years, where his education centered around biblical studies and classics. It's unclear whether or not Rembrandt completed his studies at the Latin School. In any case, he enrolled at the University of Leiden in 1620, but his proclivity toward painting led him away from university, and he began a series of apprenticeships.

The first was with Leiden-based history painter Jacob van Swanenburgh, with whom he spent three years. The second took him to Amsterdam, where he studied under another history painter, Pieter Lastman, for six months. Rembrandt also apprenticed with Jacob Pynas in Amsterdam for a few months before starting his own workshop. Sometime between 1624 and 1625 Rembrandt opened a studio in his hometown with friend and colleague Jan Lievens, and in 1627 Rembrandt began accepting students.

THE BEGINNINGS OF A CAREER

In 1629, Dutch Golden Age poet and composer Constantijn Huygens discovered Rembrandt and procured commissions for the artist from the court of the Hague. One of Rembrandt's most lucrative and steady commissions—from Prince Frederik Hendrik, who purchased paintings from Rembrandt until 1646—resulted from this liaison.

In 1631, Rembrandt permanently relocated to Amsterdam, where he became a successful professional portraitist. Upon his move, he stayed with art dealer Hendrick van Uylenburgh, and in 1634 he married Hendrick's cousin, Saskia van Uylenburgh, and began teaching a number of art students. In 1639, Rembrandt and his wife moved into a new house in an up-and-coming area with a growing Jewish population. This house is now the Rembrandt House Museum in the Jodenbreestraat district.

Rembrandt was making a sizeable income, but because he lived beyond his means, the mortgage he and his wife took out to buy the house caused major financial difficulties down the road. Adding to their financial troubles, several tragedies befell the couple. Their first three children—Rumbartus, born in 1635; Cornelia, born in 1638;

and another Cornelia, born in 1640—died in infancy. Titus, born in 1641, was the only child who survived past infancy and into adulthood, but Saskia didn't live long after his birth. She died in 1642, at the age of twenty-nine. The cause of death was likely tuberculosis, and Rembrandt produced many moving works of her on her sickbed.

While Saskia was ill, Geertje Dircx was hired as Titus's caretaker and nurse. She also became Rembrandt's lover and expected him to marry her. When he failed to do so, she charged him with breach of promise, and Rembrandt tried to have her committed to an insane asylum. In the late 1640s, Rembrandt took a very young Hendrickje Stoffels, who had initially been his maid, as his mistress, and in 1654 they had a daughter. Although they never officially married, the two were considered legally wed under common law.

Rembrandt's frivolous spending habits—on art, prints, and rarities which exceeded his income—finally caught up with him in 1656, when he required a court arrangement to escape bankruptcy. He sold the majority of his collection of paintings and antiquities, as well as his house and printing press. In 1660, he moved to a smaller house on the Rozengracht. Most of the officials involved were fairly obliging, save the Amsterdam painters' guild. They attempted to bar him from getting paid for painting, but his mistress and son set up an art-dealing business in 1660 and hired Rembrandt as an employee in order to circumvent the issue.

In 1661, that very business—with Rembrandt at the helm, of course—was commissioned to paint the city hall, and the artist accepted his final apprentice, Aert de Gelder. Hendrickje died in 1663, Titus died in 1668, and Rembrandt died in 1669 in Amsterdam, where he was laid to rest in an unmarked grave.

REMBRANDT'S SUBJECTS AND STYLES

Rembrandt's primary subjects throughout his life included portraiture, landscape painting, and narrative painting. He was especially lauded for his narratives, particularly those paintings that depicted biblical scenes. His contemporaries found his representation of emotion and attention to detail impressive. Some of his most famous paintings include *The Night Watch* (1642), *Christ in the Storm* (1633; this was the one stolen from the Isabella Stewart Gardner Museum in Boston in 1990), and *The Return of the Prodigal Son* (1669).

Although he painted in a mostly smooth fashion early on he later adopted a rough, textured style. A similar progression occurred in his printmaking as well. Starting in the late 1640s, he began to experiment much more in both style and technique.

What's in a Name?

Rembrandt's given name was—and still is—quite uncommon, and the way in which he signed his name on his work evolved throughout his career as an artist. In his earlier years, he signed his work only with the monogram *RH* (Rembrant Harmenszoon, "son of Harmen"); then, from around 1626, with *RHL*; and in 1632, with *RHL van Rijn*. It wasn't until age twenty-six that he began to sign his work with his first name only. He first spelled it *Rembrant,* but as of 1633 until his death, he spelled his name *Rembrandt*. Some hypothesize that he decided to go by one name because he thought his work was on par with that of other great artists, such as Michelangelo, Titian, and Raphael, who had done the same.

PAUL GAUGUIN (1848–1903)

The primitive European

Paul Gauguin was a French painter dissatisfied and purposefully dissociated with 1800s European culture. Beginning with his Peruvian ancestry—his mother was Aline Maria Chazal of the powerful Tristán family—Gauguin was drawn to exotic cultures. He lived his early years in Paris, with the exception of four years as a young boy in Lima with his mother, learning Spanish as his first language and preferring it as an adult. When he turned seventeen, in 1865, he once again ventured beyond France as a pilot's assistant in the merchant marine and then as a member of the navy. After ensuing careers as a stockbroker and salesman, he transitioned from painting recreationally to committing to be a full-time painter, ending ties with his family and eventually leaving Europe altogether to do so.

BREAKING AWAY

When his nomadic lifestyle with the navy came to an end, Gauguin returned to Paris and married a Danish woman, Mette-Sophie Gad. Because Gauguin's father had died when he was a child, his guardian was a wealthy Spanish financier and art collector who arranged a job for him as a stockbroker. The stock market crashed, however, in 1882, and Gauguin seized the moment to paint full-time, a recreational hobby he had taken up in 1873. Gauguin's family grew to five children, causing financial and emotional strain that led the family to relocate to Denmark, as his wife had a teaching opportunity there. Gauguin became increasingly unhappy and was convinced that his

family was holding him back from his artistic calling. Within the same year, he moved back to Paris, leaving his family behind.

IN SEARCH OF RELIEF

Gauguin struggled both practically and emotionally to immerse himself in the Parisian art world. Poor sales of his own paintings created financial troubles for the painter and forced Gauguin to sell off much of his personal art collection. He also received scorn for abandoning his marriage and found little support. His depression grew severe while his defiance magnified, and he traveled to Brittany, Panama, and Martinique in the late 1880s in search of pure inspiration freed from Europe's societal influence. In Martinique, Gauguin absorbed himself in a primitive lifestyle, living with painter Charles Laval in a hut among the locals. Fever and dysentery ultimately brought him back to France.

Returning to Pont-Aven, an artist commune in Brittany, Gauguin was able to expand upon his cultural inclinations. Those at Pont-Aven were showing much interest at the time with Japonism, or the adoption of Japanese techniques and aesthetic. Use of woodblocks to produce prints created much different imagery than that of the Impressionist paintings in vogue at the time: Japanese prints contained large, flat areas of strong color with lines and patterns that lacked perspective. Together with fellow *Pontaveniste* Émile Bernard, Gauguin expanded on the Japonist style, evolving it into Synthetism, a play on what he considered "synthetic symbolism." Synthetism emphasized bold use of line, color, and form in painting and celebrated how these aspects collaboratively imbue emotion and meaning into a composition.

SEEKING PARADISE IN TAHITI

In 1891, Gauguin moved to Papeete, Tahiti, in hopes of freeing himself from the French world, although the French colonization there dampened his perceptions of an exotic paradise. Gauguin nevertheless identified himself as different from Westerners and was fascinated by the Tahitian natives. An air of scandal was brought about him, as rumors surfaced that the young Tahitian girls he used as artistic subjects were in fact sexually involved with the painter. He also was said to have mythicized and even plagiarized his experiences in Tahiti in the book about his life there, *Noa Noa*, which he published.

Regardless of the controversy, his time in Tahiti was highly successful in producing a collection of artwork. He titled many of his paintings in Reo Ma'ohi, the native language, and delved into primitive-style sculptures and woodcuts. In 1893, he returned to France, emboldened by his repertoire, and displayed his work in a one-man exhibition. French society, however, did not take to his art and considered it crude, along with Gauguin's eccentric, ostentatious ways. In fact, Gauguin's work was not fully appreciated until after his death.

Gauguin left France forever in 1895, venturing back to Tahiti and giving up not only his former country but also his art career. He bid farewell to painting "except as a distraction" on Sundays and holidays, and there is no known painting of his after 1900. He did, however, continue to channel his creativity through sculpting. The themes of his artwork grew darker and more metaphysical, often exploring ideas of death and contrasting civilized society with primitive purity. His contemplations turned nearly fatal when he tried to commit suicide by ingesting arsenic. After that incident,

he somewhat stabilized his life and founded his own publication, *Le Sourire: Journal méchant.*

Gauguin once again sought refuge from the Western world by moving in 1901 to Hiva Oa island in the Marquesas, which was less colonized than Papeete. His health was failing him and he clashed with the authorities, who sentenced him to prison time and a fine. He never did go to prison, as he died of syphilis at age fifty-four before his sentence began.

LEGACY

Even though Gauguin's feelings were cold for the Western world, he still had meaningful collaborations with many important artists of the time. His use of bold color and designs was novel in Europe and paved the way for the shift from Impressionism to Post-Impressionism, and thus the era of modern art. Painters he inspired include Henri Matisse, André Derain, Vincent van Gogh, Pablo Picasso, and Georges Braque. Even though he did not receive recognition in his lifetime, he is now considered a master.

MARK ROTHKO (1903–1970)

Creating drama on canvas

Mark Rothko, originally Marcus Rothkowitz, was born in 1903 in Russia and emigrated to Portland, Oregon, in 1913 with his family. He was a hard worker and an exceptional student, interested in a variety of academic fields. He was eventually drawn to art, enrolling in the Art Students League. Rothko was perhaps equally fascinated with the theatre and had a brief career as an actor, which was deterred when he was denied acceptance to the American Laboratory Theater in New York. His love of theater nevertheless remained strong throughout his life and influenced the way he perceived art. To him, his paintings were "dramas" and the forms within the paintings were "performers." Throughout his career, he looked for novel, liberating ways to set the stage on canvas.

GROWING UP QUICKLY

Rothko dealt with many struggles at a young age, beginning with his emigration from Russia. Jews in Russia were terrorized at the time, and Rothko's father, Jacob, additionally worried about his older sons being drafted into the Imperial Russian Army. Jacob decided to move to the United States and try to build a new life so his family could join him later. Fortunately, he was able to work for his brother, who already lived in the United States, and three years later, his entire family was able to relocate. Just seven months later, however, Jacob passed away from colon cancer and the family was left to fend for themselves.

Rothko knew no English and resultantly was enrolled in the third grade at eleven years old. He was forced to pick up the language (which would be his fourth) as quickly as possible to make it easier to find work and thus help support his siblings and mother. He found jobs delivering groceries and selling newspapers, meanwhile moving up academically so quickly that he finished high school in three years. During his adolescence, he was passionate about music and literature, and participated in political discussions at the Jewish community center on topics such as workers' rights and women's rights to contraception.

Academic success earned Rothko a scholarship to Yale, and he left the west coast for New England. The elitist academic culture displeased him and he dropped out of Yale during sophomore year, although at sixty-six he would return to receive an honorary degree. Moving to New York, he went to art school, already having a recreational interest in art but becoming enthralled with the idea after witnessing a friend's art class. Merging this with his theatrical inclinations, he painted stage sets while visiting home in Portland.

INTRODUCTION TO MODERNISM

When Rothko returned to New York, he once again enrolled at the Art Students League and worked closely with another Russian Jew named Max Weber, an artist highly involved with the French avant-garde's Modernist movement and who experimented with Fauvist, Cubist, and Futurist styles of painting. Through Weber, Rothko explored Modernism as it became more prominent in the United States. Specifically, he experimented with Expressionism, which used visual distortion to elicit an emotional experience. In adopting

the Expressionist style, Rothko began to value artistic creation as a means of emotional expression, and thus began his belief in the importance of artistic freedom.

DEPRESSION IN AMERICA

In the 1930s, America was in the midst of the Great Depression and people in New York, including Rothko, struggled to keep afloat financially and to maintain good spirits emotionally. To gain supplemental income, Rothko taught children part-time at the Center Academy of the Brooklyn Jewish Center. In 1932, he met and married Edith Sachar and the two struggled together, with Sachar taking various jobs and Rothko working essentially as an unknown artist.

Rothko found himself painting scenes of city living in New York, especially street scenes and subway corridors. The shapes and colors in the works drew attention to the architectural space, either moody in its emptiness or creating confinement with walls, windows, and railings. The paintings included human figures; however, Rothko was dissatisfied by them, feeling that they did not satisfactorily express the emotion he sought.

He began to incorporate Surrealist elements into his artwork—a genre of art that was often characterized by angst. Forms became increasingly obscure, symbolic, and often biomorphic, or made up of shapes and patterns reminiscent of organic life. In doing so he wished to achieve dissociation; as he explained, "the familiar identity of things has to be pulverized," thereby allowing the content of the painting to assert its own meaning.

Through a Child's Mind

Rothko highly valued his time spent as a teacher, and he taught at the Center Academy of the Brooklyn Jewish Center from 1929 until 1952. His experiences with teaching children were fundamental in his own search for truth, as he was fascinated by their ability to associate realities to the crude symbolic paintings they created. Rothko described his observations in an essay about teaching art, titled "New Training for Future Artists and Art Lovers":

"Most of [the children], full of ideas and interests, know just what they want to portray. Sometimes it is something from the history lesson, sometimes from Hebrew history; at other times, something they might have seen in the movies, on a summer trip, on a visit to the docks or at a factory, or some scene observed on the street; often it is a subject that is born entirely in their own minds as a result of reflection, or of particular sympathies and dreams. They proceed to work. Unconscious of any difficulties, they chop their way and surmount obstacles that might turn an adult grey, and presto! Soon their ideas become visible in a clearly intelligent form."

NEW THEORY

As Rothko delved into Surrealist principles and made them his own, he became fascinated with philosophy and the human struggle. In 1939, he decided to take a break from painting to read extensively on mythology and philosophy. By 1945, he had divorced Edith and married Mary Alice Beistle and released a pivotal art show showcasing his blend of Expressionism and Surrealism.

Rothko felt that the more abstract his works became, the more clarity he achieved. Further evolving into new territory, his paintings lost a traditional sense of form altogether by 1946. His new style came to be known as "multiform" paintings: huge canvases that were devoid of any landscape or figure and instead contained large, blurred blocks of color. For Rothko, these paintings epitomized "human drama," freed from the restraints of figures and thereby embodying emotion alone. As Rothko explained, "I am interested in expressing the big emotions—tragedy, ecstasy, doom."

In the 1950s, his time of recognition and success finally came, not only in America but across the world. Some viewers of his paintings broke down in tears in reaction to the emotions that the paintings elicited. This was validation for Rothko that the paintings were in fact a conduit for emotion, and thus the study of relationships between lines, color, or form were irrelevant.

As Rothko continued to explore these emotions, his paintings became darker in color with grays, blacks, and browns, and Rothko's mental state became increasingly depressive. In 1970, he committed suicide at the age of sixty-six. He was a man burdened by the human emotions he strived to paint, and his creations are revered for the power they hold.

PIET MONDRIAN (1872–1944)

Simplified abstraction

Piet Mondrian was raised in an environment that fostered his artistic inclinations. Art and music were encouraged in his family and Mondrian received drawing lessons from his father and painting lessons from his uncle. His formal education consisted not only of art school but also philosophical studies that greatly influenced his perception of art and ultimately led him to create a new art theory, called Neoplasticism. A precise and stripped-down form of abstraction, Mondrian's Neoplastic paintings aimed to create a universal art language that remains popular to this day.

ARTISTIC UPBRINGING IN HOLLAND

Mondrian's father Pieter was an amateur artist involved with the Hague School, and his uncle Frits was a self-taught and successful painter. The Mondriaans, as their name was actually spelled, were orthodox Calvinists and active in opposing the liberal movement sweeping the Netherlands at the time. Mondrian was encouraged by his father to obtain a teaching license and began teaching art in primary and secondary schools as a teenager. In 1892, at age twenty, Mondrian made the decision to forego teaching in favor of an art career and went to Amsterdam to study at the Royal Academy of Visual Arts, which he was able to afford with the support of his uncle.

Mondrian was highly involved in the art world in Amsterdam and joined formal art groups through which he was able to exhibit his art. His income was earned in side endeavors that utilized his painting skills: He illustrated books, painted tiles and portraits, gave drawing lessons, and was commissioned to decorate a canal house ceiling.

PARTING WITH THE HAGUE

Mondrian's artistic style at the time was understandably influenced by the current trends in Holland. Foremost was the Hague School with its somber, realist landscapes and Amsterdam Impressionism, which largely depicted the countryside's rivers and pastures. Mondrian adopted these styles but with some distinguishable differences, including his use of vivid orange and purple; painting landscapes on a single plane; and creating series with motifs, such as his windmill motif in the early 1900s. He was inspired by Vincent van Gogh's work when it became popular in Amsterdam after a 1905 exhibition, and Mondrian's work then minimized detailing and expanded on Symbolism. Many of his compositions focused on plant life cycles, using air, trees, and water reflections to impart growth, maturity, and decay.

As Modernist ideas grew popular among young Dutch artists, Mondrian was exposed to Cubism, which disassembled an object and reassembled it as an abstraction. Specifically, he was moved by the works of Pablo Picasso and Georges Braque. Mondrian's interests with Modernism pulled him toward the avant-garde and in 1912 he moved to where the movement thrived, in Paris. In a significant act, Mondrian started spelling his surname without the second "a," thereby departing from his Dutch heritage in favor of a more French-sounding version.

FROM CUBISM TO NEOPLASTICISM

In Paris, Mondrian began his Cubist period, which took place from 1912 to 1917. He was fascinated by the way Cubism isolated an object into geometric fragments but he sought even more abstraction. He explored ways to purify the abstract forms by way of flat lines and

shapes devoid of curvature. The goal was to remove any association to natural objects.

Balance in Opposing Forces

To create the harmony he coveted in his Neoplastic paintings, Mondrian believed that a balance of life's opposing forces needed to be achieved. These were positive versus negative, dynamic versus static, and masculine versus feminine. Representations of these competing forces, rather than symmetry, were what he considered to create a "universal" balance.

In 1914, Mondrian returned home to Holland to visit his father, who was in poor health. Because of the onset of World War I, he was unable to travel back to Paris and remained in the Netherlands until 1919. Surrounded once again by Dutch artists, he refined his artistic techniques in cooperation with artist and architect Theo van Doesburg. Together, they outlined a new art theory in a periodical Van Doesburg established in 1917, called *De Stijl*, meaning "The Style." The publication's name became synonymous with the theory it presented in various essays written by Mondrian.

The De Stijl movement was not intended for painters alone. It was an ideal to be applied to various art forms, including architecture, furniture design, poetry, and typography. Its principles rejected all pictorial representations in favor of the visual elements stripped down to their most basic level: straight vertical and horizontal lines, and primary colors, along with black, white, and gray. Philosophically speaking, the goal was to create an expression of order and harmony, which could only be achieved when the expression was abstracted so much that it existed according to a universal art "language."

When Mondrian returned to Paris, De Stijl was widely prevalent in Holland but practically unknown in France, or outside of the Netherlands, for that matter. Mondrian's goal was to share his theory with the art world and thus he published *Le Néo-plasticisme* in 1920. At that point, he referred to the De Stijl movement as Neoplasticism, or "the new plastic art." The term "plastic" referred to the artistic elements that he constructed with and the rhythms those elements created.

GLOBAL STATUS

Mondrian's work grew in prevalence throughout Paris, Germany, and the Netherlands due to his regular exhibitions. It wasn't until 1926, at age fifty-four, that he first presented his paintings in the United States. Doing so bolstered his success, as American artists and collectors sought his work and ideas. He published articles on Neoplasticism in English, allowing his American followers direct access to his art theory. When conflict with Nazi Germany intensified and his work was considered forbidden according to Nazi rule, New York became a haven where he could live without danger. New York fostered his artistic abilities, as it was a hub of culture and rhythm and introduced him to the inspiring jazz scene.

Mondrian never married, but had a wide circle of friends and acquaintances and was made wealthy by his art career. He died in 1944 of pneumonia in New York, and the following day a memorial in his honor was attended by nearly 200 visitors. To this day, Mondrian's art is recognizable in pop culture around the globe and has reached iconic status. His most recognizable works consisting of parallel lines and colored squares, such as his 1937 piece *Composition with Yellow, Blue, and Red*, can be found in museums the likes of the Tate Modern, the Philadelphia Museum of Art, and the Met.

RENAISSANCE ART

Rebirth and renewal

Renaissance is a French term for "rebirth" and was the name given (in the nineteenth century) to the European era between the fourteenth and seventeenth centuries. It was considered a rebirth because it was a time when pre-existing values from ancient Greece and Rome were resurrected and applied in unprecedented ways, created out of new inspirations, new technologies, and new techniques. Renaissance art depicted mainly religious themes but also included mythological and historical subjects. Because of the cultural climate, Renaissance art was able to examine religion from a humanistic and individualistic perspective, versus the previous dogmatic perspective.

A TIME OF GROWTH AND OPTIMISM

The Renaissance followed the Middle Ages, a time that was marked by feudalism, barbarian warfare, plague, famine, and holy crusades. Following this dark era, the people of the Renaissance welcomed stability, freedom, and appreciation of pleasures. Politically, there was more peace as feudalism was replaced with a commerce-based social system, allowing citizens the ability to earn and trade for themselves to become prosperous. A moral conscience had developed that pointed a finger at controlling governments and instead praised justice and republicanism—products of ancient Greece.

The rise of a middle class, which allowed opportunity and respect for citizens, led to an emphasis on learning, intellectualism, and personal growth. Classical literature was examined in new ways: Scholars studied Greco-Roman original texts and gathered knowledge from them using

their own reasoning and observations. This approach to study, called humanism, relied on and was confident in "the genius of man" to achieve discovery. Humanism was both a method of learning and a philosophy, as it focused on the study of the five humanities—poetry, history, moral philosophy, grammar, and rhetoric—as a means to improve the self. It was important for a person to think and act virtuously and thus be a good citizen.

Equally important as a strong mind to the humanists was physical excellence. It was believed that mental and physical health together were critical for religious transcendence. Human aesthetic was a focus of interest and it motivated examination of the human anatomy, including skeletal shape, muscles, organs, and their physiological purposes. The application of biological science worked in tandem with mathematics and art as the two came to be intertwined.

In addition to biology, the Renaissance saw great strides in astronomy, geography, physics, chemistry, manufacturing, and engineering. Advancements in these fields propagated largely thanks to the invention of printing, which encouraged the spread of ideas. All the while, Christian ideas were highly influential and unconventional thought was applied to the New Testament, leading to a divide of the Catholic papacy with the expansion of Protestantism.

"The Cradle of the Renaissance"

The Renaissance movement began in Italy and was said to specifically have been born in Florence. It was one of the largest European cities at the time and was technically a city-state, meaning that it was self-governed apart from Italy's other regions. Florence contained a large amount of wealth among the middle and upper classes, which allowed its citizens the freedom to explore artistic pleasures. Notable Florentine artists in the Early Renaissance period included Donatello, Lorenzo Ghiberti, Filippo Lippi, and Andrea del Verrocchio.

THE RENAISSANCE ARTIST

Art was seen as highly important to society during the Renaissance because it was considered its own form of knowledge, capable of providing insights about humans in their relation to God and the universe. Because of its significance, art was highly sought after and fueled a demand for skilled artists. People of all social statuses were capable of learning how to produce art and turning it into a viable career. To do so meant a period of introductory study as an apprentice, after which they would join a professional guild and work for an eminent artist. Guilds would be commissioned by wealthy merchant families to produce works for palaces, churches, monasteries, and homes, although contracts for more prestigious work required that the master artist complete the majority of the work himself. In homes, art was commissioned for devotional purposes, but it was also a way for those in the rising middle class to bring aristocratic elements into their lifestyle.

Art was prevalent everywhere, taking form as frescos on chapel walls and ceilings, altarpieces, gateways and architecture, sculpture, and of course canvases.

LIFELIKE ART

As scientific understanding came to influence art, techniques to create realistic depictions were developed and artistic portrayals were noticeably sophisticated compared to those of the Middle Ages. The techniques forever changed artistic understanding and are taken for granted today as common sense.

Renaissance artists paved the way for perspective, adjusting the sizes of figures to create visual distance and using foreshortening, which is to shorten lines to create depth in consideration with horizon lines and vanishing points.

Foreshortening

Renaissance artists also established other techniques:

- Another way to establish depth was *sfumato*, from the Italian word *fumo*, meaning "smoke." With *sfumato*, lines are blurred to create contours, essentially making shapes by shading instead of outlines.
- *Chiaroscuro*—literally, "light-dark"—utilized high contrasts of light and dark coloring as a means to create three-dimensional volume. *Chiaroscuro* was also used for dramatic effect and to draw the eye to a focal point.
- Lastly, proportional accuracy was used in the depiction of figures, especially human figures. Michelangelo in particular was

highly influential in understanding proportion as well as detailing musculature.

INSPIRATION OF THE INDIVIDUAL

Renaissance art was intended to be inspirational, eliciting such powerful emotion that it would stir its viewer's morality and ultimately make the viewer a better person. Focusing mainly on religious themes, compositions were filled with great detail to establish beauty and mystery, encouraging personal contemplation. Artists themselves created pieces based on their own interpretation of religious events, and in doing so, personal ideas about Christianity sometimes deviated from those of the religious authority.

Also prevalent were secular scenes, detailing natural landscapes and the common people's everyday life. Consistent throughout Renaissance artwork was reverence to humans, both in their physicality and in their accomplishments.

STORYTELLERS

Renaissance artwork is largely tied to the idea of storytelling, in that representations of scenes and people were created from an observational perspective. It was important for artists of the time to be visually descriptive and, as a result, some of the most impressive and captivating religious art comes from the Renaissance era. Renaissance artists such as Giotto, Masaccio, Sandro Botticelli, Michelangelo, Raphael, and Leonardo da Vinci were astonishing in their craft and transformed art into a means of describing human life.

SCULPTURE

Finding the figure within the rock

Sculpture is not only one of the oldest forms of art, it is also one of the most varied and enduring. The art form ranges from massive statues such as the 420-foot Spring Temple Buddha in China to pieces so small and detailed they can only be viewed with a microscope. Tiny carved mammoth tusks created by Cro-Magnon man have survived tens of thousands of years. Elaborate Greek and Roman masterpieces sculpted in antiquity are revered in museums around the world.

CARVING VERSUS MODELING

For the most part, the art of sculpture falls into one of two categories: carving or modeling.

Carving

In carving, the artist starts with a large block or lump of material (stone, wood, metal, clay, wax, etc.) and painstakingly removes portions of it to reveal the finished work. This style can also be used to carve what is called a "relief," where only one side of the material is carved to create an effect whereby the finished image appears raised above the background. One of the most recognizable examples of this style of sculpture can be found in the faces of George Washington, Thomas Jefferson, Theodore Roosevelt, and Abraham Lincoln on Mt. Rushmore.

Modeling

Modeling, on the other hand, forces the artist to mold one or several pieces of material in order to shape the finished subject. Unlike carving, which is a subtractive form of sculpting, modeling is an additive method. One benefit to this method is that mistakes are less catastrophic for the artist, and pieces can be more easily adjusted during their creation.

ANCIENT SCULPTORS

Along with cave painting and body art, sculpture remains one of the oldest documented art forms. The oldest known piece, dubbed the *Venus of Hohle Fels*, was carved from a piece of mammoth tusk approximately 35,000 years ago and consists of a 2.4-inch depiction of the female form. Many early sculptures featured Venus as a subject, but numerous other pieces have been uncovered from ancient man depicting animals, mythical creatures, and even elaborate scenes such as the 13,000-year-old *Swimming Reindeer*, a carving of two reindeer swimming in tandem.

From humble beginnings carving small figurines, our ancestors moved on to more ambitious works of sculpted art. Large statues, intricately carved reliefs, and early attempts at written language permeated early Mesopotamia and paved the way for the giant monuments produced by the Egyptians.

Vibrant Color Fades to Gray

When archaeologists first began noticing traces of various pigments on Greek sculptures in the nineteenth century, most dismissed the phenomenon as the

efforts of later artists that could not possibly have been produced by their original creators. Through the use of ultraviolet lamps and other tools available with modern technology, however, we now know that many early Greek sculptures were not presented as the dull gray pieces we see today. In the early 2000s, German archaeologist Vinzenz Brinkmann was able to prove that both the Parthenon and several statues surrounding it were actually painted with a variety of vibrant colors. He was even able to produce several replicas, which he displayed at several prominent museums around the world, including the Vatican Museums.

MEDIUMS

There are no limits to the materials an artist can use to create a sculpture, however, there are a number of mediums that sculptors gravitate to, each of which have their own advantages and disadvantages.

Wood

One of the most widely available carving materials on earth, wood remains one of the most popular materials for creating sculptures. Unfortunately, it is also very susceptible to rotting and breaks down easily when exposed to the elements. Wood carvings not properly preserved will not last long, and it is likely that the vast majority of early sculptures crafted in wood have long since been lost.

Clay

When mixed with water in certain proportions, clay becomes an easily malleable substance that is suitable for both modeling or carving. When exposed to intense heat, the physical properties of the clay change dramatically and produce a hard structure. This unique

ability makes it an ideal material for creating pottery, as the potter can easily create various structures and then heat them to make the finished shape more permanent and durable.

Metal

The primary method for sculpting with metals is called "casting." The sculptor first produces a hollow mold—usually made of clay—of the finished statue, and then fills the mold with liquid metal. Once the metal cools, it can be removed from the mold and the artist can refine the work until he or she achieves the desired finished look. While this method works best with small sculptures, the Greeks were especially adept at producing life-sized bronze castings of their subjects.

Stone

One of the preferred materials of both Greek and Roman sculptors, stone is one of the most durable sculpture mediums, but it is also one of the most difficult to work with. Because stone cannot easily be molded with the hands, the sculptor must make precise cuts to remove portions of the stone using chisels and hammers to create a rough outline of the subject and resort to rasps, sandpaper, and other tools to refine the final piece. Even the slightest miscalculation on the part of the sculptor can result in an unusable finished product.

LEONARDO DA VINCI (1452–1519)

The original "Renaissance man"

The quintessential Italian Renaissance artist isn't just the man behind the world's most famous painting—he was a polymath: a man gifted with expertise in subjects ranging from sculpture, architecture, and music to engineering, geology, and writing. Described as the model for what became known as a "Renaissance man," Da Vinci's creativity and imagination lead some to claim he was one of the most talented men to ever live.

EARLY LIFE

Leonardo da Vinci was born in Vinci, Italy, in 1452. He was born out of wedlock to a legal notary, Messer Piero Fruosino di Antonio da Vinci, and a peasant woman, Caterina. His full birth name was Lionardo di ser Piero da Vinci; the "ser" title denoted that his father was considered a gentleman.

He spent his first five years in Anchiano, a hamlet that was home to his mother, and then moved in with his father, grandparents, and uncle in Vinci, where he spent the majority of his youth. Da Vinci used the texts on mathematics, geometry, and Latin available in his father's house to self-educate.

At age fourteen, Da Vinci was apprenticed to artist Andrea di Cione, more widely known as Verrocchio, whose workshop was one of the most respected in Florence. There he learned the theories of

art and a variety of skills ranging from drafting to metallurgy to carpentry, and of course drawing, painting, sculpting, and modeling.

The young apprentice was said to have assisted Verrocchio with his *The Baptism of Christ* painting. According to Vasari, a sixteenth-century biographer of Renaissance painters, Da Vinci's work was so far superior to Verrocchio that his master never painted again. It is possible that Da Vinci served as the model for the bronze statue of *David* and the Archangel Raphael in *Tobias and the Angel*.

At age twenty, Da Vinci qualified as a master in the Guild of St. Luke, the guild of artists and medical doctors. While he could now work on his own, he preferred to continue his collaborations with Verrocchio.

PROFESSIONAL CAREER

In 1478, Da Vinci left Verrocchio's studio and moved out of his father's house. That same year, he received his first independent commission, an assignment to paint an altarpiece for the Chapel of St. Bernard in the Palazzo Vecchio. In 1481, he was asked to paint *The Adoration of the Magi* for the monks of San Donato a Scopeto.

According to Vasari, Da Vinci was a talented musician, and in 1482, he crafted a silver lyre in the shape of a horse's head. Lorenzo de' Medici sent Da Vinci to Milan to present the lyre as a gift to Ludovico Sforza, the Duke of Milan, to secure peace. He struck up a bond with Ludovico and stayed in Milan until 1499. During that time, he was commissioned to paint *Virgin of the Rocks* and *The Last Supper*, which would become one of the most re-created paintings in history. Ludovico personally contracted him to prepare floats and pageants for special occasions, design a dome for the Milan Cathedral, and model for an equestrian monument to his predecessor, Francesco Sforza.

During his time in Milan, Da Vinci also completed his drawing of the *Vitruvian Man,* a pen-and-ink drawing depicting the ideal human proportions. The drawing shows a male figure in two overlapping positions, with arms and legs apart and contained within a circle and a square.

When Ludovico was overthrown in the Second Italian War in 1499, Da Vinci fled to Venice, where he worked as a military architect and engineer. He returned to Florence in 1500, where he lived in the monastery of Santissima Annunziata and completed *The Virgin and Child with St. Anne and St. John the Baptist.*

In 1502, Da Vinci worked for Cesare Borgia, the son of Pope Alexander VI. He served as a military architect and engineer and traveled throughout the country with Cesare. It turned out that Da Vinci was also a skilled cartographer, and when he made Cesare a map of the town plan of Imola, Cesare hired him as his chief military engineer and architect.

Da Vinci eventually returned to Florence and in 1503 he rejoined the Guild of St. Luke. He worked with Michelangelo designing and painting a mural of *The Battle of Anghiari* and received a private commission to complete what became known as his most famous work, the *Mona Lisa,* sometime between 1505 and 1507. The painting was never delivered; Da Vinci kept it with him until he died, perpetually tweaking and perfecting it.

The Science of Art

Like many humanists of the Renaissance era, Da Vinci did not see a separation between science and art. He recorded meticulous notes and drawings throughout his life—13,000 pages in total. These included designs for flying machines, war machinery, anatomy, and architecture. His drawings of human anatomy, particularly of the heart and vascular system and bone and muscular structures, are some of the first recorded by humans.

Leonardo da Vinci died in Amboise, France, on May 2, 1519. At the time, he was living in a house presented to him by King Francis I. His assistant (and rumored lover) Francesco Melzi became the principal heir and executor of his estate.

Hidden Meanings in *The Last Supper*

One of Da Vinci's most famous paintings, *The Last Supper*, has been the subject of much speculation since he originally painted it around 1495. One interpretation popularized by the 2003 novel *The Da Vinci Code* states that the figure to Jesus's right is actually the woman Mary Magdalene and not his disciple John. Some speculate that the lack of an obvious chalice to symbolize the Holy Grail that housed Jesus's blood during the first communion implies that Da Vinci believed Mary Magdalene was actually Jesus's partner and housed his blood in the form of a child.

PAUL CÉZANNE (1839–1906)

The father of Post-Impressionism

Born January 19, 1839, in Aix-en-Provence, France, Paul Cézanne was a revolutionary artist who inspired transitions between old and new forms of art. Even such artists as Picasso and Matisse claim him to be "the father of us all," declaring him as a major influence of modern and Impressionist art. Cézanne didn't always hold this acclaimed status as an artist. During his career, he was denied access to several major exhibitions, and his fame as a talented painter only began in the later years of his life.

EARLY LIFE

Cézanne was born and grew up in southern France, which became the inspiration for several of his most famous paintings, including *Montagne Sainte-Victoire*. His father was a wealthy banker who wanted his son to follow in an accredited field and become a lawyer. However, Cézanne detested the subject and asked his father if he could pursue a career as an artist. He was given an allowance and attended a private art school in France, (the Académie Suisse) where he studied with childhood friend Émile Zola.

During his time in Paris, Cézanne formed relationships with other Post-Impressionist painters such as Claude Monet and Camille Pissarro, who would greatly influence Cézanne's style. Pissarro in particular was a great inspiration to Cézanne: After studying with the famous painter, he began to transform his artistic technique. Using pure, vibrant colors, thick application of paint, and real-life subject matter, Cézanne became the forerunner of the movement we know today as Post-Impressionism.

Inspiration for the Apples

During his childhood, Cézanne befriended Émile Zola, who became a prominent French writer of the nineteenth century. While he and Zola were children, Cézanne was quite larger than his friend and came to defend Zola from a bully at school. As a thank you, Zola gave him a basket of apples as a gift. It is said that this gift influenced the many paintings Cézanne created with apples as the focus.

Due to his educational background in Paris, he was very intelligent for a major painter of his era; he was versed in many languages, even dabbled in translating Latin and Greek in his spare time, and was very knowledgeable about other contemporary French artists.

THE RECLUSIVE MASTER

While Cézanne was alive it was often difficult to view his work: He was a fairly well-known artist in his time, but he was often socially isolated. His artwork was off-putting for many critics; some found his use of odd colors and unique brushstrokes strange. But others saw it as the beginning of a new movement in art and beauty. He was known as a "painter by inclination": He wanted to paint, but also wanted to express his own view in ways people were not used to seeing. His signature subjects were ordinary people painted like royalty, dissecting their emotion and communicating it through the paint and canvas. The most noticeable element of Cézanne's work was that it often seemed unfinished, abrupt, and/or hurried. Famous philosopher Hidaka described this process as looking at a single frame in order to view the passage of time through the artist's eyes.

Another interesting aspect of Cézanne's character came through in his thorough and calculated approach to painting. Some of his contemporaries noted that he would often take minutes between brushstrokes, staring and contemplating his next move. Cézanne dissected the idea and reality of what he was looking at, such as the landscape, and re-created it into a painting that truly reflected his mind and psyche.

FAVORITE LOCATIONS TO PAINT

Cézanne loved painting the countryside of his home in southern France. His favorite painting was *House on the Hill*, as it captured his part of the world that was so dear to him. Another local subject was Montagne Sainte-Victoire, a mountain that was just outside the window of his painting studio. He actually painted this mountain thirty times, at different times of the day and from numerous angles. Another famous piece that arose from his love of the outdoors is *The Bathers*. The painting depicts several women bathing, mostly with their backs to the viewer.

In his later years, Cézanne moved back to his hometown and settled into a secluded life. As the Post-Impressionist movement began to grow, he found that more and more people were taking interest in his art. In 1895, a French painter named Ambroise Vollard set up a collection of Cézanne's later paintings, and it was met with much approval and success. He became the inspiration for many young, aspiring artists, who would even travel from Paris simply to see him paint. In 1906, Cézanne came down with a case of pneumonia that eventually led to his death. Although Cézanne may not have been able to see his legacy, his unique style and techniques inspired many of the most famous paintings we know and love today.

FUTURISM
Out with the old, in with the new

There have been various art movements in Italy over the centuries, each known for its distinct characteristics. Many periods, such as the Renaissance and Baroque, are regarded as having classical influences in works that seek to portray religious and philosophical messages. Then there is Futurism, an artistic and social movement that negated the past and glorified themes of the future through the admiration of all things new.

WE WANT NO PART IN THE PAST

In 1909, Italian writer Filippo Tommaso Marinetti launched a movement that would significantly impact Italian art. *Futurist Manifesto*, published on February 5, 1909, in *La Gazzetta dell'Emilia*, expressed Marinetti's discontentment with the old, particularly political and artistic traditions. "We want no part of it, the past," he wrote, "we the young and strong Futurists!" This passionate declaration identified Futurists as those who admired youth and violence, speed, technology, the car, the airplane, and the industrial city—essentially, all things that showed technology dominating nature. The Futurists were also fervent nationalists who praised originality, repudiated previous art, and glorified science.

KEY ASPECTS OF FUTURIST STYLE

A distinctive style and subject matter did not come naturally to Futurism. In 1910–1911, Futurist painters used Divisionism techniques,

which sought to break light and color down to dots and stripes. Gino Severini, a leading member of the Futurist movement, later observed Cubism and adopted its methods in 1911, inspiring other Futurist painters to follow suit. This blend of techniques allowed Futurist art to analyze energy in paintings while expressing dynamism.

Modern urban scenes became the preferred subjects for Futurist painters. For example, Umberto Boccioni's *The City Rises* (1910) portrays construction scenes and manual labor by way of a large, rearing red horse in the center as workingmen struggle to control him. Boccioni went on to become a major player in the Futurism movement.

While the adoption of Cubism helped shape the style of Futurist painting, there were still several major differences. While Cubism paintings were often quiet and static portraits, Futurist paintings regularly contained motion. Boccioni's *The Street Enters the House* (1911) centers around a woman on a balcony overlooking a busy street. The sounds of the activity below her are shown through boisterous shapes and colors.

Futurism was also displayed through sculpture as a means to translate movement into three dimensions. Boccioni's *Unique Forms of Continuity in Space* (1913), a sculpture cast in bronze, attempts to distinguish a relationship between the object and its environment, a key factor in dynamism.

While Futurism always glorified war, claiming it as "the world's only hygiene," it did not become heavily involved in politics until the autumn of 1913, leading up to Italy's decision to join World War I in 1915. Many Futurists enlisted to fight, and the war essentially signaled the end of Italian Futurism for a time. Boccioni produced a single war picture and was then killed in 1916, and while Severini painted some significant war pictures during 1915 (including *War,*

Armored Train, and *Red Cross Train*), he turned toward Cubism in Paris after the war.

Following World War I, Marinetti revived Futurism, which was later called *il secondo Futurismo* (Second Futurism). Giovanni Lista, Italian art historian and critic, has classified Futurism by decades: "Plastic Dynamism" for the first decade (1910s), "Mechanical Art" for the 1920s, and "Aeroaesthetics" for the 1930s.

Aeropittura

Aeropainting, or *aeropittura*, was prominent in the second generation of Futurism beginning in 1926. The new technology of flight offered a new subject for Futurist painters as they explored aeropainting (the act of painting airplanes and images inspired by them) through realism, abstraction, dynamism, portraits of Mussolini, and images of planes. There were more than 100 aeropainters, including Fortunato Depero and Tullio Crali, who continued to produce *aeropittura* until the 1980s.

FASCISM IN FUTURISM

Many Italian Futurists supported Fascism, in hopes of modernizing a divided Italy. As Italian nationalists admired violence and opposed parliamentary democracy, Futurism gained official acceptance in Italy after Fascism's triumph in 1922. Yet when Marinetti, founder of the Futurist Political Party, attempted to make Futurism the official state art of Fascist Italy, he was unsuccessful. Benito Mussolini, leader of Fascist Italy, denied these attempts, claiming, "Art belongs to the domain of the individual."

FUTURISM'S LEGACY

Futurism was influential in many other twentieth-century art movements, including Art Deco, Constructivism, and Surrealism. While Futurism's art movement has been extinct since 1944, following Marinetti's death, its ideals remain significant in modern Western culture. For example, Ridley Scott imitated the designs of Antonio Sant'Elia in the movie *Blade Runner*. Marinetti's legacy is also found in transhumanism, a movement that seeks to transform the human condition by developing technology to enhance human capacities.

A revival of the Futurist movement was attempted in 1988 with the unveiling of the Neo-Futurist style of theatre in Chicago, focusing on speed and brevity to create a new form of theatre. There are still active Neo-Futurist companies in Chicago, New York, and Montreal.

TIZIANO VECELLI—TITIAN (CA. 1488–1576)

The sun amidst small stars

One of the most versatile painters in Italy, Tiziano Vecelli, or Titian, was the most influential member of the sixteenth-century Venetian school. Titian redefined Renaissance art through the use of color, loose brushwork, and subtlety of tone in portraits, landscape backgrounds, and mythological and religious subjects. Color remained a lifelong interest for Titian, even though his artistic manner changed throughout his lifetime. He influenced other painters of the Italian Renaissance as well as future generations of Western artists.

AN ARTIST'S INFLUENCE

Titian's actual birthdate is unknown, but modern scholars estimate that he was born between 1488–1490. He was born to Gregorio and Lucia Vecelli, who sent Titian and his brother Francesco to an uncle in Venice to find an apprenticeship with a painter from ages ten to twelve. Titian began working in the studio of Gentile Bellini, one of the leading artists in Venice at the time, and befriended a group of young men, which included Giorgio Castelfranco (also known as Giorgione), another Renaissance painter who would become a close friend of Titian's.

One of Titian's earliest works is said to be a fresco of Hercules; others included the *Gypsy Madonna* in Vienna and the *Visitation of Mary and Elizabeth*, now in Venice.

Titian eventually became Giorgione's assistant, yet contemporary critics favored his work, creating tension in the relationship

between Titian and Giorgione. The two were recognized as leaders of *arte moderna*, a new school characterized by paintings that featured less symmetry than found in the work of earlier masters, like Bellini.

Following Giorgione's death in 1510, Titian obtained a broker's patent, called La Sanseria, in 1513 that was a coveted privilege for rising artists. This led Titian to become the superintendent of government works for the city, including being asked to finish an incomplete painting by Giovanni Bellini.

MASTERING HIS ART

During 1516 to 1530, Titian made great strides in his artwork, moving away from his early Giorgionesque style in order to tackle larger, more intricate subjects. His famous masterpiece, the *Assumption of the Virgin*, was completed in 1516 for the high altar of the Basilica di Santa Maria Gloriosa dei Frari. This style of painting was grand and rarely seen before in Italy; the color used to unite earth and heaven, the temporal and the infinite, created a stir amongst observers. He continued this style in other works until creating his most studied work, the *Madonna di Ca' Pesaro* (1519–1526) for the Frari church.

Titian also composed multiple half-length figures and busts of young women during this period of maturity. The *Flora* (at the Uffizi in Florence) and the *Woman with a Mirror* (at the Louvre in Paris) are ideal examples of these works.

A MORE MATURE TITIAN

Titian's following period of art spanned from 1530 to 1550, and a new style was introduced through his dramatic painting, *The Death of St. Peter Martyr* (1530). Known as one of his most extraordinary works, *The Death of St. Peter Martyr* combined violence and a landscape consisting of a large tree invading the scene and accentuating drama. It was originally displayed in the Dominican Church of San Zanipolo, but was destroyed by an Austrian shell in 1867. The only remnants of the painting are copies and engravings, but its style echoes the characteristics of the Baroque art movement that followed.

It was also during this period when Titian began to paint the *Battle of Cadore*, yet this painting was lost in the great fire of 1577 that destroyed the chambers of Doge's Palace in Venice. This period of Titian's work is still represented in two of his most popular canvas paintings, the *Presentation of the Blessed Virgin* (1539), and the *Ecce Homo* (1541).

Titian's advancement as an artist during this time period has led him to be compared to the likes of Raphael, Michaelangelo, and Peter Paul Rubens. He continued to receive pensions for his work, and prepared to take Holy Orders as holder of the *piombo*, or papal seal, but he was called to Venice in 1547 to paint Charles V in Augsburg. In 1550, he painted a portrait of Philip II, which was shipped to England and is said to have influenced the marriage between Philip and Queen Mary.

THE FINAL YEARS

The final period of Titian's life spanned from 1550–1576, where he worked primarily for Philip II, focusing on portraits. He became a perfectionist then, holding some paintings hostage in his studio for

upwards of ten years, continually retouching and adding new details to each of his works. He also painted a series of large mythological paintings known as the "poesie" for Philip II, which are regarded by many as his greatest works.

Titian continued to accept commissions until his death. Before his death, he had decided to be buried in the chapel of the Crucifix in the Basilica di Santa Maria Gloriosa dei Frari, where he completed the *Assumption of the Virgin* under Franciscan Order. He offered a picture of the *Pietà* as payment for a grave, in which he displayed himself and his son, Orazio, before the Savior.

Titian passed away in his late eighties as a result of the plague that killed many in Venice. He died on August 27, 1576, and was the only plague victim to be given a church burial. He lies near his famous painting, the *Madonna di Ca' Pesaro*, in the Frari.

The "Poesie"

The "poesie," also known as Titian's greatest works, was a series of paintings influenced by the Roman poet Ovid. They include the following:

- *Venus and Adonis*
- *Danaë*
- *Diana and Actaeon*
- *Diana and Callisto*
- *Perseus and Andromeda*
- *The Rape of Europa*
- *The Death of Actaeon*

JOHN SINGER SARGENT (1856–1925)

Portrait artist of the rich and famous

John Singer Sargent was a widely celebrated American painter who lived in Europe and traveled the world in search of inspiring new subjects. His portrait work helped him gain notoriety in Paris and continued to occupy much of his career, but he eventually impressed the art world with his talents in genre paintings and made his mark with watercolors later in his career. Sargent had an expert command of the paintbrush, wielding it with the speed and accuracy of a pencil. He was able to bring forth the emotional inner life of his many aristocratic subjects while capturing their exact likeness in the tradition of the great masters. His technical skill was the stuff of legend, allowing him to portray light with surprising accuracy and to closely emulate the work of artists who inspired him.

EARLY LIFE AND WORK

John Singer Sargent was born in Florence, Italy, on January 12, 1856. His parents were Americans who had moved to Italy to heal from the grief of losing their first child.

Sargent had very little formal schooling. What he knew of arithmetic, reading, and geography he learned at home from his physician father. His mother did her part as well, piquing his interest in drawing at a young age and nurturing his talent for the arts. It wasn't until the 1870s that Sargent received formal art training at the Accademia

delle Belle Arti in Florence. By the time he finished his studies there, Sargent had proven to his father that he could succeed as an artist. He moved to Paris in 1874 and studied under the fashionable young portrait artist, Charles Auguste Émile Durand (known as Carolus-Duran) and later at the École des Beaux-Arts.

Sargent's work was deeply influenced by Carolus-Duran's encouragement to skip the preliminary sketches and paint more spontaneously—as if he were sketching. Sargent was a star student, winning the silver prize for his anatomy and perspective drawings. Carolus-Duran recognized Sargent's talent and chose him as his protégé. He shared with Sargent his admiration for bold artists like Frans Hals, Rembrandt, and Diego Velázquez, who took considerable stylistic risks. Most of Sargent's paintings after 1877 fell in line with the teachings of Carolus-Duran and incorporated the lessons he learned from studying history's greatest masters.

Sargent the Prodigy

Henry James was one of many who were shocked by John Singer Sargent's aptitude at such a young age. He described the artist's work as exhibiting "the slightly 'uncanny' spectacle of a talent which on the very threshold of its career has nothing more to learn."

After a trip to America in 1876—one of many he would take in his life—John Singer Sargent returned to Paris to build his portfolio. While he successfully submitted both portrait and subject paintings to the Salons over the next five years, his portraits (including his 1879 submission of a portrait of Carolus-Duran) succeeded in making the best impression. Sargent satisfied his wanderlust and

fueled his career by traveling to Spain, Holland, and—closest to his heart—Venice. His travels as a young, emerging artist loaded his portfolio with inspired paintings of the beautiful sites and customs he encountered.

SARGENT'S CAREER TAKES A TURN

Sargent returned from his extensive travels invigorated by all he had seen and learned. Inspired by Velázquez's dark palette and Manet's unconventional poses and use of space, Sargent painted his most controversial work, a profile portrait of a woman clothed in a long, black, sleeveless evening gown with a plunging neckline. When he submitted the painting, *Madame X*, to the Salon in 1884, it immediately made waves. The scandal of *Madame X*, provoked by its departure from tradition and the risqué wardrobe of its elegant subject, was considered a failure and haunted Sargent for years.

To escape the scandal, Sargent visited and painted alongside Monet in Giverny and moved to London in 1886, hoping to secure portrait work. Unfortunately, his avant-garde reputation preceded him and the English were hesitant to pose and invite more controversy. Determined to find favor, Sargent traveled to America in 1887 and 1890 and succeeded in finding willing (and wealthy) portrait subjects who would offer him a commission. His refined technique for suggesting both movement and emotion in his subjects brought him increasing attention and fame. Sargent's talent for capturing his subject's most unique human qualities could no longer be ignored.

Still, the English remained reticent until 1887 when Sargent, having returned to England, premiered his now-famous masterpiece *Carnation, Lily, Lily, Rose* at the London Royal Academy. This

painting of two girls lighting lanterns at dusk was a breathtaking piece that revealed Sargent's technical acuity and his command of the Impressionist style. He painted for a few minutes at dusk for months on end so that he could accurately portray the gentle aura of light that gives this work its serene beauty. After the English saw this painting, he was forever in their favor and rarely without portrait work.

A RETURN TO HIS TRUE PASSION

After decades of painting in oil, Sargent turned to watercolors in 1903 and created thousands of travel pieces that spanned the globe. His vivid watercolors of Venice are some of his most celebrated works and reveal his extraordinary talent and command of color. Sargent seemed to excel at everything he tried. Increasing fame and recognition for his mastery of watercolors earned him a major solo exhibit at the Carfax Gallery in London in 1905.

In 1907, at the age of fifty-one, Sargent finally freed himself from the confines of indoor portrait work. He spent most of the remainder of his career traveling, working on murals in Boston, and painting some of his favorite subjects—landscapes, travel pieces, and friends— in the great outdoors. His death in England in 1925 marked the end of a celebrated artist and the beginning of many major exhibits in his honor.

PHOTOGRAPHY

Photography: an evolution

Today's society is dependent on photography in a way that no other generation has been. Advances in technology and smartphones have afforded us the opportunity to have constant access to cameras, and social media sites such as Instagram, Twitter, and Facebook encourage us to share our photographs with various social networks. Photography is a personal form of self-expression in today's world; it defines our interests and who we are as individuals. Yet in its history photography was not always so convenient. Photography took great strides to reach where it is today.

DEFINING PHOTOGRAPHY

The word photography is derived from the Greek word *photos*, meaning "light," and *graphos*, meaning "drawing." It is the art, science, and practice of creating lasting images by recording light or other electromagnetic radiation, either chemically or electronically.

A COMBINATION OF TECHNICAL DISCOVERIES

Photography was not always achieved by way of a camera. Chinese philosopher, Mo Di, and Greek mathematicians described a pinhole camera in the fifth and fourth centuries B.C.

Pinhole camera

In 1566, Daniele Barbaro described a diaphragm (a solid structure with an opening that can be expanded to either let light in or block it out), and in 1760, French author Tiphaigne de la Roche described what has been interpreted as traditional photography today. The first successful reproduction of images without a camera occurred when Thomas Wedgwood transferred copies of paintings on leather by use of silver salts. These, however, could only be seen in a darkroom.

It wasn't until the 1820s when camera photography was invented as a means to capture further detail and information. French inventor Nicéphore Niépce produced the first permanent photoetching in 1822, but a later attempt to duplicate it destroyed the image. Niépce was successful again four years later, making the first permanent photograph from nature (*View from the Window at Le Gras*) with a camera obscura

(a device that projects an image onto a screen so it can be copied by an artist) in 1826. Instead of sketching the image, however, Niépce coated a pewter sheet with bitumen—a substance that hardened when exposed to light—which he then removed with solvent to leave a lasting image. While the technique was a major breakthrough, it required an eight-hour exposure time to capture the image.

Niépce eventually partnered up with Louis Daguerre, seeking to decrease the lengthy exposure time. Daguerre continued to work toward this goal after Niépce died in 1833, and eventually took the first photo of a person in 1838, when a Parisian pedestrian stopped for several minutes to get a shoeshine while a daguerreotype was being taken. France eventually offered Daguerre and Niépce's son Isidore lifetime pensions for his formula and Daguerre announced his discovery of photography to the world as the gift of France in 1839.

Meanwhile, English inventor William Henry Fox Talbot read about Daguerre's invention and, having earlier discovered a means to capturing images, refined his process. By 1840, Talbot invented the calotype process, also known as negative images. His famous 1835 print of the oriel window in Lacock Abbey remains the oldest known negative in existence. The cyanotype process, also known as the "blueprint," was also invented in the 1830s by John Herschel.

MONOCHROME TO KODACHROME

Photography was originally all monochrome, or black-and-white. In 1861, the first permanent color photograph was taken using James Clerk Maxwell's three-color-separation principle, which took three separate monochromatic photographs through red, green, and blue filters. Color photography required extremely long exposures

spanning hours or days for camera images, and was expensive. Black-and-white photography remained dominant as a direct result of its lower cost and "classic" look.

In 1907, the Lumière brothers introduced the first commercially successful color process for photographs, Autochrome. Autochrome plates were often used in several varieties of additive color screen plates and films between the 1890s and 1950s.

It was following this invention that Kodak introduced their first "monopack" color film called Kodachrome in 1935. By capturing three-color components in a multilayer solution, each layer was sensitized to record a specific color—red, green, or blue.

In 1963, instant color film was introduced by using a special camera that produced color photographs only minutes after the exposure. This is now known as the Polaroid.

Stand Still!

Taking a photograph in the nineteenth century meant standing steady for long periods of time due to the camera's slow exposure rates. Enter the "Brady stand" side table, invented in 1835. This side table offered a cast iron base for stability and an adjustable leg that could be used as either an armrest or neckrest. Named after famous nineteenth-century American photographer, Mathew Brady, the "Brady stand" became a standard prop used in photographs, offering some relief to portrait models who were unable to move during long exposure times.

THE DIGITAL AGE

Digital photography has been around longer than many of us are aware. In order to record an image, digital imaging uses an electronic

image sensor instead of chemical changes on film. Sony unveiled its first consumer camera, the Sony Mavica, in 1981. Though it did not require film, it was not a fully digital camera as it saved images to a disk and then displayed them on television. A decade later Kodak released the DCS 100, the first commercially available digital single lens reflex camera. The DCS 100 essentially paved the way for digital photography to advance.

Since the 1990s, digital point-and-shoot cameras have become popular consumer products. Many include various settings dependent on the type of image the user is trying to capture, features such as video and audio recording, and editing capabilities. Digital photography became so widespread that in 2004, Kodak announced that it would no longer produce or sell reloadable 35 mm cameras; Nikon followed suit in January 2006.

Photography and the Arts

Fine art photography and documentary photography were not accepted as a form of fine art until the twentieth century. Photographers such as Alfred Stieglitz, Edward Steichen, John Szarkowski, F. Holland Day, and Edward Weston were major advocates of photography as a fine art. Pictorialism, a movement in which fine art photographers sought to imitate painting styles by using soft focus to create a dreamy, "romantic" look, was often used when photography was first being accepted as a fine art. In protest, photographers like Ansel Adams and others formed the group f/64, which used "straight photography" in which photographs were sharply focused and represented the image itself, not an imitation of something else.

BAROQUE
Religious art for the masses

Imagine a trip to Rome, Italy. After a full day of visiting landmarks, you arrive at the Piazza di Trevi in the Quirinale district and you notice it: the Trevi Fountain. You observe its ornate details—Neptune, god of the sea, stands atop a chariot drawn by two sea horses and two gods. The goddess of abundance stands to his left, and on the right is the god of salubrity. You are overcome with emotion and awe, moved by the direct message that is held within these sculptures. That is Baroque art.

ART AS A RESPONSE FROM THE CATHOLIC CHURCH

Originating around 1600, the Baroque movement was essentially a result of an internal reformation of the Catholic Church. The Protestant Reformation, launched by Martin Luther, was well underway; citizens were converting and new Protestant denominations were emerging. To counteract this movement, Pope Paul III called the Council of Trent to begin a Counter-Reformation in which it was declared that art should be used to explain the intricacies of faith to the masses—both the educated and the illiterate. Religious art was called to be direct, evoke emotion, and persuade the viewer toward spiritual imagination. While Protestants sought for their places of worship to be simple and bare, the Council argued that Catholic churches should be grand and echo God's greatness and power. It reaffirmed the emotional depths of the Catholic faith while reminding the observer of the church's power and influence.

SCULPTING THE BAROQUE WAY

Baroque sculptures often provided multiple viewing angles and featured groups of figures, helping to evoke energy. Baroque sculptures also offered additional elements such as concealed lighting or water fountains. Bernini, the most important sculptor of the Baroque period, was known for his innate ability to carve marble, creating figures that were physical and spiritual. One of his most famous sculptures, the *Saint Teresa in Ecstasy* (1645–1952), was created for the Coronaro Chapel of the church of Santa Maria della Vittoria in Rome.

Aleijadinho of Brazil, another great Baroque sculptor, created a set of statues called the *Santuário de Bom Jesus de Matosinhos* in Congonhas, Brazil. The sculpture, comprised of soapstone, shows prophets of the Old Testament around a terrace, and is considered one of his finest works.

GRAND ARCHITECTURE

Baroque architecture emphasized colonnades (sequences of columns), domes, chiaroscuro (light-and-shade), color effects, and intimidating size scales. The interiors to Baroque architecture featured monumental staircases that had never been seen before. The state apartment, a lavish throne room or state bedroom with rich interior details, also became a common characteristic of Baroque architecture.

Central Germany embraced Baroque architecture, and its presence can be seen at the Ludwigsburg Palace and the Zwinger Palace in Dresden. Similarly, Baroque architecture can also be found in Austria, Russia, and England, as well as in other European towns and in Latin America. Town planning also spread throughout Europe, and in many cities today one still finds avenues that intersect in squares and plazas, a similar characteristic of Baroque garden plans.

THEATRE ARTS

The Baroque era helped theatre to evolve in multiple instances, beginning with the actual architectural space. Theatre became a multimedia experience during this time period. The stage became a framed area in which viewers only saw specific actions; the machinery and technology behind the scenes—mostly consisting of ropes and pulleys—remained beyond the curtains. Suddenly, stage changes could occur seamlessly, transforming a romantic garden to the interior of a palace in mere seconds. This kind of stage set is what is currently used in Broadway and commercial plays today.

The term "Theatrum Mundi" was introduced as a result of the changes in theatre during the Baroque era, expressing that "the world is a stage." This type of theatre allowed for the real world to be re-created and manipulated. The staging of *Orpheus* at the Gran Teatre del Liceu in Barcelona is a great example of the production style used during the Baroque period. Despite the mythological nature of the opera, which takes place both on earth and in Hades, great pains were taken to mask the appearance of ropes and set workers during the play so as not to ruin the illusion.

Baroque Crosses Boundaries

Literature and music were also influenced during the Baroque era. Metaphors and allegories were often found in Baroque literature. And while the term "Baroque" in music was not used until 1919, many musical forms were born in the era of Baroque, including concerto, sinfonia, sonata, cantata, and oratorio.

GEORGIA O'KEEFFE (1887–1986)

Flower power at its finest

Georgia O'Keeffe is a true American original. This twentieth-century painter allowed the public to see familiar elements of nature as though viewing them for the first time. O'Keeffe was a major player in the development of American Modernism and is best known for vivid close-ups of flowers and animal bones as well as rich, dreamy landscapes of her beloved New Mexico.

GEORGIA BECOMES AN ARTIST

Georgia O'Keeffe was born in 1887 in Sun Prairie, Wisconsin. Her relationship with art formed early on: It began with lessons at home and grew as her instructors took notice of her unique talent. By the time she finished high school, O'Keeffe knew that she wanted to be an artist. In 1905, she began her studies at the Art Institute of Chicago and continued her studies in 1907 at the Art Students League in New York, under William Merritt Chase. Imitative realism was the curriculum of the moment and while she could create prize-winning still-life oil paintings, ultimately the genre left her uninspired and made her second-guess her future as an artist.

She stayed in Chicago long enough to dabble in commercial art before accepting a job as a teacher in the Texas public school system in 1912. During her first summer in Texas, she enrolled in some teaching courses at the University of Virginia, Charlottesville. She may have disappeared into anonymity if not for visiting professor Alon Bement, who took time to introduce O'Keeffe to the revolutionary ideas of his

colleagues at Columbia College in Columbia, in South Carolina. It was the groundbreaking philosophy of his colleague Arthur Wesley Dow that reawakened O'Keeffe's passion for creating art.

ARTHUR WESLEY DOW'S INFLUENCE

Arthur Wesley Dow was a specialist in Orientala. He believed that an artist should represent his or her deepest emotions using a balance of color, line, and "notan" (a Japanese term that refers to the skillful arrangement of darkness and light). Dow's perspective and that of his colleagues was a departure from the teachings of imitative realism, but it suited O'Keeffe so well that it would soon free her to create her signature works.

Georgia went to South Carolina in 1915 to study under Dow. When she returned to Texas, she incorporated the principles of Dow's teachings into her own art. The result was a collection of charcoal drawings of ferns, clouds, and waves unlike anything she had previously created. They were alive with emotional tension and energy.

ALFRED STIEGLITZ DISCOVERS GEORGIA O'KEEFFE

O'Keeffe mailed her groundbreaking collection of charcoal drawings to a friend in New York who then showed them to photographer and gallery owner, Alfred Stieglitz. Stieglitz was impressed. He found O'Keeffe's charcoal drawings so remarkable and vibrant that he soon put them on exhibition at his famous 291 Gallery. Thus, in 1916 Stieglitz introduced

the true Georgia O'Keeffe and her art to the public for the first time. In 1917, the two finally met and a love affair grew.

It took a few years for Stieglitz to divorce his wife and convince O'Keeffe to move to New York to paint full-time, but in that time he began to build her reputation with regular showings of her work in his gallery. The artists married in 1924 and spent the next two decades living and working together at the Stieglitz's family home in Lake George, New York and New York City. This dynamic and powerful artistic partnership altered the landscape of the Modernist era. Stieglitz's striking photographs of O'Keeffe (over 300 of them, showcasing every facet of her personality) became one of his greatest artistic legacies. Stieglitz promoted and displayed O'Keeffe's newest paintings in his gallery just about every year.

The 1920s were a momentous decade for O'Keeffe. She created some of her most popular works in this period, including *Black Iris* (1926) and *Oriental Poppies* (1928). Her alluring renditions of the intricacies of lush flowers added tension and eroticism to the genre of still-life paintings. While she is best known for these grand depictions of nature, living in the city also inspired famous paintings like *Shelton Hotel, New York No. 1* (1926).

GEORGIA'S UNIQUE STYLE

Georgia O'Keeffe regularly painted in oils and pastels, though she also worked in charcoal and watercolors from time to time. Her sharp eye and expert command of the paintbrush allowed her to translate the intricacies of color, shape, and light onto canvas in a way that brought simple objects to life. In this sense, she combined the forces of American pictorialism and European abstraction. She played with scale and employed vibrant

colors to create visual impact. O'Keeffe also liked to work in series. She explored the same flower, or animal bone, or landscape in three or four paintings over the course of a year, a decade, or more.

HER LOVE FOR NEW MEXICO

O'Keeffe's relationship with New Mexico began in 1929 when she vacationed in Taos with a friend. She fell in love with the colors of the landscape, the sky that went on for miles, and the natural relics she found there. Every chance she got, she returned to New Mexico to paint its colorful clay landscape, its clouds, and the animal bones that have since become famous. New Mexico infused her work in the 1930s with a new palette of colors and novel themes. A few years after Stieglitz died, in 1946, she made New Mexico her home, where she lived until her death in 1986.

O'KEEFFE'S LEGACY

Georgia O'Keeffe died at the age of ninety-eight, leaving behind a vast portfolio of more than 2,000 works. She has been called the first female American Modernist; a woman who steered her own path and found her own unique niche apart from current trends. Several decades after O'Keeffe's death, her famous abstractions of the natural world are on display in museums all over the world and are some of the most memorable icons of American art.

Groundbreaker

The Georgia O'Keeffe Museum in Santa Fe is the first American museum to be dedicated to a female artist.

ANDY WARHOL (1928–1987)

The artist for the people

Andy Warhol is the offbeat American artist who electrified the Pop art movement of the 1960s with his colorful screen prints of well-known celebrities and an endless portfolio of peculiar multimedia creations (including a six-hour video of a man sleeping). His bold screen prints took recognizable, mass-produced items, like a box of Brillo pads or a Campbell's Soup can, and reclaimed it as art. The sometimes mundane nature of Warhol's subject matter left his audience guessing: Was it a celebration or a critique of American commercialism?

Warhol loved to get people talking about his work and he created a public persona that kept him relevant. He dove willingly into the limelight, incorporating himself into the glitzy New York social scene and building his name into a strong, far-reaching brand. His quirky but accessible style remained deeply influential across fashion, film, art, music, and entertainment throughout the mid- to late twentieth century.

ROUGH TAKEOFF; SMOOTH LANDING

Warhol was born in Pittsburgh in 1928 to a working-class family of Czechoslovakian immigrants, and he grew up feeling like an outsider: His pale skin and shocking white hair was just the beginning. At a young age, he was bedridden with a rare illness (chorea) that covered his skin in pink splotches, causing him to shake uncontrollably and keeping him out of school for a long stretch of time. He withdrew into comic books, celebrity magazines, and drawing. Art became therapy for him, and would later grant him the widespread acceptance he craved.

After graduating high school, he went on to get a bachelor's degree in pictorial design from Carnegie Institute of Technology (now Carnegie Mellon University). Soon after settling in a Manhattan apartment, Warhol had a relatively easy time landing some impressive commercial art jobs. His advertising designs made it into *Glamour* magazine, *Vogue, Harper's Bazaar,* and Tiffany & Co.'s Christmas cards. Warhol's unique blotted-line technique garnered the attention of more than a few influential people and was reaching new audiences every day.

Famous Saying

Andy Warhol was obsessed with the notion of fame and the celebrity world. Warhol is attributed with the notion of fifteen minutes of fame. He said, "In the future, everybody will be world famous for fifteen minutes."

ARTIST AS DUPLICATOR

The blotted-line technique was something Warhol experimented with in college. He taped two blank pieces of paper together, making a sort of hinge and drew his design on one page in ink. Then he pressed the blank page onto the wet design and was left with a perfectly imperfect version of the first drawing. He added watercolor paints to achieve his desired more final effect. The real beauty of this technique was based in practicality. It allowed him to create several options from which his client could choose, thus increasing the chance that one of his designs would get him the work he wanted.

Later, to create more extensive series, he turned to silkscreening and generated bold, photograph-based artwork with sometimes garish color schemes and subject matter ranging from the mundane

(a Coca-Cola can) to the elegant (Marilyn Monroe). This technique yielded such famous works as the thirty-two-canvas study of Campbell's Soup cans that caused a stir at its gallery debut in 1962 and his famous portrait series of Marilyn Monroe and Mao Zedong of China.

The mechanical reproduction process became just as much a signature of Warhol as the art itself. He seemed to be moving as far away from handmade elements as possible. Warhol's screenprinting work in the 1960s echoed the growing impact of mass production and seemed to urge its audience to find something noteworthy in both the everyday and the celebrity world.

A MAN OF MANY FACES

Commissioned portraits of the rich and famous may have been Warhol's bread and butter, but he had no interest in restricting himself to any one genre. Just the opposite: He tried his hand at just about everything creative, including performance art, filmmaking, video installations, music—even fashion modeling. Each decade revealed a new side of him.

During the 1950s, Warhol made his mark in the field of graphic design and won various awards for his efforts. He dipped into book illustration as well, lending his artistry to a collection of Truman Capote's work and Amy Vanderbilt's *Complete Book of Etiquette*.

He was swept up in the Pop art movement that stormed America in the early 1960s and soon his series paintings of Coca-Cola cans, dollar signs, and celebrities like Jacqueline Kennedy Onassis were displayed at solo exhibitions in Europe and the United States. It was during this rebellious decade that Warhol also created an extensive library of films, including *Sleep*, which invited viewers to watch the poet John Giorno sleep for six hours, and *Eat*, a forty-five-minute

documentary of a man eating a mushroom. *Chelsea Girls* (released in 1966) stands out as his most widely acclaimed film. It consists of two side-by-side stories projected onto a screen with the volume adjusted as the focus alternates between stories.

In the 1970s and '80s, Warhol's influence spread across still more genres. When he wasn't hanging out with celebrities like Liza Minnelli and Bianca Jagger at the popular Studio 54, he could be found hosting his own television show, making an appearance on *The Love Boat*, designing award-winning album covers for the Rolling Stones, or helping to discover bands like The Velvet Underground and Nico.

Brush with Death

In 1968, a mentally unstable fan entered Andy Warhol's studio and shot him in the chest. He was pronounced dead at the scene but was miraculously revived by a doctor who opened up his chest and massaged his heart until it began beating again. This incredible brush with death was said to have made him more reclusive but did not stop him from creating heaps of new art.

THE LEGACY

Warhol died unexpectedly in 1986 after a routine gallbladder surgery. He was just fifty-eight years old. While many still look down on the idea of soup cans as art, even his greatest critics admit that he succeeded in bringing art to a wider audience of people from all social classes and walks of life. His subjects were accessible, his colors were bold and friendly, and his quirky persona (he was buried wearing sunglasses and a platinum wig) endeared him to an audience eager for his next wild experiment.

ICONOCLASM

Destruction in the name of religion

Throughout the history of art, one of the primary motivations for its creation has been religious in nature. Depictions of enlightened beings in Buddhist artwork date back to around 600 B.C., and representations of Jesus Christ and the Virgin Mary were prolific among early Christians. Even Islam, which generally forbids the depiction of living figures in religious works of art, has inspired religious artwork in the form of calligraphy and religious architecture. While religious artwork has inspired some of the most heralded masterpieces in human history, disagreements over what to portray and how have been the source of heated debate and even violence.

WHAT IS ICONOCLASM?

At its heart, iconoclasm is the destruction of or opposition to images or artwork depicting particular religious figures or themes. While the very definition implies antireligious sentiment, iconoclasts are more often firmly religious in their beliefs and motivations. Their desire to destroy religious works of art often stems from differing interpretations of doctrine and how it applies to art. However, it is not uncommon for practitioners of opposing religions to engage in iconoclasm against one another—for example, when Emperor Constantine first adopted Christianity and destroyed sculptures and artwork depicting Roman gods.

Although iconoclasm occurs in nearly every major religion, the most widely known instances of iconoclasm centered around the

Christian religion and occurred in the Byzantine Empire between A.D. 730 and 787 and again between A.D. 814 and 842.

FIRST BYZANTINE ICONOCLASM

In the centuries following the rise of Christianity, particular significance was placed on holy relics that were either physical remnants of various saints, such as bone fragments or vials of blood, or items identified with either Jesus or his disciples, such as portions of the cross on which he was crucified. Early Christians believed that physical proximity to these relics could bring them closer to the divine. Over time, this belief began to extend beyond physical relics and similar significance was placed on mere depictions of the saints, Jesus Christ and his disciples, and the Virgin Mary.

While many believed that religious paintings and statues served to strengthen their relationship with God, others felt the opposite was true. They adhered to a strict interpretation of the Ten Commandments, which states: "Thou shalt not make unto thee any graven image, or any likeness of any thing that is in heaven above, or that is in the earth beneath, or that is in the water under the earth."

In their opinion, those who created and prayed to religious images were idolaters, and the images themselves were obscene and blasphemous.

The two opposing philosophies came to a head around 730, when Emperor Leo III outlawed the worship of religious images and ordered many paintings, tapestries, and other items removed from churches. It does not appear as if Leo conferred with members of the church when making his proclamation, and even Pope Gregory III denounced his actions.

Following his death in 741, Leo's son Constantine V continued his father's stance on religious imagery, but his campaign of iconoclasm was met with hostility from many members of the church and citizens of the empire. In 754 he summoned approximately 330 bishops to the Council of Hieria to settle the matter, and it was determined that depicting holy figures using simple tools such as paint or wood was, in fact, blasphemous.

Constantine's campaign against religious imagery continued with his son Leo IV and would not end until Leo's wife Irene restored image veneration in 787, one year after Leo's death, while acting as regent for her son Constantine VI.

SECOND BYZANTINE ICONOCLASM

Irene's decree restored the worship of icons, but only temporarily. In 814, Emperor Leo V reinstituted a period of iconoclasm, citing the fact that many of his predecessors who allowed their subjects to worship icons had died in war or revolts, while those who banned the practice died of natural causes. His first major act of iconoclasm involved removing an image of Jesus Christ from the entrance to the Great Palace of Constantinople and replacing it with a simple cross.

Leo's decree became official in 815 and continued with his son Theophilus. It was not until Theophilus died and his wife Theodora took power as regent for their son Michael III that Byzantine iconoclasm would come to an end. She officially ended the practice in 843 and reinstituted the practice of icon veneration.

HENRI MATISSE (1869–1954)

Colorful nonconformist

Matisse was an unexpected artist: a reluctant law student fatefully turned painter whose work was detested at first, only to be revered shortly after. Entering the art world in the late 1800s, he attended prestigious art schools in Paris that taught classical techniques to create objective images. He ultimately could not commit to the strict art rules of the time and followed his instincts instead, using bold colors—often straight from the palette—to project emotion instead of reality and ignoring use of perspective.

A BUMPY ROAD TO FAME

Matisse's art career began at age nineteen while bedridden after a bout with appendicitis. To pass the time in recovery, his mother gave him art supplies with the simple instruction to paint according to his emotions and not the rules. Matisse was immediately captivated by painting and later explained, "From the moment I held the box of colors in my hand, I knew this was my life. I threw myself into it like a beast that plunges towards the thing it loves." Shortly after, in 1891, he quit law school and dedicated himself into the life of an artist, studying at the Académie Julian but moving on after a year to train with the more progressive Gustave Moreau.

A second attempt with art school was once again difficult; Matisse failed the drawing exam on the first attempt for the École des Beaux-Arts. In 1896, he joined the Société Nationale, which allowed him to display his artwork each year without needing approval. And approval he did not receive, as his work was reviled by his countrymen.

FAUVISM'S FOUNDING FATHER

Through John Peter Russell in 1897, an Australian Impressionist residing in France, Matisse was acquainted with the work of then no-name Vincent van Gogh, and then later Paul Cézanne and Paul Gauguin. So began Matisse's experimentation with color as a form of expression. While his earlier paintings were visually dark and somewhat somber, his work around 1900 became filled with vivid and freeform color. His paintings had markedly pronounced brushstrokes, fluid shapes devoid of shadows or perspective, and a looser style of pointillism, or the application of dots of pure paint to create an image. The unprecedented approach came to be known as Fauvism.

After an unsuccessful solo exhibition in 1904, Matisse relocated to southern France and a year later collaborated with painter André Derain who, although eleven years younger than Matisse, was considered a cofounder of the Fauvist movement. Fauvism lasted only so long as Matisse worked to promote it, in the first decade of the 1900s. Despite its brevity, Fauvism and Matisse's bold endeavors are considered an indispensable part of the avant-garde movement of the time.

The Wild Beasts

The term "Fauvism" was born of the first exhibition to collectively display the movement's works, in 1905. Critic Louis Vauxcelles negatively reviewed the paintings, which were roomed with a Renaissance-themed sculpture. To Vauxcelles, it was *Donatello au milieu des fauves!*" meaning "Donatello among the wild beasts." From then on, the painters were "fauves" to the mainstream.

POPULARITY WITH FOREIGNERS

In spite of derision from critics, Matisse was determined to perpetuate his unique approach to painting. He moved back to Paris in 1906 and remained there for another ten years while he tenaciously continued to paint and also experiment with lithography and sculpture. He not only lived and worked in the Hôtel Biron, a historic estate that housed artistic tenants, but established a school there as well. His new home allowed him to become acquainted with influential artists of the time; however, he was a man apart from them. His artwork was intended for those beyond the artistic elite. As Matisse described it in 1908, he wished to create art "for every mental worker, for the businessman as well as the man of letters, for example, a soothing, calming influence on the mind, something like a good armchair which provides relaxation from physical fatigue."

What Matisse lacked in French acceptance he gained elsewhere, beginning in Berlin. A German art dealer named Paul Cassirer had been previously involved in advocating French Impressionists and Post-Impressionists, and in 1908 he arranged an exhibit of Matisse's art in his home country. Less than a year later, American photographer Alfred Stieglitz displayed Matisse's art in his gallery in New York City.

In France, he became acquainted with Gertrude Stein in 1905, who became an important collector and supporter of his work, along with her brothers Leo and Michael and friends Claribel and Etta Cone (the Cone Sisters) from Baltimore, two wealthy socialites who amassed a large collection of French modern art in the early twentieth century. Perhaps just as important, Stein also introduced Matisse to Pablo Picasso.

Picasso was eleven years younger than Matisse, but the two remained lifelong friends. The two were opposites in style and appearance; Matisse was known to be orderly and conservative in

appearance and habits, while Picasso was physically smaller yet out-wardly egotistical and charismatic. Artistically their style differed as well, even though both were considered leaders of modern art. Their friendship in spite of their differences created an enduring rivalry that was as inspirational and motivating to the other as it was competitive.

While the artists both learned from each other and favored still lifes and female nudes, their artistic sensibilities were quite different. Picasso's Cubism portrayed aggressive abstractions that stemmed from his imagination. Matisse, on the other hand, preferred soothing, balanced use of shape and color inspired by what he perceived. Their styles created two divergent teams of devotees during their lifetimes, and their complementary differences still fascinate the art world today.

LIMITLESS EXPRESSION

Unlike some experimental artists in the modern movement, Matisse continued to evolve throughout his career without turning into an abstract painter. He found new influences and inspirations as he relocated to Morocco, Nice, and New York. To maximize his creativity, he would recurrently sculpt, draw, and write. His repertoire includes twelve livres d'artiste, or artist's books, which became popular among the avant-garde as compilations of text and illustrations, intended to be works of art in themselves. Later, after Matisse was diagnosed with cancer in 1941 and disabled by restorative surgery, he composed what he called his "flower books" containing a medley of colorful objects and body parts drawn using hand-cut paper stencils and cutouts. In 1947 he published a limited edition of one of these books, called *Jazz*, and considered the art to be "painting with scissors."

DAVID HOCKNEY (1937—)

The playboy of art

A major contributor to the 1960s Pop art movement, David Hockney's art explores a variety of mediums, including prints, portraits of friends, and stage designs. His artwork has varied from the abstract and personal, at times dealing with human sexuality and love, to the naturalistic, realistic style that he is most known for today. He has often been regarded as a playboy of the art world due to his relationships and involvement in unique artistic circles. Yet Hockney's tireless devotion to his artwork has never wavered, and he has enjoyed much success and praise as an artist.

LIFE AND EMERGENCE

Hockney was born on July 9, 1937, in Bradford, England, to Laura and Kenneth Hockney, who raised their children as strict Methodists. Hockney began exploring art as a young child in Sunday school as he drew cartoons of Jesus. Following a viewing of the Carl Rosa Opera Company's production of *La Boheme*, Hockney also developed a strong interest in musical theatre. This could be attributed to his synesthesia, a unique neurological condition that blurs the boundaries among the senses and causes him to "see" music as a spectrum of synesthetic colors.

In 1948, Hockney was awarded a scholarship to the Bradford Grammar School, where he decided to pursue a career as an artist. He enrolled in the Regional College of Art in Bradford in 1953 and began to paint with his preferred medium, oils.

He then attended the Royal College of Art in London, where he claimed to feel at home and took great pride in his work. It was at the Royal College of Art where Hockney was featured in the exhibition *Young Contemporaries*, which afforded him national recognition and established the arrival of British Pop art. In search for more meaningful subject matter, Hockney began to paint works about vegetarianism and poetry he enjoyed. This led to his exploration of his sexual orientation in his paintings, in which he would include words such as "queer" and "unorthodox lover."

In 1962, Hockney's final year at the Royal College of Art, Hockney protested against the school by refusing to write a required final essay, saying his artwork should be the assessed body of work. The Royal College of Art did not allow him to graduate, resulting in Hockney's sketch, *The Diploma*, which was set to auction for £20,000 in June 2013. The RCA later changed its regulations and awarded Hockney the diploma while recognizing his talent and evolving reputation.

Hockney traveled a great deal during the 1960s, visiting New York for the first time in the summer of 1961. It was in New York that he befriended Andy Warhol. Hockney's fascination remained on California, however, and he eventually made Santa Monica his home for some years. This new environment was the inspiration for a series of paintings of swimming pools featuring vibrant colors and a new tool, acrylic. One of the most famous paintings of the series was titled *The Splash*.

Open Expression

Hockney, who is openly gay, experienced his first true romance with nineteen-year-old student, Peter Schlesinger. Schlesinger quickly became Hockney's favorite

subject and he included him in various drawings that explored their intimacy. Yet Hockney has explored the nature of gay love in his portraiture from as early as 1961 in *We Two Boys Together Clinging*, named after a poem by Walt Whitman. *Domestic Scene, Los Angeles*, painted in 1963, also explores Hockney's sexual orientation, portraying one man showering while the other washes his back.

PROGRESSION IN ART

Hockney's artwork consists of prints, portraits of friends, and stage designs for the Royal Court Theatre, Glyndebourne, La Scala, and the Metropolitan Opera in New York City. Beginning in 1968 and for a number of years that followed, Hockney began focusing on painting portraits of friends, lovers, and relatives. These portraits followed the concept of naturalism, depicting things as they were actually seen. He often painted the same subjects for multiple portraits; some included his parents, writers, artist Mo McDermott, and fashion designers Celia Birtwell and Ossie Clark. *Mr. and Mrs. Clark and Percy* (1970–1971), one of his most famous paintings, is currently on display in the Tate Gallery in London.

Hockney's artwork shifted in the 1980s as he began to take Polaroid photographs of his subjects in motion and arranged them into a grid layout, creating a photo collage. The various photographs show the subject's movement from the camera's perspective, creating a narrative, almost as if the viewer is moving with the subject. This series of photo collages were called "joiners," and echoed the style of Cubism.

Hockney continued to experiment with his artwork through the 1990s as he began to explore new technologies. Hockney used a color laser copier to reproduce some of his paintings and was impressed

with the vibrancy of colors that could be achieved. He continues to explore different art technologies today and has painted hundreds of portraits, still lifes, and landscapes using the Brushes iPhone and iPad application.

A Profitable Partnership

Hockney has been represented by art dealer John Kasmin since 1963, and over the years, the two have found great success. In 2006, Hockney's painting *The Splash* sold for £2.6 million. *A Bigger Grand Canyon*, a series of sixty paintings that combined to produce one grand image, was sold to the National Gallery of Australia for a whopping $4.6 million. The record price for one of Hockney's paintings, however, remains with *Beverly Hills Housewife*, a twelve-foot-long acrylic that portrays collector Betty Freeman standing by her pool in a long hot-pink dress that was sold for $7.9 million at Christie's in New York in 2008.

A LIFE OF RECOGNITION

Hockney has received a great deal of recognition throughout his career as an artist, including the John Moores Painting Prize of the Walker Art Gallery in Liverpool in 1967; The Royal Photographic Society's Progress Medal in 1988; and the Special 150th Anniversary Medal and Honorary Fellowship in 2003 that recognized his sustained and significant contributions to the art of photography. The Other Art Fair declared Hockney Britain's most influential artist of all time in November 2011. In 2012, Hockney was appointed to the Order of Merit by Queen Elizabeth II, an honor restricted to twenty-four members at one time for their contributions to the arts and sciences.

WATERCOLOR

Portability meets utility

The art of watercolor painting can be found adorning the walls of ancient caves, hanging in the most prestigious art galleries and museums, and gracing the refrigerators of millions of parents the world over. It is one of the most accessible painting mediums, but it is also one of the most unpredictable and difficult to master.

WHAT IT IS

The defining characteristic of watercolor paint is, as the name would suggest, the use of water to thin the paint as opposed to oil. The paint is frequently manufactured using water-soluble binders that allow it to be stored dry and mixed with water later. This makes the medium very portable, as an artist can carry a large number of dry paints and mix them as needed.

Paints typically come in three grades: Artist, Student, and Scholastic, with the Artist and Student grades containing a higher concentration of pigments and fewer fillers. All three can be found dry in pans or wet in tubes.

The primary tools used to work with watercolor paints are similar to those for oil, with a few significant differences.

Paper

While watercolor paintings can be made on numerous surfaces, typically the paper used ranges from highly absorbent and roughly textured to uniformly smooth and almost completely nonabsorbent.

Because there is no true transparent white watercolor paint, watercolor paper is often white to allow the artist to create the illusion of white paint by leaving areas of the paper unpainted.

Watercolor Pencils

Similar to a colored pencil, the watercolor pencil allows the artist to draw fine details directly on the canvas or paper. Then, the artist can apply water directly to the painting using a brush and thin out the lines and blend them with the rest of the painting. The artist can also leave the strokes unsaturated to create bold, contrasting lines.

Watercolor Pastels

These function similar to watercolor pencils, but have a broader tip and can be used to shade in larger areas.

PROS AND CONS

What makes watercolor such a challenging medium is its unpredictable nature. While oil and acrylic paint more or less stay put when applied to the canvas, watercolor has a tendency to bleed and shift as it is absorbed into the paper. The absorbent quality of the paper also makes it difficult to cover up a mistake or significantly alter a painting once the artist has already begun working. With oil or acrylic, it is often possible to simply paint over areas of the canvas should a mistake occur. Because watercolor paint is generally transparent, mistakes tend to show through even after subsequent layers are added. However, it is possible to lighten or even remove some colors by wetting them with a clean brush dipped in water and then blotting the area.

Once mastered, however, watercolor allows the artist to produce effects that simply are not possible with other mediums. For example, a skilled artist can paint layers of paint with varying dilution and allow the colors from the previous layers to shine through. This technique can also be used to show gradients across a color spectrum or to create new colors.

The artist can also use the absorbency of the paper to change the appearance of the watercolor paint by saturating the paper with water prior to painting. This can create feathery wisps of paint that flow across the paper while the artist paints, with lighter areas surrounding darker ones where more paint has accumulated.

Van Gogh's Watercolors

Although best known for his vibrant oil paintings, the famous Dutch painter Vincent van Gogh produced some 150 watercolor paintings during his short and tragic career. Unfortunately, few survive and the authenticity of those that are presumed to have been preserved is questionable.

FROM CAVE WALLS TO THE LOUVRE

Watercolor may have first appeared as many as 40,000 years ago, when ancient humans used water mixed with clay pigments to create elaborate paintings on the walls of the caves they inhabited. The resulting works of art can still be seen in hundreds of cave sites throughout the world. Watercolors were also used to add colorful flourishes to ancient Egyptian manuscripts. The medium did not gain widespread appeal, however, until the Renaissance.

At first, most artists mixed their watercolor paints on their own. However, in the eighteenth century, specialty shops began opening up in Europe that produced the paints in the form of dried cakes. Once the medium became more accessible to the masses, the popularity of watercolor painting grew immensely. It became a pastime of the aristocracy and became especially popular among artists and mapmakers in England. In America, artists such as Winslow Homer, Georgia O'Keeffe, and John Singer Sargent found the medium ideal for depicting landscapes and capturing the rapidly changing weather patterns of the American countryside.

Artists on the Go

Before companies manufactured portable kits en masse, early watercolor artists constructed their own. Books and pamphlets on watercolor technique and theory often contained detailed instructions for crafting portable painting kits made of ivory, wood, leather, tin, and a multitude of other materials. They contained room for brushes, various color cakes, mixing pans, scrapers, and other tools.

While underrepresented both in museums and on the list of the world's most valuable paintings, watercolor still remains a popular art form among professionals and amateurs alike. Its versatility and portability have been the cornerstones of its appeal since its inception, and it is unlikely the medium will fall out of favor anytime soon.

CAVE PAINTING

The first artists

Millennia before humans first set brush to canvas, our ancestors adorned caves with drawings ranging from simple figures to elaborate hunting scenes. Once believed to be nothing more than crudely drawn hoaxes, cave paintings have been discovered in hundreds of locations scattered across every major continent.

FACT OR FICTION?

The first major discovery of cave paintings came in 1876 when archaeologist Marcelino Sanz de Sautuola stumbled upon Spain's Altamira cave. The entrance had been sealed by fallen rocks some 13,000 years earlier, but a fallen tree disturbed the blockade and revealed a stunning gallery of intricate drawings adorning the walls and ceilings. The subject matter consisted mostly of large animals including deer, horses, and herds of bison, and were created using charcoal and ochre pigments. Outlines of human hands also appeared throughout the 300-meter length of the cave. The paintings were so detailed and elaborate that Sautuola's contemporaries accused him of forgery. They refused to believe that ancient humans were capable of such extraordinary works of art.

As it turned out, the paintings were quite authentic and we now know they were painted as many as 35,000 years ago. Radiocarbon also reveals that the paintings may have been completed over the course of 20,000 years, as opposed to in a single session. If the dating is accurate, this would mean that hundreds of generations of

early humans retouched the drawings and added their own figures over the course of millennia.

The caves are no longer open to the public, as it was discovered that carbon dioxide in human breath could damage the paintings. An exact replica of the cave and its paintings resides near the original site and is open to the public.

FROM FINGERPAINTS TO ANCIENT MASTERPIECES

Since Sautuola's discovery, caves with paintings of varying skill have been discovered all around the world, with more than 300 in Europe alone. Some of the drawings are crude, like the red spheres and hand outlines found in Spain's Cueva de El Castillo. These are believed to be the oldest ever discovered, dating as far back as 40,800 years. Their age makes it possible that they were actually painted by Neanderthal man, but most scientists believe they were drawn by modern humans. Others are more elaborate, such as the Chauvet Cave paintings in France where the artists cleared the walls of debris before painting and even etched the stone around some of the animals to add a three-dimensional quality. Also in France, the paintings of the Lascaux Caves number close to 2,000 with one image of a giant bull stretching for 17 feet.

THE FIRST CARTOONISTS

Many animals depicted in cave paintings throughout France appear to possess erroneous appendages and heads. Archaeologists have

been baffled by the phenomenon for decades, but Marc Azéma of the University of Toulouse-Le Mirail believes he has the answer. When viewed alongside the light produced by a small fire or torch, Azéma speculates the images on the cave walls would have flickered and "moved" depending on which portion of the figures was illuminated. He believes the extra limbs were far from accidental, and may have been the first animated images created by humans.

An example of a cartoon-like cave drawing

WHAT THEY DREW AND WHY

The focus of the vast majority of cave paintings are large animals that ancient humans would have encountered and hunted in their daily lives. Depending on the region, the animals vary from grazing herbivores and megafauna like the woolly mammoth to predators like lions and tigers in Africa and Asia. While hand tracings are quite common in cave paintings found throughout the world, actual

depictions of human beings are few and far between. When they do appear, they are rarely as detailed as their animal counterparts. No one is certain of the reason for the dearth of human images, but some speculate our ancestors may have adhered to strict taboos forbidding the graphical representation of human beings. Also absent are images of foliage or landscapes in any large number. Not all of the cave paintings are tangible animals or figures, however. Many drawings depict geometric shapes and dots that may have been used as primitive calendars.

While brushes have been found made from animal hair, many cave paintings were likely created by blowing pigments onto the cave surface from the mouth or using small tubes. Ancient humans also used their fingers to create designs combined with rocks and other tools.

Modern-Day Cave Paintings

Not all cave paintings are ancient. In fact, the art of cave painting is very much alive to this day. In Malaysia, the Negrito tribe even incorporates modern items like automobiles into their artwork.

We may never know why our ancestors created such elaborate works of art and why they maintained them from generation to generation, but there is no shortage of theories. Building off of the notion of taboos forbidding human representation, some anthropologists speculate that the paintings may have had religious significance. They theorize that early holy men would retreat to the depths of the caves on vision quests and re-create what they saw in their visions on the cave walls. Others insist the paintings were used for storytelling

and held more cultural than religious significance. The prevalence of hand outlines could indicate that the process was a rite of passage for members of the tribe, with members tracing their hands as they came of age.

Whether magical, religious, cultural, or merely for decoration, the thousands of cave paintings found throughout the world serve as a direct link between the artists of the past and the artists of today. For any who question the artistic merit of these "crude" cave sketches, you do well to take heed of the words of Pablo Picasso on the subject. When he first viewed the paintings in Lascaux he allegedly emerged and remarked, "We have learned nothing in twelve thousand years."

VINCENT VAN GOGH (1853–1890)

The archetypical starving artist

Virtually unknown during the majority of his career—some historians insist he sold but one painting in his lifetime—Vincent van Gogh is now one of the most prominent artists in history. At the time of his death at age thirty-seven, Van Gogh had produced some 1,000 watercolors and sketches and approximately 900 oil paintings, which routinely sell for tens of millions of dollars today. His short career was plagued by failure and mental illness, but some believe this hardship was essential for his creative genius.

EARLY LIFE

Vincent van Gogh was born on March 30, 1853, in Groot-Zundert, Holland. He expressed interest in the arts early on, and at the age of sixteen traveled to the Hague to work in an art gallery. He was later transferred to galleries in London and Paris, but quickly lost interest in art dealership and, after briefly trying his hand at ministry, chose to pursue a career as an artist.

Mostly self-taught at first, Van Gogh enrolled in the Académie Royale des Beaux-Arts in Brussels from 1880 to 1881 but did not enjoy the experience. Instead of studying art theory, he preferred to focus his early attentions on creating portraits and watercolor paintings that captured the working class going about their daily lives. It wasn't until Van Gogh settled in the Hague, however, that

he discovered oil painting and created some of his most famous pieces.

The Dutch realist painter Anton Mauve took Van Gogh under his wing in 1882 and instructed him in the use of oil paints, which would later become his favorite medium. About the same time, Van Gogh began a relationship with Clasina Maria "Sien" Hoornik, who served as both a domestic partner and as a model for many of his paintings.

THE ARTIST PERSEVERES

Despite a lack of paid commissions, Van Gogh continued with his art. His obsession with the working class led him to paint his first major work, titled The Potato Eaters, in 1885. The painting featured a group of peasants seated around a table enjoying a meal in a poorly lit room. He chose to use objectively unattractive models to make the painting seem more realistic and allow viewers to connect more deeply with the plight of the working class. The painting was considered a failure by Van Gogh's most trusted critic—his brother Theo—as well as many of his contemporaries; however, he remained quite proud of it until his death.

Soon after, Van Gogh began painting still lifes in dark earth tones in direct contrast to the bright colors of his Impressionist contemporaries. The interest for his new paintings was no greater than his earlier works of peasant life, but still he persisted. Toward the end of 1885, he moved to Antwerp, where he rented a small studio and immersed himself even more heavily in his art. He drank to excess and ate little. His health deteriorated and his work continued to be ignored.

Manic Correspondence

Much of what we know about Van Gogh's life and struggles come from approximately 600 letters exchanged between himself and his brother Theo. Van Gogh began the correspondence when he was nineteen, and he continued to write letters to his brother discussing his life and art until his death.

When Van Gogh moved to France in 1887, his art took a drastic new turn. Surrounded by Impressionist influences, he adopted a brighter color palette and began painting local landscapes that would later become some of his most famous works. Just as he was honing his artistic vision, however, his mental health began to suffer.

DESCENT INTO MADNESS

Toward the end of his life, Van Gogh battled depression, epileptic seizures, delusions, and psychotic outbursts. His mental situation came to a head when he attacked his friend and contemporary painter Paul Gauguin with a razor blade, then fled to a local brothel. Once there, he removed a portion of his left ear and gifted it to one of the prostitutes. The next morning Gauguin discovered him unconscious at his home, bleeding profusely, and took him to the hospital.

Shortly thereafter, Van Gogh checked himself into a mental hospital in Saint-Paul-de-Mausole where he would paint his most famous masterpiece, *Starry Night*. Similar to *Starry Night*, many of his other paintings produced during his institutionalization took on a surrealistic tone, littered with long swirling brushstrokes that created a hazy, dreamlike effect. Van Gogh left the asylum a year

later, but his mental state would never fully recover. Just two months after leaving the hospital, he shot himself in the chest. He actually survived the initial wound, but died two days later from a resulting infection.

THE WORLD TAKES NOTICE

Although many of his contemporaries appreciated Van Gogh's work during his lifetime, he did not achieve worldwide recognition until after his death. Following the death of his brother Theo some six months later, Theo's wife collected all of Van Gogh's work and sought to get him the recognition he never achieved in life. Memorial exhibitions shortly after his death exposed his paintings to art enthusiasts throughout Europe. As time passed, Van Gogh's popularity grew, with retrospectives and exhibitions that featured his work taking place in the early twentieth century in Paris, New York, and Amsterdam.

Today, Van Gogh's paintings are some of the most valuable in existence. His *Portrait of Dr. Gachet* sold for more than $80 million in 1990 and *Irises* sold for more than $53 million in 1987. His most famous painting, *Starry Night*, can be found in the Museum of Modern Art in New York City and is one of the museum's most popular pieces.

THE *MONA LISA*

The most famous painting on earth

Despite the diminutive size of Leonardo da Vinci's *Mona Lisa*—it takes up just 31" x 21" of wall space (not counting the bulletproof glass)—his portrait is arguably the most famous painting in existence. The *Mona Lisa* attracts an estimated six million visitors annually to its home at the Louvre in Paris, many of whom wait several hours just to spend a few seconds with the masterpiece. It's graced the halls of the Palace of Versailles; adorned Napoleon's personal bedroom in Tuileries Palace; and, from 1911 to 1913, sat hidden in a trunk in an unassuming Paris apartment.

BIRTH OF A MASTERPIECE

Taking away the fame and fanfare associated with the painting, the *Mona Lisa* is simply a portrait of a young woman seated in front of an imaginary mountainous landscape painted in oil. The identity of the model has been a subject of heated debate for centuries. Some insist the portrait actually depicts Da Vinci himself in female form, while others contest she may never have existed outside of Da Vinci's imagination. The most popular theory, however, states that the woman is Lisa Gherardini, a French aristocrat and wife of the prominent silk merchant and politician Francesco del Giocondo.

If the most popular theory is to be believed, Giocondo commissioned Da Vinci to paint the portrait in 1503, but he never received a finished piece. Instead, Da Vinci carried the *Mona Lisa* with him for many years but ultimately left it unfinished. Upon his death in 1519,

it passed to his apprentice Salaì, who sold it to the king of France to be kept at the Palace of Fontainebleau. Many years later, it was given to Louis XIV before making its way to the Louvre during the French Revolution.

THEFT

Despite its estimated value of nearly $750 million, attempts to steal the *Mona Lisa* are rare and almost never successful. Almost.

On the morning of August 22, 1911, a French painter walked into the Salon Carré of the Louvre and discovered the *Mona Lisa* was not resting in its usual location. Security initially assumed the painting was being photographed elsewhere in the museum, but quickly discovered it was nowhere to be found. An intensive investigation of the Louvre ensued, which left the museum closed for a week. An international hunt for the famous work of art continued for the next two years.

In the weeks following the theft, the Louvre posted a reward of 25,000 francs for the painting's safe return, but no one came forward with any information regarding the whereabouts of the *Mona Lisa*. The theft made national news, with several French newspapers offering their own rewards for anyone who could help track down Da Vinci's masterpiece. Accusations and conspiracy theories quickly emerged with some blaming an unknown American millionaire bent on snatching up French art to the Kaiser of Germany himself attempting to bring shame to the French people as tensions mounted between the two countries before World War I. As it turned out, the painting spent the majority of its time away from the Louvre locked in a trunk just a mile away from the museum.

The culprit, an employee at the Louvre named Vincenzo Peruggia, was caught in 1913 when he attempted to sell it to the Uffizi Gallery in Florence, Italy. Two nights before the painting was discovered missing, Peruggia hid inside a broom closet and emerged the following morning while the museum was closed to the public. Blending in with the other museum employees present that day, he waited until the room containing the *Mona Lisa* was empty and removed it from the wall. After retreating to a stairwell to conceal the painting under his clothes, Peruggia simply walked out of the museum.

Once under arrest, Peruggia insisted the theft had been an act of patriotism in order to return the *Mona Lisa* to its rightful place as an Italian treasure. The Italian courts took his claimed motivation into account when sentencing him and he served just six months in jail for the theft.

The Girl in the Bubble

Both to preserve the painting and to protect it from theft and vandalism, the *Mona Lisa* is kept in a climate-controlled case made of bulletproof glass. The temperature is kept between 64 and 70 degrees Fahrenheit with humidity around 50 percent.

JE NE SAIS QUOI

While it is difficult to dispute that the Mona Lisa is a masterpiece, it is often just as difficult for anyone to explain why. However, there are a couple of notable features that tend to stick with the observer:

- First, the eyes of the woman depicted in the portrait have an uncanny ability to follow observers around the room as they

view it. This is not unique to Da Vinci's painting, and is actually a phenomenon produced when we view any static two-dimensional image from different angles. Nonetheless, this feature never ceases to amaze visitors and is one of the piece's defining characteristics.

- The second famous element of the most famous painting on earth is the woman's enigmatic smile. It is vibrant and radiant one moment, and then indifferent and passive the next. Similar to her wandering eyes, the *Mona Lisa*'s changing smile has a scientific explanation. Depending on where in the painting you focus your attention, different areas of your eye will decode the woman's face and the result can be a more exaggerated smile. For example, if you focus on the eyes, her lips are in your peripheral vision and are not as clear. Thus, her smile appears more broad. If you focus on her lips, however, her smile appears in greater detail and is more likely to be described as neutral.

Regardless of the artistic merit of Leonardo da Vinci's *Mona Lisa*, there is no denying the cultural impact his small portrait has had on the artistic community. Her face is more recognizable than any celebrity, politician, or athlete in recorded history and she shows no signs of fading into obscurity anytime soon.

BODY ART

Seven billion canvases and growing

Many people assume that the first art created by humans took the form of small sculptures, seashell jewelry, or cave drawings. But as it turns out, that might not be the case. It's actually quite possible that our ancestors used a far more intimate medium for their first masterpieces: their own bodies.

BODY PAINTING

Notable for its lack of permanence, body painting is one of the most popular forms of body art throughout the world and is also likely the oldest. While the earliest cave drawings date back some 40,000 years, some anthropologists speculate that *Homo heidelbergensis*, an early ancestor of *Homo sapiens*, may have adorned their bodies with red pigments as many as 500,000 years ago. The first simple clay pigments called "ochres" likely served to help *Homo heidelbergensis* identify one another from a distance.

Since then, the uses for body paintings have evolved, as have the tools used to create them.

One of the most elaborate forms of body painting originated in Indian culture, but has since made its way into Western fashion and culture. The practice of Mehndi, also commonly referred to as "henna art," involves the application of brown dye to the skin to create ornate semipermanent artwork. Traditionally reserved for weddings and other special occasions, the design can take many hours to create and will gradually fade over a period of several weeks.

In modern society, the uses for body painting are a mix of artistic exploration, recreation, and practical application. Nearly everyone has witnessed a face painter adorning children's faces with tiger stripes at a fair or been delighted (or terrified) by a white-faced clown with exaggerated, drawn-on features. The makeup industry is worth approximately $50 billion in the United States alone, while the practice of full-body painting is becoming an increasingly popular means of expression for artists. While the artistic merit of these sorts of body painting are debatable, there's no questioning the ubiquitous existence of the art form.

TATTOOING

Similar to body painting, tattooing creates designs on the skin varying from simple lines and dots to elaborate landscapes and portraits. The important difference is that tattoos are intended to be permanent.

It is difficult to determine how far back tattooing dates in human history, due to the fragility of the canvas: human skin. However, several ancient Egyptian mummies as well as Ötzi the Iceman were discovered with evidence of tattoos on the preserved skin, indicating the practice dates back at least several thousand years.

The process for tattooing ranges from the simple method of rubbing charcoal into an exposed wound to modern tattoo machines, which can inject ink into the skin more than 100 times per second. In some cultures, tattoos are created using a needle or sharpened bone to inject the dye into the skin without the aid of a machine during a painful and lengthy process, even today.

The reasons for tattooing are even more varied than the methods for doing it. Many tribes, such as the Polynesian Māori people, use tattooing as both a rite of a passage and an adornment to appeal to the opposite sex, while others use it as a means to intimidate their enemies. A popular form of tattooing in Southeast Asia some 2,000 years ago called "yantra" was believed to imbue the wearer with magical powers that would protect him in battle. Not all tattooing is beneficial to the wearer, however. Ancient Romans tattooed runaway slaves as punishment, while the Nazis were notorious for tattooing prisoners with numbers to identify them.

Guinness Record for Tattoos

The Guinness record for most tattooed person goes to New Zealand native Gregory Mclaren, a.k.a. "Lucky Diamond Rich." Mclaren sports tattoos on 100 percent of his body, including his gums, the inside of his foreskin, and the skin between his toes.

BODY MODIFICATION

Arguably the most controversial form of body art, body modification refers to any number of methods used to alter the physical appearance of the body. This can range from minor alterations, such as ear piercings, to more drastic modifications, such as the process of skull-binding—a practice of the Paracas people of Peru and other tribes throughout the world to elongate the cranium. As with tattooing, body modification often carries with it religious and ceremonial significance.

One of the most well-known examples of body modification can be found in the Kayan women of Burma. Traditionally starting at the age of five, brass rings are slowly added to the necks of female members of the various tribes. Eventually, the neck appears to have greatly increased in length; however, this is merely an illusion. Instead, the weight of the rings compresses and lowers the collarbone to give the impression of a long, slender neck. While the practice is decreasing in popularity, it is still quite common in the region.

Another popular body modification spans the globe and comes in the form of ornamental lip plates. Practiced by tribes in Africa, the Amazon, and the Pacific Northwest, the process usually begins with a small incision to the upper or lower lip (or both) which is kept open with a piece of wood, clay, or other object until it can heal. Later, discs of various sizes stretch the hole until it reaches a desired diameter. The size of the disc often equates to social status or denotes exceptional beauty.

The practice of body modification has made its way into modern culture as well, with piercings, tongue splitting, branding, and subdermal implants becoming increasingly common practices.

MARINA ABRAMOVIĆ (1946—)

Pain is beauty

The self-proclaimed "grandmother of performance art," Abramović's artistic career spans more than forty years from the 1970s until today, focusing predominantly on the relationship between the audience and the artist using her own body as her primary means of artistic expression. Her performances often contain controversial elements ranging from self-mutilation and drug use to violence and nudity.

EARLY LIFE AND PERFORMANCES

Abramović was born in 1946 in Belgrade, Serbia, where she lived until the age of twenty-nine. She attended the Academy of Fine Arts in Belgrade from 1965 to 1970 and later taught at the Academy of Fine Arts at Novi Sad. It was there that she began staging her first performances.

Her first notable piece, titled *Rhythm 10*, took place in 1973 and featured the young artist surrounded by a collection of various knives, which she used to play a popular game. After turning on a tape recorder, Abramović splayed her hand out on the ground, picked up a knife, and rhythmically jabbed it into the spaces between her fingers in rapid succession. Whenever she missed and cut herself she moved on to a different knife and began again. After twenty cuts, she listened to the recording and attempted to re-create the experience: both the cuts she made and the resulting cries of pain.

The following year, Abramović performed several additional pieces in her *Rhythm* series, the first being *Rhythm 5*, during which the artist threw trimmings from her own hair and nails into a large flaming communist star on the floor. The piece culminated with her jumping into the star's center, at which point she quickly lost consciousness due to lack of oxygen and had to be rescued by several members of the audience.

Losing control of her ability to perform in her previous piece left Abramović frustrated, but determined to incorporate that sense of helplessness into her next performance, *Rhythm 2*. In this piece, Abramović ingested a pill normally reserved for patients suffering from catatonia, after which she experienced violent seizures and spasms. Since her mind was unaffected, Abramović could observe the physical changes in her body but could do nothing to alter them. After the effects of the drug wore off, Abramović ingested a second pill, which removed her mind from the performance but left her body unaffected.

Her final, and arguably most dangerous, *Rhythm* piece was titled *Rhythm 0*. In this performance, Abramović stood naked in front of a table containing seventy-two objects the audience could use on her however they chose. Some objects were harmless, such as a feather or perfume, but many of the objects were dangerous weapons such as knives, razor blades, and even a loaded gun. For six hours, she stood silent as members of the audience poked, prodded, cut, and carried her around at their whim, with one patron even pointing the loaded gun at her head. At the end of the performance, Abramović stood up and walked out, bloodied and bruised but alive.

RELATIONSHIP AND COLLABORATIVE WORK

Abramović's solo performances ended shortly after the completion of her *Rhythm* series when she began dating another performance artist, Uwe Laysiepen, who took the single name Ulay. The two considered themselves two parts of one being and their collaborative performances often reflected that belief. In the performance piece *Breathing In/Breathing Out*, for example, the two artists positioned their mouths against one another's and shared breaths back in forth, with one artist exhaling while other inhaled. The performance lasted for seventeen minutes, until both passed out from lack of oxygen.

In another collaborative piece, Abramović and Ulay stood naked in a doorway while audience members were forced to squeeze between them and decide which one to face.

The couple's eventual parting was in itself a performance art piece. In 1988, Abramović started walking along the Great Wall of China from the Yellow Sea while Ulay began from the opposite end near the Gobi Desert. After walking more than 1,500 miles during the course of ninety days, the two met in the middle and ended their relationship as well as their final piece together, titled *The Lovers*.

Change of Heart

Abramović and Ulay actually developed the idea to walk along the Great Wall several years prior to their completion of *The Lovers*. They intended for the original performance to end with their getting married in the middle, instead of breaking up.

REEMERGENCE

In 2010, the Museum of Modern Art in New York City re-created a number of Abramović's most famous performances and the artist herself performed a new piece entitled *The Artist Is Present*. For the performance, Abramović revisited the theme of the relationship between the artist and the audience by setting up a table and chairs where patrons could sit across from her for as long as they wished without moving or speaking. Over the course of several weeks, Abramović sat for approximately 736 hours, arriving before the museum opened and often staying with guests after it closed. During that time, she remained entirely emotionless, apart from a brief embrace which she shared with Ulay with hands stretched across the table when he arrived unexpectedly on the opening day of the performance.

Abramović continues to perfect her performance art and plans to continue doing so until she dies. At which point, in her final performance, coffins will be placed in Belgrade, Amsterdam, and New York with no indication of which one (if any) contains her remains.

THE GOLDEN RATIO

The mathematics of beauty

First described by the Greek mathematician Euclid, the Golden Ratio refers to any two quantities where the ratio of the smaller to the larger is the same as the ratio of the larger to the sum of both. Also known as the Divine Proportion, the resulting number of approximately 1.618 is often represented as **φ**, the Greek letter phi. Since Euclid's explanation of the mathematical principle, and possibly thousands of years before, the Golden Ratio has been a cornerstone of architectural design, sculpture, painting, and even music.

THE GOLDEN RECTANGLE

While the basis for the Golden Ratio refers to two points on a line, this principle can be extrapolated to apply to any manner of geometric shapes. Most common in art and architecture is that of the Golden Rectangle. In the following figure, you can see that the length of one side of the rectangle can be used to form a square section, which if removed leaves another Golden Rectangle with the same aspect ratio as the original.

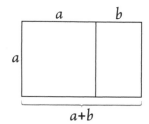

Golden Rectangle

ART 101

IN ARCHITECTURE

Evidence for the existence of the Golden Ratio in ancient architecture is compelling; however, there is much debate over whether the proportions were intentional or coincidental. For example, the spacing from the center line to the outside of the columns of the Greek Parthenon are in the Golden Ratio, as is the height of the columns relative to the horizontal beam resting at the top of the structure.

Before its smooth outer shell eroded away, the Great Pyramid of Giza may well have formed a Golden Ratio more than 2,200 years before Euclid first described the concept. Other notable structures with elements that closely adhere to the Golden Ratio include:

- The Great Mosque of Kairouan
- Notre Dame Cathedral
- Stonehenge
- The Taj Mahal
- The Temple of Apollo

In modern architecture, the use of the Golden Ratio is often less ambiguous. The Swiss architect Le Corbusier used the Golden Ratio as a fundamental principle to create his Modulor system, a philosophy influenced by mathematical proportions in the human body applied to architecture. The exterior of one of his most famous works, the United Nations Headquarters in New York City, contains Golden Rectangles throughout its exterior, as does his Villa Stein in Garches, France.

IN ART AND MUSIC

The Golden Ratio can be found scattered in famous works of art throughout history, but similar to its appearance in architecture, it is difficult to determine whether the artists intentionally adhered to the Golden Ratio or if it was just a happy accident. Many art historians and scientists insist the proportions of Da Vinci's famous *Mona Lisa* strictly adhere to the Golden Ratio and that is the reason for its undisputed visual appeal.

But as Frank Fehrenbach, Renaissance expert and professor of art history at Harvard University put it in a 2006 article for *Live Science*: "Art historians will sometimes treat paintings with a meter stick to find some kind of hidden geometry, but you can always find something if you're looking."

Regardless of intent, however, the Golden Ratio can be found in *The Sacrament of the Last Supper* by Salvador Dalí, *Bathers at Asnières* by Georges-Pierre Seurat, Michelangelo's *David*, and countless other famous works.

Many also speculate that several composers, most notably Wolfgang Amadeus Mozart, may have arranged their compositions in respect to the Golden Ratio. Because the sonata-form movement consists of two parts (the exposition and the development and recapitulation), the two parts can be compared to determine their relationship in regard to the Golden Ratio. Using the first movement of Mozart's *Sonata No. 1 in C Major* as an example, the two parts consist of thirty-eight measures for the exposition and sixty-two measures for the development and recapitulation. When compared, the two sections translate very closely to the Golden Ratio of 1.618, although not perfectly.

THE GOLDEN RATIO AND HUMAN BEAUTY

Some scientists speculate that the beauty of a human face can be objectively determined using the Golden Ratio. In theory, a face where the length and width are close to a 1.6 ratio is more aesthetically pleasing than one where the proportion is significantly greater or less.

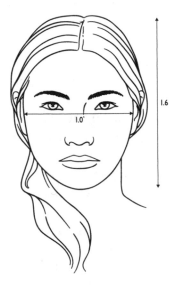

OKAY, BUT WHY?

Possibly much more important than the question of how artists use the Golden Ratio in their work, is why?

Whether employed purposefully by the artist or subconsciously, there is no denying that humans respond well to the Golden Ratio. In one experiment, Italian scientist Cinzia Di Dio showed volunteers

with no artistic background slightly distorted images of famous sculptures alongside the originals that fell within the Golden Ratio. When viewing the originals, areas of the brain corresponding to emotional memories lit up with activity. When volunteers viewed the distorted versions, this brain activity ceased. The subjects were also asked to rate the various images based on how visually appealing they found them to be. Time and time again, the volunteers selected the pieces adhering to the Golden Ratio as more beautiful.

One scientist thinks he has uncovered the reason. According to his study conducted in 2009 at Duke's Pratt School of Engineering, the reason behind our preference for the Golden Ratio is hard-wired into our brains. Adrian Bejan, a professor of mechanical engineering at Duke University and his team found that the human eye can scan an image more quickly when it contains elements of the Golden Ratio. Humans, like many animals, are most likely to encounter dangers across the horizontal axis instead of from above or below. As a result, we are more visually in tune to images that follow that linear pattern and find them more appealing. As it turns out, images that adhere to the Golden Ratio follow this pattern as well. So what we presume to be beauty, might actually just be our brain's appreciation for an image that it doesn't have to work hard to sort out.

ÉDOUARD MANET (1832–1883)

Causing scandal one canvas at a time

Édouard Manet was a French painter who did everything but follow the rules of academic painting. He challenged the popular perception of art by using traditional formats to portray modern-day leisure and (some would say) lechery. His loose brushstrokes, bawdy subjects, and bold nudes remained barriers to his acceptance in the art scene but would eventually endear him to a new generation of soon-to-be-Impressionist painters.

FINDING EARLY INSPIRATION

While his high-society parents struggled to interest him in just about anything else, Manet held a persistent appreciation and aptitude for art. Eventually they gave into the charismatic boy and sent him to Paris to study under Thomas Couture, a traditional history painter.

Manet spent a significant portion of his art education copying the masterpieces hanging in Paris's museums. He never truly identified with his teacher's by-the-book style, but in their travels together through Europe, Manet met artists who did impress him. The Spanish artists Diego Velázquez and Francisco José de Goya inspired the dark tonal contrast present in Manet's paintings and influenced his choice of subject matter for years to come.

THE MANET TOUCH

Manet worked mainly in oils, producing more than 400 paintings in this medium, although he also painted in watercolor and pastels. His trademark style came from reinventing traditional formats (full-length portraits, for example) using modern-day, urban subjects (a barmaid, a heavy drinker, a dancer). Manet's work reflects a serious commitment to poet friend Charles Baudelaire, who made a call to artists to paint modern life. Manet would walk the streets of Paris for hours in this endeavor, pausing to make sketches and record the activity that would form the basis of his next piece.

The artist's brushstrokes and manner of painting were as controversial as his modern subject matter. He was one of the first to abandon the traditional method of layering various colors of paints to achieve a desired color. Instead, he simply painted with the color he saw in his subject, favoring the suggestion of detail over the exact replication of it. This technique—known as *alla prima*—freed the painter to work more spontaneously and to create dramatic contrasts of color. The Impressionists would later adopt it as it helped them match the changes in light they witnessed in real time. Manet's finished work was characterized by a much "flatter" appearance than that of his contemporaries. While this feature was often attacked as the mark of an amateur, it would later gain popularity and respect with the rise of modern art.

On His Own Terms

"I paint what I see and not what others like to see." —Édouard Manet

MANET VERSUS THE SALON

Overall, what made Manet's work distinctive was also what made it controversial. Its homage to traditional pictorial arrangements was often "perverted" by its use of everyday, urban subjects plucked straight from the streets of Paris. While the Parisian Salon was the key to notoriety for emerging artists like Manet, its traditional leanings often stood in the way of his success.

Manet began submitting his realist paintings in 1859, and continued to gain the Salon's acceptance throughout his career. His first submission, *The Absinthe Drinker*, was rejected for its traditional approach in depicting a very untraditional subject: The full-length portrait took a man on the fringes of society and gave him a place center stage. It was the beginning of a long clash between Manet's bohemian ideals and the stifling traditions of the art world. The everyday person; the socially disenchanted; the dregs of society would enjoy a disproportionate amount of attention from Manet, and this offended many of his critics and peers.

Manet's first Salon acceptance came in 1861 when his painting *The Spanish Singer* received honorable mention. In 1863, however, more than half of the Salon's entries were rejected, including Manet's *Le Dejeuner sur l'herbe (The Luncheon on the Grass)*, which portrayed two fully-dressed men enjoying a relaxing picnic while a nude woman reclines beside them and another bathes in the background. When the painting was displayed at a unique showing of rejected Salon entries, it caused a great uproar. It didn't matter that the painting emulated Titian's classic work, *Le Concert Champêtre (The Pastoral Concert)*—the critics perceived Manet's work as outright debauchery. His 1864 entries were also poorly received. In *Incident in a Bullfight*, it was the experiment in perspective that enraged his critics. In *The*

Dead Christ with Angels, it was the heretical portrayal of Christ's frightfully realistic corpse.

Manet's rocky relationship with the Salon, the critics, and the public hit its climax with the painting *Olympia* in 1865. Although the Salon accepted the painting (perhaps knowingly throwing him to the wolves), it had to be guarded at all times due to public outrage. The realism in Manet's portrayal of a bold, unflinching, nude prostitute in a goddess-like pose was offensive to many. Manet, a likeable gentleman, did not take the public's response lightly. After the heated reaction to *Olympia*, he wrote to his friend Charles Baudelaire: "They are raining insults on me. Someone must be wrong."

Saving *Olympia*

Manet could never bear to part with his painting, *Olympia*, during his lifetime. After his death, his financially strapped widow attempted to sell the painting, but Claude Monet stepped in and raised enough funds to halt the sale. Thanks to Monet's allegiance to his friend, *Olympia* has been preserved in the Louvre since 1893.

MANET FINDS HIS FANS

Soon after—and in part because of—the *Olympia* scandal, Manet found loyal fans in the younger artists of his time. He became the leader of a small group of artists, writers, and art devotees who met at Café Guerbois. Many of these artists—Edgar Degas, Claude Monet, Pierre-Auguste Renoir, Alfred Sisley, Camille Pissarro, and Paul Cézanne—would go on to become the central figures of the Impressionist movement. Just as Manet influenced their departure

from the norm, so did these artists impress upon Manet a heightened sensitivity to the effects of light and color on his subjects.

One of his last and greatest works to reach the public was *A Bar at the Folies-Bergere*, exhibited in 1882. Manet was fifty years old the year it was put on display at the Salon, but in very poor health. This now-famous painting captures a Parisian barmaid in the chaos of her surroundings. An old friend ensured that Manet was given the Legion of Honor for this striking culmination of the artist's talents. It was an award that Manet had long pursued and it delivered the positive recognition he'd been starved of all his career. Manet died the following year, eleven days after having his leg amputated due to complications from untreated syphilis. The public would be robbed of his burgeoning artistry just as they were beginning to appreciate it. As Degas said at Manet's funeral, "He was greater than we thought."

FOLK ART

The cultural emblems of ordinary people

Folk art is a term that is used to describe the myriad ways in which craftspeople, artisans, and indigenous people exhibit their skills while showcasing their local culture in the process. Contrary to the principles of formal academic art, folk art is often made for a purpose beyond aesthetics. Examples of this style run the gamut from a simple road sign to a hand-carved wooden mask to ornate jewelry. While fine art spends its life in a glass case or frame, folk art often becomes part of community rituals, businesses, and everyday life.

AMERICAN FOLK ART PAINTING

Most American folk art painters of the 1700s and 1800s were tradesmen from rural areas, with a great number concentrated in the Northeast. Their experience painting signs, houses, ships, and furniture gave them a unique understanding of the craft that allowed them to transition to canvas. Bold colors, broad brushstrokes, and a variable scale were common features of their work (which was primarily portrait work). Folk artists did not often concern themselves with the painstaking replication of lighting or shading, so the end product had a flat and linear quality. The artists often worked on the road, traveling to make commission. It was in their financial interest to produce quickly and cheaply, so they adhered to a set formula of composition and used whatever tools were at their disposal.

Folk artists took more liberties in their paintings than fine artists of their time. For example, when painting a portrait in tribute to

a deceased family member (a fairly common practice), the folk artist might add intense detail to the face of the subject to convey lasting personality traits or to achieve a likeness to the subject. The rest of the body, however, was often drawn in less detail and without much concern regarding proportion. This lent folk art a peculiarity that did not always sit well with purveyors and critics of fine art.

Folk Artist Communities

Religious groups like the Amish, the Quakers, and the Shakers lead a quiet, peaceful existence in rural Pennsylvania and other areas of the Northeast. Their tight-knit communities were bound by common beliefs and a commitment to craftsmanship. Because of this, folk art flourished in these communities with a focus on beautiful, hand-carved wood furniture.

The extensive body of American folk art showcases more than just painting skills. Wood carvings, metal crafts, gravestone carving, quilting, furniture making, pottery, and paper crafting are just some of the areas in which these artists excelled. From barbershop poles to children's toys to serving ware, American craftsmanship was—and to a lesser extent continues to be—an illustrious fact of life.

WELL-KNOWN AMERICAN FOLK ARTISTS

It wasn't until the end of World War I that folk artists began to gain recognition for bringing something authentically "American" to American art. While many folk artists worked in relative obscurity,

those who achieved fame include Grandma Moses (1860–1961) and Edward Hicks (1780–1849). Grandma Moses's style, labeled "American Primitive" during her time, is now on display at major galleries across the United States. She produced thousands of paintings showing country life in upstate New York and Vermont. Her work depicted traditions of American farming, including making maple syrup, candles, and apple butter.

Edward Hicks, a devout Quaker and preacher, also found fame as a folk artist. His landscape paintings and representations of Quaker beliefs were rarely without a moral or some form of scripture.

INDUSTRIALIZATION LEAVES FOLK ART IN ITS DUST

The growth of industrialization in the mid-nineteenth century and the presence of new technologies put a lot of artists out of work. Mechanical processes could accomplish an artisan's task much faster, albeit with less grace and artistry. By the end of the century, most handmade products had been replaced by machine-made ones. Folk art lost its everyday functionality but found a new purpose: personal expression and cultural preservation.

Folk art as a movement is ongoing. It is alive in rural communities throughout the world as people naturally express their culture through their handiwork. In America, it continues in the work of modern-day folk artists like David Eddy, Larry Zingale, and countless others.

From Condescension to Celebration

Folk art has not always been a respected category of art. This is evident in historic and critical descriptions of the art as "naive," "plain," "rural," "provincial," "outsider," "idiosyncratic," and "nonacademic." Today's museums use more sensitive terminology to underscore the talent of its creators.

FOLK ART SPANS THE GLOBE

Folk art is not an American phenomenon but an international one, reflecting the deep traditions of tribes, villages, and regions of every nation.

- African folk art includes the jewelry, masks, costumes, and pottery used in daily and spiritual rituals. In many tribes, women passed down skills required to make textiles, baskets, and beadwork used in tribal ceremonies while men expertly carved wood and metal into weapons and other tools.
- Chinese New Year prints, Indonesian shadow puppets, Indian temple toys, and Japanese woodblock prints are just some representations of the abundance of Asian folk art.
- The Middle East collection includes Turkish ceramics and beautiful amulets and textiles from Palestine, Iran, Saudi Arabia, and Jordan.
- Latin American countries yielded an overwhelming amount of cultural emblems due to the many indigenous populations of countries like Peru, Guatemala, and Brazil. These artists crafted wood and ceramic figures, dance masks, religious objects, costumes, jewelry, paintings, dolls, and toys.

- Mexican folk art is a particularly diverse genre due to the variety of raw materials at the artists' disposal: Wood, clay, metals, fibers, and dyes were easy to obtain and gave way to decorative pottery, wood carvings, cloth, metal, and paper crafts.

Today's top museums honor the contributions of both trained and untrained folk artists from all over the world, presenting them as valuable keys to understanding history and culture.

INDEX